Media and Memory

Media Topics

Series editor: Valerie Alia

Titles in the series include:

Visit the Media Topics website at www.euppublishing.com/series/MTOP

Media and Memory

Joanne Garde-Hansen

Edinburgh University Press

© Joanne Garde-Hansen, 2011

Edinburgh University Press Ltd
22 George Square, Edinburgh

www.euppublishing.com

Typeset in 10/12 Janson Text
by Servis Filmsetting Ltd, Stockport, Cheshire, and
printed and bound in Great Britain by
CPI Antony Rowe, Chippenham and Eastbourne

A CIP record for this book is available from the British Library

ISBN 978 0 7486 4034 8 (hardback)
ISBN 978 0 7486 4033 1 (paperback)

The right of Joanne Garde-Hansen
to be identified as author of this work
has been asserted in accordance with
the Copyright, Designs and Patents Act 1988.

Contents

Acknowledgements

I owe a great debt to Kristyn Gorton (University of York) without whom I would not have proposed and written this book. She is a generous and thoughtful scholar and friend. As with all books, there are many people to thank for getting to this point. I am grateful to my colleagues at the University of Gloucestershire: Justin Crouch, Abigail Gardner, Jason Griffiths, Simon Turner, Owain Jones and Philip Rayner as well as colleagues at other universities who have inspired my thinking and writing: Anna Reading and Andrew Hoskins in particular. Mostly, though, I owe a debt of gratitude to the hundreds of students I have taught on the Media and Memory undergraduate module at the University of Gloucestershire. Unwittingly, they have been the guinea pigs for much of this material over the years.

Many thanks to Valerie Alia and the Edinburgh University Press team who have been generous with their support and editorial guidance.

This book is dedicated to the memory of my mother-in-law Lise Garde-Hansen for inspiring me to rediscover my creativity.

Preface

When an author is defining a title for a book, simplicity is not the only watchword. The title has to be easily remembered – and not necessarily by the potential readers who could, would and should read it. It has to be memorable to the archiving power of research/commercially-driven Internet search engines that trawl data and retrieve information for those who are actively seeking out a topic or who might stumble across it. It has to be contractible in text speech, taggable for blogs, storable on tweet decks, searchable in publisher's web pages and not be too drowned out by the superfluous when Google returns its search results. The wrong choice of book title and bloggers, tweeters, Facebookers, and e-literate researchers using del.ico.us will not commit, create and connect the book to the mnemonic technologies, structures and networks that form our mediated ecology in which our ideas circulate. The fact, therefore, that this book is entitled *Media and Memory* should not mean that the author thinks that the two spheres conjoin easily, equally and permanently. They do connect and this book is about making those connections. The use of the conjunctive could simply be there because any student from any field of study interested in the connections between the two would most likely enter 'media and memory' into the search engine box. The title is smoke and mirrors. I could have just as easily replaced the conjunctive with a preposition or an infinitive and then a whole different spatial, temporal and existential relationship between the two spheres would have opened up. Media as Memory, Memory as Media, Media is Memory, Memory is Media, Media in Memory or Memory in Media. Consider these all, at one and the same time, the title of this book.

When reading this book, imagine that the relationship between media and memory is not one of simple connection, as if a piece of string has been secured into a complete circle and now we see the join and understand the relationship. At last, we say, the circle is complete and it has always been going around and around. Of course, media (the discourses, forms and practices) function as mnemonic aids and

remembering devices, and memory is mediatised as well as a mediator between self and society. To see one intimately connected to the other, as imbricated in the other, as interpolated into the other, does not go far enough for understanding the complexities of the connections and that increasing complexity in a digital age. I cannot, of course, even dare to hope that this book will provide the reader with the full depth and breadth of that complexity but I conjecture that this book will open up the reader's mind to a new appreciation of the exciting, creative and connective possibilities that bringing these two spheres together might offer students of media, history, memory studies, heritage, museology, sociology, geography, digital media, psychology and all other disciplines with an interest in exploring the connections.

Imagine, then, that media and memory have always been together, two sides of the same coin, two sides of a piece of card. Remember that pens and paintbrushes are as much technologies of memory as mobile phones and photocopiers. In classes with students on my media and memory course, I demonstrate the relationship with A4-sized paper card – in fact it is with many pieces of coloured card, stacked together but the class cannot see that there is more than one piece of card: they expect simplicity. One side of the card is media and the other side memory. They see they are together but distinct from one another and representable in their own way, but connected and impossible to separate. I then fold the card around and by connecting it temporarily at the join form a useful container. I tell them the outside of the container represents media and the inside memory. (It could just as easily be the other way around but I like the fact that the memory is private and on the inside and the media is public and facing outwards, albeit this is changing.) I put my hand under the bottom to make a temporary container. Sometimes I drop objects through without the hand there and then do the same with the hand in place. The objects represent society, culture, identity, politics and history (the big concepts), for example, and the media/memory container holds all of these (albeit rather contingently) in place. I tell them about how we see both media and memory as containers, storehouses and archives. It seems like an understandable three-dimensional object metaphorising the relationship between two dynamic forces. It is straightforward at this point but when we unravel the container and reveal the multi-coloured layers of card that make up media's relationship with memory, it gets tricky. It is the layers of meaning, continuously and unstoppably laid down, that make the relationship between them equally one that could be defined by another middle term: in, as, on, with, through, a forward slash.

In fact, by the time this book has been published more layers to the relationship will have been added, more combinations, more connections and more possibilities. As the controller of BBC archives, Tony Ageh, rejoiced and lamented in his keynote address at an ESRC-CRESC conference on the Visual Archive in May 2009, it would take 300 years to view the BBC's infamous programmes archives (amounting to 800,000 hours). By which time the BBC would have created 15 million more hours of programmes. If, by 2044, the BBC intends (through such fledgling software as iPlayer) to make a million hours of programming available daily compared to the 21 hours offered in 1937, then memory, in all its permutations, will form an important perspective from which to study media.

In Memory of Lise Garde-Hansen

Introduction: Mediating the Past

History and (the) Media

> The past is everywhere. All around us lie features which, like ourselves and our thoughts, have more or less recognizable antecedents. Relics, histories, memories suffuse human experience [. . .]. Whether it is celebrated or rejected, attended to or ignored, the past is omnipresent. (Lowenthal 1985: xv)

Apart from mandatory history lessons at school that may inspire a minority to pursue historical studies at a higher level and beyond, where do the rest of us get an understanding of the past? It is safe to say, as we stand firmly established in the twenty-first century, that our engagement with history has become almost entirely mediated. Media, in the form of print, television, film, photography, radio and increasingly the Internet, are the main sources for recording, constructing, archiving and disseminating public and private histories in the early twenty-first century. They provide the most compelling devices for accessing information about the last one hundred years within which many of the media forms were invented and developed. Moreover, they form the creative toolbox for re-presenting histories from periods and events long before, of which those media forms were not a part. Think of all those costume dramas, history documentaries and heritage centres that are so popular. It seems we are not able to understand the past without media versions of it, and the last century, in particular, shows us that media and events of historical significance are inseparable.

The focus upon media's relationship with history is fairly recent (Baudrillard 1995; Sturken 1997; Zelizer 1998; Shandler 1999; Zelizer and Allan 2002; Cannadine 2004 to name but a few key authors) and undoubtedly performs the *fin-de-siècle* experience of disgust at a war-ridden, genocidal twentieth century mixed with hope for what a new millennium might offer. It may have been born out of the

simultaneous calls for an end to the grand narratives of history from key theorists of postmodernism (Lyotard 2001, Fukuyama 1992 and Derrida 1994) and a new approach to understanding the past through *little narratives* of and from the people, or as *history from below* (see Foucault 1977). Whatever the reasons for the last few decades of grappling with the uneasy bedfellows of media and history, it is now clearly established that the two are in a symbiotic relationship. David Cannadine has argued that 'it does indeed seem as though history and the media are more completely interconnected and more variedly intertwined than ever before' (2004: 2). The essayists in his book (historians working in media, media practitioners working in history) argue that the divide between history and media is impossible to maintain. In fact, as students of media are already aware, literally 'everything' is mediated (Livingstone 2008) and mediatised (Lundby 2009). We know from our own consumption of history that our diet consists of a great deal of televised and cinematic versions of the past mixed with selective research of the Internet. What we do not know is how true and reliable the information is, whether it challenges us to think differently or whether we simply consume what we already know rather than seek alternative histories.

We are, though, thinking here about history with a capital 'H' and in doing so grappling with the prejudice that media, in particular screen media, through which much history is disseminated, cannot help but 'dumb down' the past. This is a well-worn charge against television that continues to be debated (see Hoggart 1957, 2004; McArthur 1978; Postman1986; Miller 2002, 2007; Bell and Gray 2007; De Groot 2009), and it seems we are at a stage where popular culture has such a firm grip on the past that we need to turn our attention to big issues such as authenticity, reality, evidence, ethics, propaganda and the commercialisation of the past:

> 'History' as a brand of discourse pervades popular culture from Schama to Starkey to Tony Soprano's championing of the History Channel, through the massive popularity of local history and the Internet-fuelled genealogy boom, via million-selling historical novels, television drama and a variety of films. Television and media treatment of the past is increasingly influential in a packaging of historical experience. (De Groot 2006: 391–2)

The picture painted here of the popularising power of media does not take into account the position of the popular British historian Simon Schama, who draws into historical studies lessons learned from media about the value of the audience (2004: 22–3). Media's popularity is its

strength, its ability to democratise access to and representations of the past mean that those interested in history (professionals, politicians, students and citizens) are able to engage with the past along the lines of freedom, empathy and community (2004: 22–3). Therefore, if Schama describes history as 'the repository of shared memory' (2004: 23), then perhaps we can begin this book with the idea that media compels an end to history and the beginning of memory. In fact, Andreas Huyssen argues that 'memory – as something that is always subject to reconstruction and renegotiation – has emerged as an alternative to an allegedly objectifying or totalizing history, history written either with small or capital H, that is, history in its empiricist form or as master narrative' (Huyssen 2003b: 17). While memory has been a contentious issue for historical studies (see Klein 2000), it has been, as Marita Sturken (2008: 74) argues and will be shown in this book, fully embraced by media studies.

Media: The First Draft of History

With this in mind, it is common to describe media, especially print and television news media, as 'the first draft of history'. Those working in the journalism industry would like to think of themselves as privileged witnesses to events, who then truthfully convey vital information to those who need to know or do not yet know. The award-winning British journalist and war correspondent Robert Fisk stated that: 'I suppose, in the end, we journalists try – or should try – to be the first impartial witnesses of history. If we have any reason for our existence, the least must be our ability to report history as it happens so that no one can say: "We didn't know – no one told us"' (Fisk 2005: xxv). 'Media witnessing' has now become one of the key concepts for understanding the relationship between experiences, events and their representations. Frosh and Pinchevski (2009: 1) determine it as a threefold practice: 'the appearances of witnesses in media reports, the possibility of media themselves bearing witness, and the positioning of media audiences as witnesses to depicted events'. Thus, as I suggested in the preface for this book, media witnessing is produced through the complex interactions of three strands: 'witnesses [memory] *in* the media, witnessing [memory] *by* the media, and witnessing [memory] *through* the media' (Frosh and Pinchevski 2009: 1, my additions). However, there is an ethical, political and legal investment in the term 'witness' that elevates media above the messiness of memory. Respected news journalists see themselves as witnesses, as contributing to history, but how do we know they are telling us the truth?

In writing the first draft of history news media, in particular, has been found guilty of crimes against history. The 'CNN effect' (Livingstone 1997) has become an all-encompassing term for understanding how real-time television influences not only policy and government but also audiences' understandings of and reactions to major events of historical importance. It was Jean Baudrillard who caused a storm of controversy when he claimed that because we only saw the targeted bombing through television it felt like *The Gulf War Did Not Take Place* (1995). While we admire the idea of the determined journalist unearthing the hidden story, getting the facts and telling the truth in the face of danger, in reality we also know that in our media ecology of '24-hour news', repetition, recycling, studio analysis and highlights, it is more likely that journalists stand around waiting for history to happen. In fact, we are now in a position where journalists are no longer the first drafters of history at all but Twitter users are, sending out tweets of the Mumbai bombings in 2007 or the earthquake disaster in China in 2008 before CNN reporters even got out of bed (see Ingram 2008).

Therefore, it is not enough to acknowledge that media record events as they happen and therefore present the first draft of history to be memorably imprinted in our minds at the time or accessed by future generations: so we know where we were and what we were doing when X happened. That would be far too simplistic and would ignore the active and creative uses of media by producers and citizens interested in making and marking history. Consider mediated events such as the Hindenberg Disaster of 1937, in which a Zeppelin passenger ship exploded into flames as distressed American radio correspondent Herbert Morrison witnessed and conveyed the devastation to listeners. Described as the 'Titanic of the Sky', the German Zeppelin was destroyed within moments, killing around a third of its almost one hundred passengers. Seven years ago I aired the 'original' audio recording of Herbert Morrison's report to media students and we discussed the power of early broadcast radio as witness, the emotive response in Morrison's voice and his ability to convey the tragedy and trauma through sound ('Oh, the humanity', is his mournful, oft-repeated plea to the listener). However, my students were unable to emotively connect to this event at all, it was not part of their collective or cultural memory.

Did it matter to my students that the audio report was not broadcast *live* on 6 May 1937 and that it was only aired the next day on Chicago's WLS radio? Yes it did, as they were under the illusion of connecting with a past audience hearing the report 'live' for the first time, not a

pre-recorded report of an event that happened the day before. Did it matter, that my students could only *hear* the disaster? Yes, most certainly, their expectations and criteria of media witnessing were benchmarked by their memories of 11 September 2001. They found the audio difficult to understand, not socialised into poorer quality 'wireless' listening culture, and the event impossible to imagine without at the very least a still photographic image. In search of images, we found photographic slides and the 1975 George C. Scott film *The Hindenberg*, directed by Robert Wise and based upon a 1972 conspiracy thriller *Who Destroyed the Hindenberg* by Michael M. Mooney. We now had some visuals and media narratives but we needed something more emotive.

The media students interviewed the older generation about the disaster and found that those with an understanding of this historical event discussed it in terms of their memories of Scott's 1975 cinematic representation – as something to do with Nazis and sabotage – but knew little if anything about Herbert Morrison's original report. A few years later I was able to place many uploaded archival images of the event onto PowerPoint slides to satisfy my students' desire for a visual hook to help them empathise. Their desire was fully satisfied in 2009, when they undertook an Internet search for 'video results of Hindenberg' (even though we know there are no audio/visual recordings of the disaster) and retrieved 149 different videos from youtube.com, video.google.com, gettyimages.com and dailymotion.com, with all their viral derivations. Morrison's report has been seamlessly (in most cases) synchronised to footage and photographs, by professionals and amateurs, some have included a soundtrack and others have inserted retro inter-titles to covey that 1930s feeling. Almost seventy-five years after the disaster, the powerful desire to remember, to witness, to connect and to feel through audio and visual schema has been reconstructed.

What does all this mean for media and memory studies? When we begin with trying to understand the relationship between history and media we soon uncover that traitor memory lurking in the shadows. Is memory a popular, dumbed-down, emotional, untrustworthy purveyor of half-truths and trauma: an agent of repression and self-editing? Or is memory's amorphousness and lack of discipline (Sturken 2008: 74) the very tonic needed to uncover the active, creative and constructed nature of how human beings understand their past? Memory has become the perfect terrain and material for media to perform its magic: 'as "the first draft of history", journalism [for example] is also the first draft of memory, a statement about what

should be considered, in the future, as having mattered today' (Kitch 2008: 312).

From History to Memory

Consequently, if we temporarily separate the two terms then the past can be articulated as history (the writing of the past) or as memory (the personal, collective, cultural and social recollection of the past). History (authoritative) and memory (private) appear to be at odds with each other. Media (texts, photographs, cinema, television, radio, newspapers and digital media) negotiate both history and memory. We understand the past (our own, our family's, our country's, our world's) through media discourses, forms, technologies and practices. Our understanding of our nation's or community's past is intimately connected to our life histories. Therefore, mediated accounts of wars, assassinations, genocides and terrorist attacks intermingle in our minds with multimedia national/local museum exhibits and heritage sites, community history projects, oral histories, family photo albums, even tribute bands, advertisement jingles and favourite TV shows from childhood. All these are multi-modal versions of our multifarious histories flowing continuously through audio and visual schema. The historian and television-maker Simon Schama has said that we live our lives through the 'chopped-up, speed-driven, flickeringly restless quality of modern communication', our information is received 'serially', our picture of the world is 'scrambled', rhetoric passes 'through fields of sonic distortion' and our topography is 'glimpsed through the flickering flash of car-windows; each one the equivalent of a celluloid frame' (Schama 2004: 22). Schama's view has echoes of Neil Postman in *Technopoly: The Surrender of Culture to Technology* (1992) in which he states that 'to teach the past simply as a chronicle of indisputable, fragmented, and concrete events is to replicate the bias of Technopoly, which largely denies our youth access to concepts and theories, and to provide them only with a stream of meaningless events' (Postman 1992: 191).

However, this seems a rather top-down response to how we engage with history or to how non-Western cultures, for example, represent their pasts. Even long-established peoples within Europe, such as Gypsies, Roma and Travellers do not do 'history' in these traditional ways. Often victims of history, such communities engage with personal, collective, shared and cultural memories in connective ways in order to preserve their heritage. Not dissimilarly, many of us are rooted to our histories in, with and through media, we hold onto and

share photographs, store tapes, collect posters and comic books for example. However mobile, global or local our present interactions we actively connect ourselves to our pasts through a continual and dynamic accumulation of personal media archives (perhaps overwhelmingly when I look at the thousands of digital photographs accumulating on my laptop or the stacks of audio cassette 'mix' tapes I can no longer play). Our understanding of personal and public histories is structured through what José van Dijck has termed 'mediated memories' (2007). When we leave the territory of history and embrace the more inclusive domain of memory we reveal some important questions: how is memory different to history, is it a substitute for history, does it make history, does it make it up, or does history determine what is remembered and forgotten? When I consider the boxes of vinyl records, laser discs, radio cassettes and now VHS tapes slowly disintegrating in the loft how have media delivery systems themselves and all the memories associated with and held within them become history?

Given that this book is focusing on memory, it makes sense that we will be approaching media from the personal perspective. After all, memory is a physical and mental process and is unique to each of us. It is this uniqueness and differentiation that often makes it difficult to generalise about its relationship with media. Memory is emotive, creative, empathetic, cognitive and sensory. We rely upon it, edit it, store it, share it and fear the loss of it. The same can be said of the media we consume. In fact, Marshall McLuhan (1994) would argue that media are extensions of memory. It is our need to remember and share everything and the limitations of doing this mentally as individuals that drives human beings to extend our capacity for remembering through media forms and practices.

Capturing the past is becoming increasingly sophisticated and memory tools such as television, film, photocopiers, digital archives, photographic albums, camcorders, scanners, mobile phones and social network sites help us to remember. At the same time, mediating the past through history channels, documentaries and Hollywood films seems at odds with live televised events such as the fall of the Berlin Wall or 11 September. All these mediations of the past project multiple framings, which demand responsible analysis. This book is not just about media representations of the past and our relationship to them. It is about understanding the archives we leave for future generations and the way in which we use media to help articulate our own histories both as producers and consumers. In the first half of the book, I will offer some theoretical background by drawing together

the key theories that bring media and memory into a relationship. The second half will focus more specifically on case studies – on analytical interventions that respond to the multiple ways media and memory interact. The case studies will offer textual, netnographic, audience and producer accounts of some key ways media and memory come together. By applying theories of memory to media and vice versa, the book will draw out the connections between mediated memories of events, media images of the past and uses of media for memory practices. While this book offers original research in the case studies it is also essentially designed as an introduction to the study of how we individually and collectively make sense and order of our past through media.

Exercise

Undertake your own Internet search of the Hindenberg Disaster of 1937 and view the audio/visual examples you retrieve. Can you determine what was originally broadcast and/or printed about the event at the time? Who has creatively manufactured the event since and how have they done it? Interview older members of your family to determine their understanding of this event. Compare and contrast the interviews with the audio/visual evidence you have discovered.

Questions for Discussion

1. If journalists make history do they make it up and what is the audience's role in that (re)construction of the past? Consider everyday history as well as major historical events.
2. Which media representation of a past event would you trust as more truthful: radio/television news item, newspaper article, documentary, movie or Wikipedia page?
3. Does how we remember become more important than what we remember?

Further Reading

Bell, E. and Gray, A. (2007) 'History on television: charisma, narrative and knowledge', *European Journal of Cultural Studies*, 10: 113–33.

Cannadine, David (ed.) (2004) *History and the Media*. Basingstoke: Palgrave Macmillan.

Frosh, Paul and Pinchevski, Amit (2009) *Media Witnessing: Testimony in the Age of Mass Communication*. Basingstoke: Palgrave Macmillan.

Hoggart, Richard (2004) *Mass Media and Mass Society: Myths and Realities*. London: Continuum.

Kitch, Carolyn (2008), 'Placing journalism inside memory – and memory studies', *Memory Studies*, 1 (3): 311–20.

Lundby, Knut (ed.) (2009) *Mediatization: Concept, Changes, Consequences*. Oxford: Peter Lang.

McLuhan, Marshall ([1964] 1994) *Understanding Media: The Extensions of Man*. Cambridge, MA: MIT Press.

Rosenstone, Robert A. (2006) *History on Film/Film on History*. Harlow: Longman.

Zelizer, Barbie and Allan, Stuart (eds) (2001) *Journalism after September 11*. New York: Routledge.

Part 1

Theoretical Background

1 Memory Studies and Media Studies

There is a long history of thinkers who have, to certain degrees, evaluated, reflected upon and tried to explain memory and remembering. Not surprisingly, this extends as far back as Plato and Aristotle as well as being found in the more recent philosophical thinking of writers as diverse as Friedrich Nietzsche (1844–1900), Sigmund Freud (1856–1939), Émile Durkheim (1858–1917), Henri Bergson (1859–1941) and Walter Benjamin (1892–1940). It has developed from early sixteenth-century beliefs that 'memory could offer unmediated access to experience or to external reality' (Radstone and Hodgkin 2005: 9) to late nineteenth-century challenges; as 'modernity's memory' was considered at once the utopian alternative to history (see Andreas Huyssen (1995) on Benjamin, Baudelaire and Freud) as well as something to be escaped from. It would be impossible for an introductory text to cover all this terrain and recently, as the field of memory studies has emerged, so too have appraisals and anthologies to aid the student interested in the origins and developments of memory as a concept (see, for example, Misztal 2003; Rossington and Whitehead 2007; Erll and Nünning 2008; Rowland and Kilby 2010; Olick et al. 2010). What this chapter can do is introduce the reader to the key issues, debates and ideas that begin to shape connections with media studies by drawing attention to the explosion of memory-related research over the last half-century. This period post-Second World War has witnessed unprecedented changes. The developments summarised below provide an adapted and expanded version of Pierre Nora's (2002) reasons for the current upsurge in memory:

- access to and criticism of official versions of history through reference to unofficial versions;
- the recovery of repressed memories of communities, nations and individuals whose histories have been ignored, hidden or destroyed;

- the opening of existing and the creation of new archives for public and private scrutiny;
- the explosion in genealogical research and family narratives;
- the growth of museums and the heritage industry;
- the desire to commemorate, remember and memorialise in ways other than through public statues and monuments;
- an increasing emphasis upon trauma, grief, emotion, affect, cognition, confession, reconciliation, apology and therapy;
- the development of and investment in biotechnology and the increased visibility of the functions of the human brain.

All these coincide with the proliferation, extension and development of mass media, broadcast media, digital media and networked communications media. Consequently, it is not always clear from existing literature how and why memory studies (ranging from the sociological to the cognitive science approaches) should and could synthesise with media studies. I will begin to make these connections explicit in this chapter in order to build blocks of understanding for the subsequent chapters that explore the connections in more depth.

What is Memory?

Memory, like emotion, is something we live with but not simply in our heads and bodies. In a workaday way we pigeon-hole memory as memorisation: 'Memory is a kind of photographic film, exposed (we imply) by an amateur and developed by a duffer, and so marred by scratches and inaccurate light-values' (Carruthers 2008: 1). Yet memory is more than this and in her extensive re-reading of memory in medieval culture, Mary Carruthers has shown that in the Middle Ages 'memory' was akin to what we would now call creativity, imagination and original ideas (Carruthers 2008). We express, represent and feel our memories and we project both emotion and memory through the personal, cultural, physiological, neurological, political, religious, social and racial plateaux that form the tangled threads of our being in the world. Where, then, to begin studying it?

When we locate memory in the brain or mind we issue forth two different academic disciplines that have both converged upon the study of memory: psychology and neurology and all the sub-disciplines that derive from them, such as neurobiology, behavioural neuroscience, cognitive psychology and clinical psychology. On another level, even if we focus upon these approaches, we become concerned that they may miss the bodily, or corporeal and sensory, aspects to

memory and remembering. They may also be so scientifically focused that they ignore the quotidian or everyday emotional encounters that people have with the past. When you remember something painful or nostalgic, you sense it, and it sometimes evokes a physical reaction. A scent, a sound, a texture all trigger memories as images and narratives in your mind that you re-experience, visualise, narrativise and feel. So, locating memory in the brain has to take account of both mental and bodily processes as a starting point, before incorporating non-scientific understandings. The proliferation of descriptors for types of memory[1] coming from science disciplines (motor memory, false memory, corporeal memory, auditory memory, unconscious memory to name but a few) suggests that even within these, the term memory has multiple possibilities (see Roediger et al. 2007 for a more thorough understanding of the range of scientific approaches).

All this is a little too focused on the individual as a subject of science and we are not simply human beings mapped onto a landscape or situated in ecology. As memories come and go, are lost and found in our minds, so too, the present moment (full of people, places, events, actions, experiences, feelings) connects with past moments (full of people, places, events, actions, experiences, feelings). These connections are not simply with our own personal past, but with a whole range of pasts that are on a micro-level such as histories of family, local community, school, religion and heritage, and on a macro-level such as histories of nation, politics, gender, race, culture and society. All these connections contribute to our self-identity and the feelings we have about those memories. Sometimes your sense of your self is ordered and chronological (you left school, you went to university, you got a job) with different degrees of depth and factual accuracy depending on what is triggering the memories in the present moment (a CV, a reunion with an old school friend, a job interview and a Facebook page will all require the self to present the same memories in different ways and for different reasons).

Most of the time, our memories are triggered rather randomly in a fleeting and disordered way. Occasionally, we stop and reflect and work through a memory that we have often lived too fast to deal with at the time before we can move forward again. Whatever we do, when we practise memory on an everyday level we are actually undertaking a function: to remember. This functionality has been very effectively addressed by the natural sciences and psychology in, for example, *Memory in the Real World* by Cohen and Conway (2008) covering everyday actions such as making lists to remembering voices, faces and names. While it covers metacognition, consciousness, dreams and childhood memories it also reaches out to areas of memory studies

that have impact for arts and humanities research: namely 'flashbulb' memories, eyewitness memories and experiential memories. Thus as an activity and a process and, quite often, as a creative act in the present moment, memory quickly escapes the confines of the sciences and circulates in the creative spheres of research and practice.

So while we might like to imagine that our brain is some kind of biological storehouse or bio/technological hard drive from which we can retrieve data, it is in fact far more undisciplined and creative. This has made memory so interesting for the arts, humanities and social sciences and this is where memory and the creativity of media really begin to connect. In the next section, I will draw together the key research on memory that has emerged and can be connected with studies of media. For now, it is worth summarising what we can say about the study of 'memory' as a concept, which begins to explain why this territory is so attractive to media researchers and practitioners:

- It is interdisciplinary – the study of it requires attention to the relationship between academic disciplines as the field evolves and asks what new knowledge is required. For example, a range of humanities subjects address the role of archiving in the twenty-first century and the dynamic of digitalisation.
- It is multi-disciplinary – the study of it requires access to a range of disciplinary knowledge but without a common vocabulary. For example, the establishment of the journal *Memory Studies* in 2008 joins together in one place many of the disciplines engaged in the study of memory and it is often the role of the reader as third party to make the connections.
- It is cross-disciplinary or trans-disciplinary – it ignores the disciplinary boundaries and studies memory using a toolbox of approaches from the most appropriate knowledge bases. For example, media studies itself follows a postmodernist view of unconfined knowledge which is transgressive and so, in itself, often plays fast and loose with disciplinary boundaries.
- It is undisciplined – the study of it requires access to non-academic knowledge bases. For example, experiential and ordinary accounts of memory from public and private sources have as much value as academic sources.

A Brief History of 'Memory Studies'

This section provides a sketch of the emergence of memory studies over the last one hundred years in the arts, humanities and social

sciences. It is intended to set the stage for understanding the more recent developments in memory research from the 1990s to the present and in the next chapters I will delve deeper into these particular articulations of memory that have currency for media studies. For now, it is enough to simply provide the briefest of overviews so that the reader can orientate him or herself in relation to what has been written. For ease, I have organised the development of the emergent field in three phases, albeit this is arbitrary and we should not consider this a coordinated developmental structure. Indeed, one of the exciting aspects of the 'field' of memory studies is its resistance to being defined as a field in the first place.

The following does not provide a comprehensive account of all the key thinkers from the arts, humanities and social sciences of the twentieth century who have written on memory. It is important to be broad at the expense of specificity at this stage because media studies courses across the world move in and out of disciplines and the students on these courses connect with a range of disciplinary knowledge. There will be some omissions, no doubt, but it is important to sketch some of the foundational theories that students are likely to encounter and upon which many of the more recent texts referenced in this book now stand. As academics draw together required and suggested reading for their courses that concern 'memory' (whatever discipline these courses reside in) they are often selecting such foundational texts or other texts that rely upon a modicum of familiarity with them. That said, students often discover these key texts or are assigned extracts and find it difficult to navigate through them because they come from knowledge bases different to their own or use vocabularies that are unfamiliar.

This is the first problem for 'memory studies' as a taught course, whose schedule of key readings is uploaded to university websites and shared by tutors across the world. At the end of this chapter, I challenge the reader to engage with at least one of the original writings of these thinkers and the further reading at the end of the chapter provides key examples of the different ways that memory has been theorised in relation to these foundational ideas. One should not, however, consider the texts I have drawn together here as comprising a 'canon' of memory research; rather, these are the texts that my own students, who have come from courses as wide-ranging as heritage management, radio and TV production, media, communication and culture, history, psychology and sociology, have encountered and will continue to encounter.

Phase 1: Some Foundational Ideas

The seminal texts of the French philosopher and sociologist Maurice Halbwachs *The Collective Memory* ([1950] 1980) and *On Collective Memory* ([1952] 1992), the French philosopher Henri Bergson's *Matter and Memory* ([1896] 1991), the French philosopher Paul Ricœur's *Memory, History and Forgetting* (2004), the French historian Pierre Nora's *Les Lieux de Mémoire* (1984) or *Realms of Memory* (1996–8) and Jacques Le Goff's (1992) *History and Memory* are the main examples. It should not go unnoticed that these key thinkers are all French and clearly there is a tradition established here that draws upon the socialism and later *nouvelle histoire* that French academia has become synonymous with.[2] While Bergson and Halbwachs' lifespans end at the Second World War, Nora's, Le Goff's and Ricœur's reach into the twenty-first century. It is not possible to synthesise their works in depth in this book but it is important to draw out some of the ways their writings have influenced the later emergence of 'memory studies' as a more connected field of enquiry[3] and some of their ideas will reverberate in this book in a variety of media contexts.

The dynamic, creative and ever-expanding archive that is Wikipedia will no doubt be the first port of call for any student interested in getting an overview of these thinkers. This is no substitute for actually 'reading' some of what they have to say and extracts of their original writings abound on the Internet. What connects them contextually is their reaction to a twentieth-century Europe in danger: of succumbing to fascism, of rewriting history, of the destruction of people, memories, histories and archives. For these writers, a concept of memory destabilises 'grand narratives' of history and power. Imagine an earthquake so powerful and all encompassing, that while it destroys people (memories) it also obliterates the equipment that would be used to measure its destructive power (archives). How would you know it had happened? For these thinkers, memory, remembering and recording are the very key to existence, becoming and belonging.

Halbwachs' conceptualisation of memory in terms of the collective has been particularly influential in the fields of media, culture, communication, heritage studies, philosophy, museology, history, psychology and sociology. His work, inspired by his tutor Émile Durkheim (1858–1917), is often a starting point as his writing is accessible and quite easily transferrable to other disciplines. Originally published in French in 1952, *On Collective Memory* (1992) provides some very short key chapters ('Preface', 'The Language of Memory', 'The Reconstruction of the Past' and 'The Localization of Memory') that afford a good basis for grasping his sociological theory of memory. Essentially, he

introduces a common notion today that memory is not simply an indi-
vidual phenomenon but is, in the first instance, relational in terms of
family and friends and, in the second instance, societal and collective
in terms of the social frameworks of, say, religious groups and social
classes. He writes: 'One may say that the individual remembers by
placing himself in the perspective of the group, but one may also affirm
that the memory of the group realizes and manifests itself in individual
memories' (Halbwachs 1992: 40), and so it goes around and around
with individual memory and collective memory in a loop.

More than this, Halbwachs suggests that memories are created in
the present in response to society which 'from time to time obligates
people not just to reproduce in thought previous events of their lives,
but also to touch them up, to shorten them, or to complete them so
that, however convinced we are that our memories are exact, we give
them a prestige that reality did not possess' (Halbwachs 1992: 51).
Particularly resonant with contemporary media studies is the use of
terminology here with the translation of 'touch them up' and how we
'cannot in fact think about the events of one's past without discours-
ing upon them. But to discourse upon something means to connect
within a single system of ideas our opinions as well as those of our
circle' (Halbwachs 1992: 53). Subsequent chapters will draw out the
ways in which Halbwachs' concept has been used since in relation to
other memory concepts. For now, though, what is striking about his
understanding of 'collective memory' is how deterministic it is – it
'confines and binds our most intimate remembrances' (Halbwachs
1992: 53) – and how exteriorised it is, for it ensures our memories are
made and remade from the perspective of those on the outside. These
two determinants become vital for interrogating public discourses
that have powerfully constructed how and what we can and should
remember, as well as how we seek to remember ourselves to ourselves.

They are also vital for understanding how media studies has under-
stood mass media and, particularly, broadcast media as a function
of and production of a collective. It is at this point, that we discover
a tension within these twentieth-century accounts of memory. On
the one hand, memory is valorised because it is personal, individual,
local and emotional compared to history, which is seen as authori-
tative and institutional. On the other hand, memory is also part of
what Radstone and Hodgkin describe as 'regimes' which make it
difficult to claim that memory is somehow more authentic and less
constructed than history (2005: 11). In the context of media studies
which is deeply influenced by poststructuralist and postmodern think-
ers such as Antonio Gramsci, Michel Foucault, Jacques Derrida and

Jean François-Lyotard, any mechanism that at one and the same time stabilises and destabilises narratives clearly conjoins with analyses of media texts, forms and practices as inside and outside knowledge and power. Therefore to think about memory in terms of a social, cultural and political collective accords with the idea of 'regimes of memory' whereby

> history and memory is produced by historically specific and contestable systems of knowledge and power and that what history and memory produce as knowledge is also contingent upon the (contestable) systems of knowledge and power that produce them. (Radstone and Hodgkin 2005: 11)

That said, memory studies have continued to research less mediated, more authentic, more personal and more individualised accounts of memory.

The philosopher Henri Bergson's approach to memory is quite different but still has something important to offer media studies. Unlike Halbwachs' ideas, which have obvious political and social currency because they are about the connectedness of memories on a sociological level, Bergson's philosophical work focused far more on the memory of the individual as a perceptive and (un)conscious function. In *Matter and Memory* (1991), the individual, as a 'centre of action', selects experiences as meaningful that have immediate value in terms of that action. We only perceive those stimuli that act upon us and upon which we can act. The rest is matter. Your perception is selective in relation to your past experiences, thus forming memory. Bergson refines his ideas to different ways of thinking about memory. 'Habit-memory' ([1896] 1991: 81) is a repeated act, such as memorising the lyrics of a pop song, that is so enacted in the present that we do not consider it part of the past but as a function of our ability to remember accurately or not. 'Representational memory' is more a recording function that forms 'memory-images' of events as they occur in time but it needs to be recalled imaginatively (Bergson [1896] 1991: 81). The latter can give the impression that the mind is a storehouse or archive and because you are a human doing rather than a human being, your repeated actions come to determine what is useful to remember at that present moment, leaving all the other less useful stuff in the store ready to be used as and when. Bergson was keen to challenge this idea of memory as a store located in a physical position in the brain. He thought this was an illusion because when a memory-image is recalled he saw it as a creative act in the present (Bergson [1896] 1991: 84–9) or, as James Burton has recently argued, 'the recollection

can only exist as something like an *imagined* set of stimuli, parallel to those real objects that normally produce our perceptions' (2008: 326, my emphasis). This sounds complicated but put simply Bergson argued that you unconsciously give yourself the impression that your memory-images are remade from a store of memory-images and this orientates you in time, with a past, a present and future. It is the creativity and experientialism of this conceptualisation that is useful for media studies.

Bergson's ideas become interesting for arts and media studies at the point at which he thinks about memory in terms of space rather than time. Here is a question that would fascinate Bergson and, some might argue, drives our desire to archive our lives: where are all the memories you cannot recall that are not useful at this present moment? What if you could experience all of your past at all times as 'pure memory' (Bergson [1896] 1991: 106), not just the bits you are selecting in the present moment? It sounds like science fiction but these ideas have gained currency not simply in the media representation of 'pure memory' in such films as *Strange Days* (1995, dir. Kathryn Bigelow), *Cold Lazarus* (1996, Channel 4/BBC), *The Matrix* (1999, dir. Wachowski Brothers) and *The Final Cut* (2004, dir. Omar Naim) but in the practice of digital memory systems such as Microsoft Research Lab's experimental MyLifeBits.[4] I shall return to these ideas in more depth later. For now, it is enough to simply introduce Bergson as his work on memory resonates with cultural theory on memory in the context of new media theory (see Hansen 2004).

Therefore by the late twentieth century we can see the beginnings of a set of theorisations on memory that pertain to culture, society, history, politics, philosophy and identity but do not tackle media head on. Again, French academic research spearheaded this with the production of Pierre Nora's (1996–8) multi-volume work that covered 'sites of memory' alongside Jacques Le Goff's (1992) long-term studies of history, in particular the medieval period, and Paul Ricœur's (2004) *Memory, History and Forgetting*. Nora is key because his work deals with studying the construction of French national identity through the less usual sites of memory: street signs, recipes and everyday rituals. His approach to history through memory signals a shift in historiography, the writing of history, to a more everyday level. He characterised his endeavour as producing 'a history in multiple voices', as revealing history's 'perpetual re-use and misuse, its influence on successive presents' (Nora 1996–8: vol. 1, xxiv). There are parallels here with both Halbwachs and Bergson in emphasising creativity, the predominance of the present and the malleability of memory.

However, Nora emphasises two key drives at work in memory-making. Firstly, there is the archival nature of modern memory: as a drive to not forget, to store and to record at all levels of society (Nora 1996–8: vol. 1, 9). This democratic understanding of memory is particularly relevant when we consider how commercial and public bodies record, store and promote access to their 'public' archives as well as how citizens record, store and promote access to their 'personal' archives. Secondly, Nora emphasises 'place' and location and draws into memory studies the importance of community and experience. 'Memory places' are developed as broad catch-all terms for 'any significant entity, whether material or non-material in nature, which by dint of human will or work of time has become a symbolic element of the memorial heritage of any community' (Nora 1996–8: vol. 1, xvii). For media and cultural studies, this signals a very important shift because Nora's concept is so broad that it covers real, fictional, imagined and constructed places and communities as working upon, with and through memory. Media functions, if we follow Nora's proposition that '[m]emory is constantly on our lips because it no longer exists' (1996–8: vol. 1, 1), as the accelerant for a new expression of the past. He may have lamented this as the expansion and acceleration of history through media as opening up the private rituals and intimacies of memory that bonded people to activities and places. Nevertheless, Nora's work invokes the 'uprooting of memory' such that its dynamics are laid bare for all to see (Nora 1996–8: vol. 1, 2).

Nora's end-of-memory-as-we-know-it thesis may seem, at first, rather gloomy but he is keen to emphasise the ways in which memory has become 'copied, decentralized and democratized' (Nora 1996–8: vol. 1, 9), a process I shall return to throughout this book and which implicates media studies directly. For example, when trying to understand Nora's concept of 'sites of memory' and the multiplicity of sites that are now possible in the early twenty-first century, think about your favourite music performer who you may have followed religiously for a number of years. You know that the memories of the music and performances are sited at venues and concert halls and are preserved in meaningful and potentially valuable ephemera such as tickets, tour books, signed CDs and posters. You also know that there are virtual and imagined places that hold those memories: music downloads, post-concert mobile phone photos and videos uploaded and shared online, fan websites, discussion boards, fan blogs and fan magazines. If the performer or band is successful over a long career and then suddenly dies, for example Michael Jackson, then the 'places' and 'archives' of memory take on a new form that incorporate material artefacts and

monuments. They also draw upon non-material, ephemeral and communicative memorials such as when the streets of Los Angeles filled with cruising cars, windows down, blasting out MJ's songs on the afternoon and into the evening of 25 June 2009.

For students interested in history and historiography, Jacques Le Goff's (1992) *History and Memory* and his academic focus upon the medieval world may seem a far cry from Michael Jackson. Like Nora, he too was interested in the relationship and tensions between history and memory. He offers the reader in *History and Memory* a section devoted to a longitudinal approach to the study of memory from an ancient focus upon orality, to later conflicts with 'written' history, leading up to contemporary media discourses that pose challenges to history as they influence the memories that history relies upon. Le Goff articulates the relationship between history and memory with a focus upon myth, testimony, witnessing, living memory, orality and experience that all to some extent pose a threat to the written word of historians. What Le Goff emphasises in terms of history and the social sciences is an inclusive, amorphous and bustling definition of memory as an 'intersection' (Le Goff 1992: 51) of discourses, forms and practices. These begin to open memory up to a range of approaches that consider collectives, groups and individuals as now facing emergent understandings of memory, which in 1992 Le Goff defined as 'electronic memory' (1992: 91–3). Already, then, in the early 1990s, historians were battling with traditional disciplinary boundaries and memory became their weapon of choice, thus invoking autobiographical memory, living memory, popular memory and collective memory as a direct call to arms for a history from below. If we follow this through, we inevitably end up with media studies on side because its unruliness paves the way for blurring disciplinary boundaries. Notably, although Le Goff does not really arrive at media studies, he does posit photography and cybernetics as two key manifestations of memory (1992: 91–3).

Phase 2: The Beginnings of Memory Studies
Nora's and Le Goff's writings overlap with and run parallel to developments in other fields that began to connect with the topic of memory as an explosion of scholarship occurred. David Lowenthal's (1985) *The Past is a Foreign Country* and the later *Possessed by the Past* (1996), Paul Connerton's (1989) *How Societies Remember*, John Bodnar's (1992) *Remaking America: Public Memory, Commemoration and Patriotism in the Twentieth Century*, Irwin-Zarecka's (1994) *Frames of Remembrance: The Dynamics of Collective Memory*, Andreas Huyssen's (1995) *Twilight*

Memories: Marking Time in a Culture of Amnesia and Ian Hacking's (1995) *Rewriting the Soul: Multiple Personality and the Science of Memory*, provide some of the key examples that have drawn upon those early foundational ideas and then extrapolated them to deepen our understanding of social, cultural, collective, personal, public and community memory. Their work has tackled history, heritage, museums, inheritance, trauma, remembering, forgetting, amnesia, archives, memorials and nostalgia, all from different angles and in different ways. For example, while couched in psychology, Hacking's work tackles the memory debates of the early 1990s that raged over false memory syndrome (of sexual abuse). In doing so, he proposes, through invoking Michel Foucault's (1978) ideas on how power operates through bodies and souls, a concept of 'memoro-politics' (1995: 143) that takes account of how trauma and forgetting become crucial to the construction of the modern psyche. As the personal became increasingly political post the Women's Movement of the 1970s and 1980s, then trauma, forgetting and repression unsurprisingly shaped the development of memory studies during this period. Moreover, mindful of the weight of Holocaust studies, war memories, witnessing and ethics in the development of theorisations of memory it is also no surprise that many studies tended to focus on national and international events of major historical importance (see Kear and Steinberg 1999).

The relationship between the Holocaust and memory has been particularly fraught with danger. On the one hand, it seems ethical and proper that media, culture, society and history should deal with and work through this period of mass destruction (see more recently Levy and Sznaider 2005), particularly if it means unearthing hidden narratives, such as the destruction of Gypsies, Roma and Travellers who continue to be one of the most persecuted groups in Europe today. On the other hand, controversial writers such as Norman Finkelstein in *The Holocaust Industry: Reflections on the Exploitation of Jewish Suffering* (2000) have unreservedly criticised some Holocaust research as exploiting memories as an ideological weapon to support the state of Israel, while others such as Jeffrey K. Olick (Olick and Levy 1997; Olick and Coughlin 2003) have continually posited forgiveness and forgetting as central to a politics of regret in the light of mass torture and murder. Thus memory (its uses and so-called abuses) becomes a deeply politicised concept at the end of the twentieth century and the study of it can feel weighed down by the growing archive of Holocaust-related material.

Therefore before memory studies really begins to bed in and engage with media and cultural studies, it is important to understand

how these theorisations in the light of what came to be known as the Holocaust, structure the historical, sociological and psychological approaches to memory. Students interested in exploring memory and history in relation to their subject area will inevitably encounter the traumas of peoples portrayed as collectives and the need to remind future generations and record the testimonies of survivors. The impetus here is the fear of amnesia and repression. It was exemplified in 1995 by the establishment of the Truth and Reconciliation Committee (TRC) in South Africa, post-apartheid to hear and bear witness to the testimony of survivors of human rights abuses. Again memory is deeply politicised and in a post-Holocaust political landscape is inscribed with calls for justice and forgiveness, with memory and its retrieval assigned as the therapeutic cure.

For Paul Ricœur in *Memory, History, Forgetting* (2004) the student is faced with a formidable 600-page volume of research and thinking on the key concerns of memory, history and forgetting: heritage, ethics, politics, proof, representation, recognition, authenticity, being-ness, death, guilt and forgiveness. Ricœur is focused upon the phenomenology of memory: 'Of *what* are there memories? *Whose* memory is it?' (2004: 3). These questions are important for tackling forgetting and forgiveness because faithfulness to the past becomes one of the key operating principles for Ricœur's thinking. For reconciliation to occur then recognition must precede it, that is recognising the past as it was (2004: 495). Nation states, regimes, communities and individuals all engage in active forgetting, manipulated memory, blocked memory and commanded amnesia. Thus remembering and forgetting are seen to be in a symbiotic relationship, in which forgetting is an important and fundamental part of unbinding culture from the past and moving forward.

Drawing the definitions above together and considering the fuzziness of the term 'collective memory' as noted by Wertsch (2002: 30–66) there has been a shift toward understanding memory as 'cultural' (see Assman 1988, 1992 for a particularly German conceptualisation and Erll and Nünning 2008 for a broader definition). A researcher of cultural memory may be looking at a particular historical period (James E. Young (1993) on Holocaust memorials and Richard Crownshaw (2000) on Holocaust museums), from a particular ideological viewpoint (Hirsch and Smith (2002) on gender and cultural memory). They may be investigating a specific cultural project such as post-Apartheid remembering (Coombes 2003), Italian fascism and memory (Foot 2009) or war and remembrance (Winter and Sivan 2000). They may even be focusing on specific objects of memory that have long-term historical, cultural and social meaning: monuments,

museums and heritage (see Van Dyke and Alcock's edited collection *Archaeologies of Memory*, 2003). In the context of UK and US research, cultural memory studies are likely to encompass media, film, literature and the arts. With this in mind, a much clearer convergence of media studies and memory studies begins to develop.

By the end of the twentieth century, theorists of memory had begun carving out a great deal of space for considering a variety of different approaches. There are many examples of memory research over the last two decades that have ranged from the personal (Haug 1987) to the political (Sturken 1997; Hodgkin and Radstone 2005), the private (Kuhn 1995; Hirsch 1997) to the public (Thelen 1990), covering concepts of world (Bennett and Kennedy 2003), national (Zerubavel 1997), urban (Huyssen 2003a), social (Fentress and Wickham 1992), communicative (Assmann 1995), cultural (Kuhn 2002; Erll and Nünning 2008), contextual (Engel 2000), collective (Wertsch 2002), ethical (Margalit 2002), religious (Assmann 2006), performative (Taylor 2003), prosthetic (Landsberg 2004), military (Maltby and Keeble 2007) and, even, medieval memory (Carruthers 2008). Some of these approaches will be considered in this book as and when they connect with media discourses, forms, practices and technologies because many of them can be plugged in and out of media research at key points. They all, to some degree, connect back to those early foundational ideas on memory, forgetting and history and they all, to some degree, engage with memory's complexity in terms of our personal and collective investment in time, space, knowledge and others.

Some of these developing theories touch on media and cultural forms and practices. Kuhn (1995) and Hirsch (1997) considered photography, Zelizer (1992, 1995) covered journalism and Sturken (1997) addressed a range of media. These researchers devoted their understandings of memory in terms of media and their understandings of media in terms of memory. This commencement of a train of thinking has led to the key texts that place media and memory in a much clearer relationship by the beginning of the twenty-first century. It is notable that much of this research and scholarship that crosses multiple disciplinary boundaries has come from female academics. Barbie Zelizer (1998, 2002, 2010) and Carolyn Kitch (2003, 2005, 2008) have continued their research on the connections between journalism and memory, Annette Kuhn (2002; Kuhn and McAllister 2006) on photography and cinema, and Anna Reading (2002), Tessa Morris-Suzuki (2005) and Marita Sturken (2007) have covered a range of media, memorials and artefacts in terms of mass communications and culture.

Other key theorists have fleshed out the terrain with detailed under-

standings of different concepts of memory for media and cultural studies. Paul Grainge's (2002) *Monochrome Memories: Nostalgia and Style in Retro America* and (2003) *Memory and Popular Film* grapple with nostalgia and retro-style. He borrows from Marianne Hirsch's (1997) *Family Frames: Photography, Narrative and Postmemory* the concept of post-memory to describe those memories we inherit that are not ours but that become part of us. Similarly, Alison Landsberg's (2004) *Prosthetic Memory: The Transformation of American Remembrance in the Age of Mass Culture* considers memory as experienced by proxy, exploring how we account for the circulation of memories in mass culture that are felt and shared but not directly experienced. What is occurring in these texts is a gathering storm around potential inauthentic and commodified uses of memory. There is an expectation of a necessary faithfulness to the past (see Ricœur above) that Sue Campbell has described in another context as the 'memory wars' (2003).

This is a very pertinent debate for media studies because media and memory conjoin in very different ways even if we are using the same media form on the same topic. A cinematic example such as Steven Spielberg's *Schindler's List* (1993), a visual re-presentation of Thomas Keneally's Booker Prize-winning novel *Schindler's Ark* (1982), not only represents memories, it acts as a memorial while having an effect on the audience's psyches to become a part of their cultural memory. Questions of authenticity, propriety and commercialisation inevitably follow not only in terms of Spielberg's use of Keneally's novel but in terms of Oskar Schindler's narrative itself in which the line between opportunity and altruism is difficult to draw. However, the same media form, film, can conjoin media and memory in terms of intentionally faithful and detailed documentations of Holocaust first-person testimony in, for example, Claude Lanzmann's nine-hour *Shoah* (1985). This also represents memories, performs itself as a memorial while affecting the audience's psyche. Here, the audience is witness, judge and jury to what has been considered a landmark use of mediated oral history but that is also how Spielberg positions his audience. Both films are about Polish survivors, bystanders and Nazi perpetrators.

Yet, between *Schindler's List* and *Shoah*, we can begin a debate about memory and media studies and how historical events become a part of the audience's memory that draws into it questions of authenticity, faithfulness, the Hollywood industry and popular media culture. You could say that *Schindler's List* actually becomes one of Sue Campbell's 'unreliable rememberers', perhaps itself suffering from some kind of false memory syndrome. We might say this because the film is loaded with ideologies that seek to direct the audience's emotions. If you turn

to Lanzmann's *Shoah* as somehow, but we are not sure how, more truth-ful because we believe it seems less constructed then does this mean we should trust Lanzmann over Spielberg for offering the 'emotional truth' to events and experiences that we can barely imagine? Is it signifi-cant that at the time of writing this book the Internet Movie Database IMDb.com gives *Schindler's List* 8.9/10 based on 237,937 audience votes and *Shoah* 7.6/10 based on 2,596 votes. What does this information tell us about the relationship between media and memory for contemporary audiences who may approach the Holocaust with only a rudimentary and popular understanding of history? It is these kinds of questions that come to structure how media and memory have been drawn together in recent years as prime areas for sustained investigation.

Phase 3: New and Emergent Connections Between Media and Memory
Thus far, the first decade of the twenty-first century has witnessed the 'ever more voracious museal culture' or memory boom (Huyssen 2003a: 1), not least of all in research and scholarship focusing upon the complex and dynamic relationship between media and memory. Andreas Huyssen notes that this relationship is palimpsestic, whereby the different media of memory write and overwrite and overwrite so that we are left with layer upon layer of cultural meaning accumulat-ing in time and space, all material readily accessible and experiential (Huyssen 2003a: 7).

As 'memory-hungry' media technologies develop at breakneck speed, the discourses are struggling to catch up with the practices of prosumers (consumer-producers) who mediate their public and private worlds in ever more rich and nuanced ways. Recent theoretical explo-rations of memory have come directly from media theorists, conjoining media with memory. Alison Landsberg's (2004) work on cinema and memory has led to exploring film and the ways in which it invites emo-tional connections between distanced audiences and past events as a form of 'prosthetic memory'. Andrew Hoskins (2001, 2004a) proposed a concept of 'new memory' in his analysis of the relationship between 24-hour television news and the mediation of war and terror. For a more holistic understanding of the integration of media and memory José van Dijck (2007) has provided the first comprehensive paradigm of 'mediated memory'. Interwoven with this specific instance of media studies and memory studies coming together are conceptual shifts that imagine memory in different ways: as 'working' or 'reference' memory (Assmann 2006), as characterised by 'mnemonic practices' (Olick 2008), as liquid and solid memories (Assmann 2006), as connectionist memory (Sutton 2007) and as global memory (Pentzold 2009).

This suggests an emerging phase in memory studies that engages with media studies not simply as cultural but as production, industry, creative practice and technology, all of which shall be explored in more depth in the following chapters. When media engages with memory in these ways then we are asked to think about memory as mobile (Reading 2009) and malleable. In her research on the mobile camera phone, Anna Reading (2008) notes the prosthetic nature of the wearable mobile family gallery of images and how, as users scroll through them in public spaces, family photography is fully democratised in terms of its production and consumption. Photos of children are carried, handled and worn, finding themselves showcased in public spaces, featured on laptop screensavers, shared on social networking sites, moving through digital spaces and remediated into digital stories. In the next chapter, I return to understanding family photography as well as other media examples through the key concepts of personal, collective, mediated and new memory.

Notes

1. Tulving's (2007), perhaps rather ironic, list of 256 types of memory conveys the unstoppable diversity of conjunctions. To name but a few relevant to this book: active cultural memory, episodic memory, historical memory, political memory, traumatic memory, self memory, semantic memory and archival memory provide only a taster of the possibilities.
2. Pierre Nora (2002) delves much deeper to explain the reasons for France's particular concern with 'memory', due to a combination of historical, economic, social and cultural crises after the 1974 oil crisis.
3. Interestingly, Steven D. Brown has argued that the use of quotation marks when defining 'memory studies' is important because the field is currently trying to create links between academics. He offers the notion of mediation 'as the basis for such a community-to-come' (2008: 261).
4. See Microsoft's research pages for more details of their experimental lifelong project at http://research.microsoft.com.

Reading Exercise

Locate an original text by one of the following early thinkers on memory cited in this chapter: Maurice Halbwachs, Henri Bergson, Paul Ricœur, Jacques Le Goff or Pierre Nora. Locate definitions of

memory and map out their understanding of memory, remembering and forgetting. While undertaking this reading consider the ways in which the reading could be exemplified through reference to a contemporary media example. For example, Paul Ricœur defines 'happy memory' in *Memory, History and Forgetting* (2004: 495) as the ability to recognise the way things were and for the memory to match the past experience/events/persons truthfully. This could be exemplified by the experience of recognising a photograph of an old friend on their Facebook page. One is thrilled to retrieve someone who has been a dormant memory for decades.

Viewing Exercise

Undertake a comparative viewing of segments of Claude Lanzmann's *Shoah* (1985) and Stephen Spielberg's *Schindler's List* (1993). Which do you find most emotive? Which do you find most authentic? How is the Holocaust represented in film today and how does this compare to these earlier examples?

Further Reading

Erll, Astrid and Nünning, Ansgar (eds) (2008) *Cultural Memory Studies: An International and Interdisciplinary Handbook*. Berlin: Walter de Gruyter.

Hirsch, Marianne (1997) *Family Frames: Photography, Narrative and Postmemory*. Cambridge, MA: Harvard University Press.

Kear, Adrian and Steinberg, Deborah Lynn (1999) *Mourning Diana: Nation, Culture and the Performance of Grief*. London: Routledge.

Misztal, Barbara (2003) *Theories of Social Remembering*. Maidenhead: Open University Press.

Olick, Jeffrey K., VinitskySeroussi, Vered and Levy, Daniel (2010) *The Collective Memory Reader*. Oxford: Oxford University Press.

Radstone, Susannah and Hodgkin, Katharine (2005) *Memory Cultures: Memory, Subjectivity and Recognition*. Piscataway, NJ: Transaction Books.

Rosenzweig, Roy and Thelen, David (1998) *The Presence of the Past: Popular Uses of History in American Life*. New York: Columbia University Press.

Rowland, Antony and Kilby, Jane (eds) (2010) *The Future of Memory*. Oxford: Berghahn Books.

van Dijck, José (2007) *Mediated Memories in the Digital Age*. Palo Alto, CA: Stanford University Press.

2 Personal, Collective, Mediated and New Memory Discourses

> Whether we like it or not, the predominant vehicles for public memory are the media of technical re/production and mass consumption. (Mark B. Hansen 2004: 310)

Before providing a critical overview of key theories of memory (personal, collective, mediated and new), let us take a well-known example that elicits the discourses on media and memory this chapter is concerned with. This will help us to understand the ways in which memory operates as extrapolated by Paul Connerton in *How Societies Remember* (1989): through cognitive and performative modes. In the cognitive mode, the past is past and we retrieve events and experiences from the past into the present: through the act of remembering. In the performative, the past is brought into the present as a commemorative act or ritual for 'the past can be kept in mind by a habitual memory sedimented in the body' (Connerton 1989: 102). In this sense, contextual notions of memory also become defining factors to include 'a whole range of extra-verbal and non-cognitive activity such as emotional experience' (Papoulias 2005: 120). It is these contextual factors that media record, represent and are consumed by audiences.

If we were to investigate Princess Diana's death and funeral in 1997, we could undertake audience research to explore memories of watching the funeral on television. There have been analyses of Diana's death in terms of national mourning and a culture of grief (see Kear and Steinberg 1999 and Walter 1999). However, media here are largely seen as channelling memories and funnelling history rather than as involved in the construction of our lifeworlds. 'News memories', argues Ingrid Volkmer in her comprehensive book *News in Public Memory: An International Study of Media Memories across Generations*, 'provide a framework for today's world perception' that can be understood as the 'archaeology of media memories' (2006: 12,13). These need to be dug down to reveal layers of additional meaning built up since the initial media event (see Anderson 2001: 23).

Daniel Dayan and Elihu Katz (1992), in their seminal work on the live broadcasting of historical events (e.g. funerals, Moon landings, royal weddings, coronations), note that 'ceremonial participation' is enacted in the home 'where the "historic" version of the event is on view' because the home is where the television is (1992: 22). Thus the personal memory of viewing such an event is structured by the ideologies of the broadcaster and the broadcast and the consumption of the broadcast in the private sphere, not by the reality of the event as staged in the unmediated world. Dayan and Katz argue that televised events such as John F. Kennedy's funeral offer moments of 'mechanical solidarity' for the nation in question, having a cathartic effect, but also providing secondary audiences with empathic experiences of indirect intimacy (Dayan and Katz 1992: 196–8). Likewise, Carolyn Kitch (2005) has tracked the celebrity death phenomenon back to Marilyn Monroe's death in 1962 and Elvis Presley's death in 1977, whereby if it is through media that famous people come to be known then it is through media their deaths are mourned and memorialised.

In interviewing audience members on their memories of Princess Diana's funeral we would expect two operations of memory in relation to media to be revealed. Firstly, their responses to interview questions about where they were, what they did, who they watched it with and what they remember of the ceremony would be as *cognitive* acts of memory, recalling news items, conversations, reminiscing about the Princess and remembering their own life circumstances in 1997. The results of the interviews would be analysed and a media researcher would find patterns emerging in terms of how the audiences watched the ceremony ('I had the telly on all day'), the kinds of emotions they felt ('I cried when Elton John sang *Candle in the Wind*') or the differentiated actions of others ('My dad thought it was all a bit hysterical and went out of the house'). These cognitive acts of memory are revealed as personal accounts that interviewees have experienced in the past. They had to be there and they had to experience them in order to recall them, as witnesses to a media(ted) event.

Secondly, media are the context, performing and providing the social fuel for ceremonial participation either in the solemnity with which those audience members watched television ('We sat in silence and watched the whole service') or by motivating citizens to lay wreaths at Kensington Palace by mediating the 'sea of flowers' in print and broadcast media. This is *habit* memory, which Barbara Misztal states 'refers to our capacity to reproduce a certain performance and which is an essential ingredient in the successful and convincing performance of codes and rules'; it is 'sedimented in bodily postures,

activities, techniques and gestures' (Misztal 2003: 10). Unlike, cognitive memory which is the retrieval of past experience, this is concerned with bringing the past into the present by performing and using media in that performance. As Carolyn Kitch notes: 'When famous people die, magazine editors promote their coverage with labels such as "commemorative edition", "special report", and "collectors' issue"' (2005: 64–5). Bizarrely, they even do this before the celebrity has died, as was the case with *OK* magazine's Official Tribute Issue 1981–2009 of the UK reality TV star Jade Goody, which, although dated 24 March 2009, was distributed from 17 March 2009, five days before she even died. Thus the celebrity was able to view her own 'in loving memory' edition of a life lived in and through *OK* magazine. These are just two key modes of memory (cognitive and performative) in the context of a highly mediated event. Later in this chapter, I shall return to Diana's subsequent memorialisation through media in order to understand how memory is operating in a new ecology of media connectivity, networks and flows (see Hepp et al. 2008).

Personal Memory – Media and Me

One area of memory research that draws together media and memory in fundamental ways is 'personal memory', 'private memory' or 'autobiographical memory': that is, the process by which we tell the story of our life to ourselves and to others, a process that is felt and acted upon. The starting point for most students of media interested in personal memory (and vice versa) is to reflect upon their own lives: from sifting through those dusty and embarrassing family albums sitting in drawers at home to the frequent thumbing and scrolling through mobile phone photo albums. Both media practices are the 'mediation' or 'mediatisation' of everyday life that shape who we are and how we think about ourselves at specific points in time (Livingstone 2008; Lundby 2009), not in a decontextualised lifetime but in our own lifetime as it is conjoined with the development and history of media delivery systems as analogue family albums of photographs stuck behind cellophane become replaced with digital photo frames and the mobile phone gallery. Therefore how I remember 'me' is mediated from the moment I am born (if not before, if we include obstetric cameras) and in different ways by different media formats which change over time.

It is vital to note that a 'really successful dissociation of the self from memory would be a total loss of the self – and thus all of the activities to which a sense of one's identity is important' (Nussbaum 2001: 177). Personal memory, then, is at once an emotionalised and a mediated

concept. As part of the affective domain, personal memory provides a rich seam of research material for media producers. As a television audience we observe celebrities emotionally encounter their personal and family memories in successful television shows such as *Who Do You Think You Are?* These celebrities enact (and promote) the kinds of personal memory work that private individuals already undertake through genealogical research. Thus the 'memory boom' (Huyssen 2003a) in family history research has seen *Who Do You Think You Are?* broadcast first on the BBC in 2004 now franchised worldwide and airing in the US on NBC in 2010.[1] Narratives of celebrities Susan Sarandon, Brooke Shields, Matthew Broderick and Lisa Kudrow are propelled by the desire to unearth 'tragic secrets' and 'unlock family mysteries' in the first episodes of the American adaptation of the show (aired March/April 2010). If we place the marketing and consumption of history through reality television to one side for the moment (see Jerome De Groot's chapter 'Reality History' in *Consuming History* (2009)), we can turn in the first instance to Annette Kuhn's theorisation of media and personal memory in *Family Secrets: Acts of Memory and Imagination* (1995) as an excellent starting point for thinking about how to analyse the relationship between media and personal memory.

Before reality television and digital media transformed the mediatisation of the self and one's family history, Annette Kuhn, a theorist of film, was thinking through the ways in which photography and audio/visual media were not simply documentations or recordings of past realities but how they embodied emotionalised subject positions and constructed the past in the present. It is useful here to return to Roland Barthes' ideas in *Camera Lucida: Reflections on Photography* (1993) about the relationship between the photographic camera and the discovery of the self as Barthes tries to understand his mother through old photographs:

> In front of the lens, I am at the same time: the one I think I am, the one I want others to think I am, the one the photographer thinks I am, and the one he makes use of to exhibit his art. In other words, a strange action: I do not stop imitating myself, and because of this, each time I am (or let myself be) photographed, I invariably suffer from a sensation of inauthenticity, sometimes imposture. (Barthes 1993: 13)

Likewise, Kuhn notes, the building-in of constructedness to photographs as she analyses the studio portraits of herself as a baby and the posed photographs in her best dress for Queen Elizabeth II's Coronation (1953). Importantly, Kuhn argues that such family photo-

graphs are simultaneously the same as the millions of other baby and child photos that exist across the world in millions of albums and, due to the personal resonances of each one, very different. 'On the surface', Kuhn says, 'the family photograph functions primarily as a record' as 'visible evidence that this family exists' and it is these kinds of records that family history television programmes use as their research material (Kuhn 2002: 49). Photography, in its seizing of a moment, thus builds loss and evanescence into its structure and interpretation: it 'looks toward a future time when things will be different, anticipating a need to remember what will soon be past' (Kuhn 2002: 49). Likewise, Marianne Hirsch states that photography's 'relation to loss and death' is to 'bring the past back in the form of a ghostly revenant, emphasizing, at the same time, its immutable and irreversible pastness and irretrievability' (1997: 20). I shall return to these ideas in more depth in the next chapter, where I draw upon Barbie Zelizer's ideas on photographs, trauma and 11 September.

In reflecting upon the construction of the self through memorable photographs Kuhn is able to employ a critical and reflective paradigm. This reveals not only the social and historical representation of the family but the ideological underpinnings of gender, class and national identity that visually materialise and memorialise the baby girl and little girl at key milestones in her life. In this way 'the family as it is represented in family albums is characteristically produced as innocent' and 'constructs the world of the family as utopia', a construct, one might add, replicated in much advertising imagery (Kuhn 2002: 57). What at first glance appear to be simple childhood photos become media texts that can be analysed socially, culturally, technologically and historically in terms of media production conventions, which I have reproduced at the end of this chapter as an analytical activity. In terms of family photos, then, media and memory come together in a number of ways.

Firstly, Kuhn says family photography records, documents and archives everyday and domestic life (see also Patricia Holland's early work on the family album (1991) and Marianne Hirsch's analysis of framing the family and the cultural narratives attached to such framings (1997)). Secondly, as a mnemonic aid, we can say it is used to support human memory and remembering by providing an increasingly rich archive of images that stands in for the need to visualise experiences of the past. Thirdly, personal memory through photography becomes a reflective practice, in that family photographs are used for reminiscence, therapy, trauma, reconciliation and autoethnographic critique. This is what Frigga Haug et al. (1987), in the context of women's

studies, termed 'memory work' or Annette Kuhn has described as 'revisionist autobiography' or 'visual autobiography' (2000: 179). It is also the underlying principle of the digital storytelling movement, which began at the Center of Digital Storytelling, California in the early 1990s and became popular in the UK as the BBC's Capture Wales movement (2001–8). In each case, family photography (which is in danger of constraining our remembering and funnelling our memories) also has 'more subversive potential' if we employ critical analysis as with any constructed media text (2000: 183). Claims Kuhn:

> It is possible to take a critical and questioning look at family photographs, and this can generate hitherto unsuspected, sometimes painful, knowledge and new understanding about the past and the present, helping raise critical consciousness not only about our individual lives and our own families, but about 'the family' in general and even, too, about the times and places we inhabit. (Kuhn 2000: 183)

Fourthly, the *media and me* coupling performed (albeit self-consciously) by photography's relation to personal memory is further enhanced and/or subverted by more public practices such as memorial ceremonies or online social networking.

To expand on this point, in memorial ceremonies to events such as the Oklahoma City bombing in 1995 and the attacks of 11 September 2001, Sturken notes the use of family photographs printed onto t-shirts. These are then photographed by the news media as a 'testimony to the personal connection to an absent loved one, actually wearing his or her image on one's body, and inhabiting it, so to speak' (Sturken 2007: 115). In online social networking, family photographs are in the public domain to be 'mycasted' (Young 2004) and performed in new media ecologies. The connectivity of the individual's memories with others in the social network may or may not elicit collective memories (for example, alumni associations, group reminiscence, reunion events). This shift from personal, collective to connective memory will be explored in depth in Chapter 8 of this book, which focuses on Facebook. For now, it is important to note that in 'locating memory' in 'photographic acts' (Kuhn and McAllister 2006) there is a privileging of the personal, the local, the emotional and the affective domains that, while clearly mediated and inside systems of knowledge and power are also subversive and seek to be authentic online or offline.

It would be easy for us to categorise the relationship between personal memory and media as creative, largely private and empathic.

While personal memory and photography have been easy bedfellows for quite some time, there have also been politicised engagements of autobiographical memory with other media forms. It is unsurprising that film and video have offered opportunities for confession, diaries, oral testimony and re-enactment of trauma as explored by Walker (2005) in *Trauma Cinema: Documenting Incest and the Holocaust* and Waldman and Walker (1999) in *Feminism and Documentary*. From feminist films on traumatic pasts such as Lynn Hershman Leeson's videos *First Person Plural* (1988) and *Seeing is Believing* (1991) to personal documentaries that recollect exile, such as Cuban Juan Carlos Zaldívar's treacherous trip to Miami in *90 Miles* (2001). We cannot ignore the theorisations of personal memory as charged with political, historical and global significance. This can be seen in the 'successful marketing of memory by the Western culture industry' (Huyssen 2003a: 15), in the continual (re)working through of Germany's past and the Holocaust, in the politics of memory and forgetting in postcolonial, post-communist, post-apartheid, post-diaspora and post-genocide countries around the world. Therefore, in the next section, I turn to understanding media in relation to collective memory and remembering.

Collective Memory and Media – Social, Cultural, Historical

There is a great deal of contemporary research, particularly in the fields of communications, museology, heritage studies and oral history that continues to work with Maurice Halbwachs' concept of collective memory (for a concise review see Blair 2006). This concept became a touchstone for media and cultural studies scholarship in the 1990s interested in exploring the relationship between memory, history, audiences and society around themes of gender, race, class and national identity (Lipsitz 1990; Zelizer 1995; Spigel 1995; Roth 1995; Eley 1995; Sturken 1997). It offers a sociological theory of memory in the present as a social framework rather than as located in the minds of isolated beings, whereby one remembers things when prompted by others and vice versa.

As noted in Chapter 1, Halbwachs defined memory from the perspective of the group as only possible inside frameworks and as manipulated and touched up out of social necessity (1992: 40, 51). Collective memory is very localised 'common to a group [. . .] with whom we have a relation at this moment' in time (1992: 52). However, an individual belongs to many different groups at the same time (e.g. family, friends, fan communities, church, sports) and 'so the memory of the same fact

can be placed within many frameworks' (1992: 52). This can only be activated within a collective context: memorial ceremonies, family reunions, funerals, war, and commemorative practices for example (see Schwarz 1982; Zerubavel 1997; Hodgkin and Radstone 2006). Thus mediated events such as celebrity deaths (Kitch 2005), assassinations (Dayan and Katz 1992), funerals (Kitch and Hume 2008), anniversaries of tragedies (Sturken 2007), media representations of conflict (Hoskins 2004a) and the Holocaust (Zelizer 1998) all provide key investigations of media and collective memory. In these mediated contexts, collective memory offers conflicting accounts of the past opening up the 'terrain that is remembered and turns it into a multiple-sided jigsaw puzzle that links events, issues, or personalities differently for different groups' (Zelizer 1998: 3).

Importantly, media enters its relationship with a concept of collective memory at the point at which we depart from Halbwachs' initial ideas. Thus, media mediate – textually, visually, sonically, electronically – and by doing so they require Halbwachs' concept to divorce itself from personal remembering in the context of a face-to-face group encounter. Rather, as James V. Wertsch has argued:

> Instead of being grounded in direct, immediate experience of events, the sort of collective memory at issue [. . .] is what I shall term 'textually mediated'. Specifically, it is based on 'textual resources' provided by others – narratives that stand in, or mediate, between events and our understanding of them. (Wertsch 2002: 5)

It is worth highlighting the more recent refinement of Halbwachs' concept by sociologist Jeffrey Olick as a differentiation between 'collected memory [. . .] the aggregated individual memories of members of a group' which can be researched through surveys and oral history collection, and 'collective memory', which is the public manifestation as mythology, tradition and heritage (1999: 338, 342). Both are important for media studies, the first because media collect, store and archive memories (privately and publicly) and the second because media offer one of the main public manifestations of mythology, tradition and heritage in the twenty-first century. More importantly, media produce collectives at precisely the same moment they transmit collective memories. Thus '[i]t is not just that we remember as members of groups, but that we constitute those groups and their members simultaneously in the act (thus re-member-ing)' (Olick 1999: 342). How does this occur in and through media?

Let's take a popular example of media evoking, producing and performing these two approaches to collective memory. In his chapter

exploring 'empathy, authenticity and identity' in reality history television programming Jerome De Groot critiques the genre of turn of the century 'nostalgia' or cheap 'recall' shows such as the BBC's *I ©* *1970s* (2000) on through the decades. Such programmes integrate the personal memories of audience members with a stylised collection of celebrity reminiscences, as they count down toward an artificially pre-agreed consensus of the number one memorable moment or artefact. De Groot argues that the audience's (collected) personal memories become conjoined with the selected celebrity (collected) memories in a performance of collective memory through inclusive nostalgia. In establishing a 'cultural archive and a canon of experience' the 'shows project and construct imagined communities bound not by factual events but by shared cultural experience' (2009: 164).

This accords with Huyssen's negative association of media with 'mass-marketing memories' that 'we consume' as 'imagined memories' and are 'thus more easily forgettable than lived memories' (Huyssen 2003a: 17). It is important here to note the binary opposition being established by both these scholars between media as 'mass', 'popular' and 'artificial' and memory as lived, authentic and experienced. In the next chapter I will explore the many ways in which media have been used to explore and express 'lived memories'. For now though, it is important to note that there is a long history of media studies scholarship that is more celebratory of the popular collectives that fandom and nostalgia evoke (see Fiske 1987, 1989a, 1989b; Dyer 1992; Jenkins 1992; Hills 2002; Gauntlett 2005) and which would be wary of such media bashing. There is real emotional and cultural value in such programmes as viewers desire inclusion in and connectivity to shared social and cultural histories. 'Popular culture – like films, music, television, food and magazines – preserves something of a life lived, pleasures shared, joyous laughter or empathic tears. It is not accurate or verifiable, but it is affective' (Brabazon 2005: 67). It also, as Olick's ideas above suggest, produces a group and the members of those groups by calling upon the audience to co-remember with the celebri-ties and thus, as Kitch has shown, 'allows people to form their own individual and collective identities and values' through knowing the celebrity even better (2005: 65). Therefore if we want to investigate media and memory then we need to make the methodological shift from high culture to popular culture (Erll 2008: 389–90).

Clearly, as entertainment, these shows do not present testimony and witnessing in order to produce collective remembering along deeply politicised, historical but emotionalised lines of thought and action. This is the case with traditional documentary film, such as Claude

Lanzmann's *Shoah* (1985), which takes hours of oral history footage from survivors of Nazi Germany's extermination of Jews (albeit Jews were not the only victims), or more recently Rob Lemkin and Thet Sambath's *Enemies of the People* (2009) which interviews Khmer Rouge perpetrators of the slaughter of Cambodians in the late 1970s. In both cases, and there are many more examples of documentary film as bearing witness, as personal and collective memory become conjoined with a concept of 'media witnessing'. This, as Frosh and Pinchevski (2009: 1) argue, 'refers simultaneously to the appearance of witnesses in media reports, the possibility of media themselves bearing witness, and the positioning of media audiences as witnesses to depicted events' thus 'witnesses *in* media, witnessing *by* the media, and witnessing *through* the media'.

Therefore, collective memory as mediated in these contexts is shot through with critical questions about authority, truth, storytelling and reliability, and personal questions about trauma, therapy and reconciliation. For Zelizer, these questions become immaterial as we allow collective memories to fabricate, rearrange, elaborate and omit details about the past, 'pushing aside accuracy and authenticity so as to accommodate broader issues of identity formation, power and authority, and political affiliation' (Zelizer 1998: 3). These media examples of producing (what we might call) collective memory could be criticised as anti-historical as the historian Peter Novick has argued:

> To understand something historically is to be aware of its complexity, to have sufficient detachment to see it from multiple perspectives, to accept the ambiguities [. . .]. Collective memory simplifies; sees events from a single, committed perspective; is impatient with ambiguities of any kind; reduces events to mythic archetypes.
> (Novick 1999: 3–4)

Here, a historical concept of memory becomes ever more important so that the opposition between history and memory I provided in the introduction to this book is replaced with a reconsideration of the connections between the two. If memory becomes too popular (see Chapter 3 for a definition of 'popular memory' and the debates surrounding this issue), then in the context of collective memory studies it is in danger of producing the past as how we would like to remember it rather than as it happened. 'However,' says Carole Blair, 'if we think of history and memory not as competitive but as mutually enriching, memory studies can serve our understanding of communication' (2006: 57) by offering a wider range of analytical tools for researching the past.

Mediated Memory – Mediatised, Made Up, Mashed Up

In *Tourists of History: Memory, Kitsch, and Consumerism from Oklahoma City to Ground Zero* (2007), Marita Sturken provides an account of how American culture encourages a 'tourist' relationship to history through social and cultural practices that (re)package American memorialisation and produce a 'politics of memory and emotion' that enable 'a consumer culture of comfort' (2007: 4). Teddy bears, commemorative dollar bills, adverts, flags, t-shirts, memorial walls, pins, coins, cartoons, stickers, photographs, urban shrines, snow globes, dust-filled urns, bottled water and a whole host of souvenirs provide examples of cultural memory as (commercialised) ritual and repetition. In this context, then, the mediation of cultural memory offers consensus along deeply nationalised lines but also along commercialised ones. Here enters a conceptualisation of memory as somehow manufactured and commercialised and thus as deeply involved in mass media communications. A good example of this is Steven Spielberg's 1993 film *Schindler's List*, which invited much critical scholarship concerning how a society balances a cinematic representation of traumatic memory with being a 'hit movie' that defines how future audiences understand history. The film, argues Yosefa Loshitzky, 'reifies the fragile moment of transition in historical consciousness from lived, personal memories to collective, manufactured memory' which 'signifies the victory of collective memory as transmitted by popular culture over a memory contested and debated by professional historians' (1997: 3). The impact of *Schindler's List* seemed to mark a point in the mid-1990s where media scholars really turned their attention to the power of media to manufacture memory (see Zelizer 1997). As the title of Loshitzky's collection *Spielberg's Holocaust* (1997) suggests, memories belonged to Hollywood and this could not go without critique.

Clearly, 'people constantly transform the recollections they produce' (Zelizer 1995: 216), both in their minds and through media. Yet Huyssen counters that 'we know how slippery and unreliable personal memory can be: always affected by forgetting and denial, repression and trauma, it, more often than not, serves the need to rationalize and maintain power' (Huyssen 1995: 249). The position of media as simultaneous producer and saboteur of power is important here because it is impossible think about memory and media without connecting it with popular culture and interpersonal communications. It is also impossible to think about media and memory without realising that not only have the last two decades witnessed a ubiquity

of media but also increased media literacy, accessibility to producing media content and individualisation of audiences. While much of our lives goes undocumented but is still remembered, more of our lives is being mediated and not forgotten, particularly by cameras. From CCTV to photoblogging, photosharing to digital storytelling, camcorder footage to video diaries, personal memory is mediated, consciously or unconsciously. José van Dijck states it is, to a large extent, predetermined by conventions in that 'people decide what to record or what to remember without records, often being unaware of the cultural frameworks that inform their intentions and prefigure their decisions' (2007: 6–7). Having said this, students of media already know that media texts can be subversive, can materialise in different formats and escape authorial intention. They can, as Henry Jenkins (1992, 2006a) has shown in the context of fan cultures, be poached, excorporated and intertextually realigned in a creative way to produce something new, (self-) critical and different from the original.[2] Likewise, remembering is a creative act for '[p]roducts of memory are first and foremost creative products, the provisional outcomes of confrontations between individual lives and culture at large' (van Dijck 2007: 7).

Lately, then, 'mediated memory' (van Dijck 2007) comes nearer to understanding the mechanisms by which personal, social, cultural and collective memories become mediatised and thus transmitted in both placed and boundaryless ways. In the context of Sonia Livingstone's recent evocation of the 'mediatization of everything', memory is one more experience of daily living that is extended by and through media. While personal memories of the elderly may still articulate experiences before media really got a grip of our psyches, in the days long before television when life seemed much less mediated, the act of remembering these experiences today is entirely mediated through documentaries, films, literature, digital storytelling and video diaries. My concern with the adjectival thrust of the term mediatisation upon memory or as mediated memory is that it suggests that something happens to memory by media rather than something equally happening to media by memory. Although van Dijck is keen to ensure that the relationship between media and memory is read as one of inseparability, it does not more fully account for how individuals compel and create media to perform in mnemonic ways as well as design media/real-world interfaces that are driven by nostalgia, memorialisation, loss, trauma, forgetting and other acts of memory. Individuals do things to and with media so as to remember, not simply for the sake of personal memory or to contribute to a community's history, but rather to project the

multiple and multiplying layers of complex connections between people, places, pasts and possibilities. I shall explore these ideas in more detail in the next two chapters.

A key researcher to explore the mediatisation of memory is Carolyn Kitch (2005) who in *Pages from the Past: History and Memory in American Magazines* explores the production of a nation's 'heritage' through magazines that are collectibles in themselves. From *Life* magazine, *Time, Newsweek, People Weekly* and *Sports Illustrated* to *Rolling Stone, Entertainment Weekly* and the *New Yorker*, as well as investigating *Ebony, Good Housekeeping* and nostalgia magazines, Kitch provides a comprehensive survey of how magazines have become 'public historians of national culture' (2005: 11). For when 'journalists write in terms of national memory, they produce reports that are meant to serve as keepsakes; in a mediated conversation with their audiences, they characterize the past in ways that merge the past, the present, and the future into a single, ongoing tale' (2005: 11).

Analysing the production of narratives of national, racial and ethnic identity through media is not new (see Stuart Hall's influential *Representation: Cultural Representations and Signifying Practices*, 1997). What is new is the attention turned toward the production of narratives of nation, culture and society through mediated memories. For example, through lucrative re-purposing of historical, literary and cultural archives, heritage film (see Vincendeau 2001), English costume drama (see Higson 2003), the historical film (see Landy 2001) and the biopic (see Custen 2001) can all be considered vehicles by which social and cultural memories become manufactured by media industries for commercial gain. At stake here are notions of fidelity, authenticity and factuality but these become redundant issues argues Robert Rosenstone if we think about screen media as experiment rather than as documentation and witnessing (2001). Therefore, with a focus upon creativity and experimentation with the past, we enter what Marianne Hirsch would describe as a concept of 'postmemory' (1997). This is 'mediated not through recollection but through an imaginative investment and creation' which 'characterizes the experience of those who grow up dominated by narratives that preceded their birth' such as children of Holocaust survivors, whose life stories are determined 'by traumatic events that can be neither understood nor recreated' (Hirsch 1997: 22). I shall return to this issue in the next chapter when exploring the concept of a Holocaust or Memory Industry. What then is the ethical responsibility of media to make sense of the past? Does media cannibalise or create the past? Does media make history or make it up?

New Memory – Global, Digital, Mobile

Even in 1977 Brown and Kulik were describing the concept of 'flash-bulb memory' in terms redolent of news media as memories that are dramatic, surprising, printed on the brain. We can all think of such mediated images and sounds that record events and occurrences in public and private lives. From the unforgettable news photo of nine-year-old Kim Phuc running from a napalm attack in Vietnam (8 June 1972), her clothes burned away from her body, to the swirls of white smoke against black as the Challenger Shuttle disintegrated (28 January 1986), to the camera phone images of survivors of the London Bombings (7 July 2005), these 'snapshot' memories, defined and debated since Brown and Kulik's initial studies, have used models of thinking about memory borrowed from photographic media. They acknowledge not only the mediatisation of memory but the mnemonic qualities of media thus suggesting technologies of memory. As Marita Sturken claimed in the first issue of the journal *Memory Studies*: '[c]ultural and individual memory are constantly produced through, and mediated by, the technologies of memory' (2008: 75). Moreover, Van House and Churchill in their article 'Technologies of Memory' (and in response to Sturken's article) found with human–computer interaction (HCI) and memory that 'explicit and tacit models of social and personal memory are "baked into" the design of these technologies. These design decisions then play a part in how memory is constructed and enacted' (2008: 297).

With satellite broadcasting technologies comes the possibility and opportunity to print such memories on the brains of many more millions of people than was possible only a few decades ago. It is a tragic truth of the twenty-first century that it is those furthest away from a disaster that can observe and gain a fuller knowledge of it, as it is happening, than those directly involved and witnessing it first hand. The events of 11 September 2001 proved that and it reverses our common-sense notion that is only those who witness events first hand who can tell the truth of what really happened. Networked television news covered 11 September in real-time, repeating the moment the planes hit the towers and then the towers collapsing, over and over again, as if it was always the first time this shocking event was seen by someone in the world somewhere. Such events bring with them a concept of 'media witnessing' that is explored in depth by Frosh and Pinchevski in *Media Witnessing: Testimony in the Age of Mass Communication* (2009). Although this collection is not concerned with memory per se, it does solidify key developments in media and history that concern memory

studies: trauma and testimony are mediated retrospectively in terms of the Holocaust but are entirely ubiquitous and presentist by the time we get to 11 September. I shall explore the connections between the Holocaust and 11 September in terms of making memories with media in the next chapter. For now though, it is important to note that media has become, post-11 September, the vigilant anticipator of the dramatic, surprising and printed-on-the-brain event. Andrew Hoskins, in his theorisation of 'new memory', has called these 'media flash frames, produced by new technologies', that 'change the nature of the memorial process' (Hoskins 2004: 6).

'New memory' can lead to mis-remembering according Hoskins, referring to the poll that the majority of Americans believed they had witnessed the assassination of John F. Kennedy (1963) live on television when, in fact, Zapruder's film was not televised until 1975 and was only available as still photographs in *Life* magazine at the time.[3] Media flashframes of new memory discourse and practice, which are recycled by media workers and revisited by media audiences, provide what Hoskins (2004) and Barbie Zelizer (2002) have defined as media templates. A good example of this might be the news of the fall of Saddam Hussain's statue on 9 April 2003. News workers are likely to fixate upon this scene as memorable because the fall of a statue of a dictator has original templates in the past. I watched and recorded this event live on BBC 24-hour news. The statue did not fall easily or quickly and the crowd gathered was not large or representative. Significantly, I remember the America flag being thrown over the statue as the US soldiers assisted the Iraqis. The controversy of the American flag aside (which was quickly removed and replaced by an Iraqi one), within 30 minutes of the statue being attacked, BBC newsworkers had ironed out all the inconsistencies and delays and produced a condensed two-minute piece to camera with stilled frames, expert witnesses and the news anchor defining the toppling 'as the most memorable moment in the history of this campaign [Operation Iraqi Freedom]'.

It is this image that has been endlessly recycled as symbolising the 'end' of a controversial war in a news item considered controversial today in terms of its Americanised construction of history and memory. Such memorable moments template onto past events that televisually resonate (the first Gulf War, the Vietnam War), so that those templates, 'in making connections between past experience and events in the present or likely future, construct powerful historical trajectories which frame ways of seeing' (Hoskins 2004: 43). What this reveals for studying the relationship between media and memory is a way of critiquing the sanitisation of memory by investigating production cultures

within media whereby pooled agency images circulate widely and images from independent photographers (professional and amateur) offer a critique of dominant ideologies of collective memory. It is the shift toward the global and away from national and corporate circulation of media templates that digital, mobile technologies and Internet services offer. Since 2004, Hoskins' ideas on new memory have had to be adapted and transformed in the light of the explosion of citizen journalism and digital media, which make memory mobile, connective and 'premediated' (Grusin 2010).

The most recent media theory argues that there is a new mobility and variable speed of memory-making and formation that is 'technomediated' (Reading 2009), that memory is 'transcultural' and 'travelling' (Erll 2009), global, 'globital' (Reading 2009) and 'digital' (Garde-Hansen et al. 2009). The viral proliferation of mediated memories is due to our changing world of contemporary communications that appears to democratise memory-making. In her keynote speech 'Towards a Philosophy of the Globital Memory Field', Anna Reading asks us to rethink memory in the light of the 'new communication ecologies' of 'networked and mobile media' (2009). Memories are now distributed globally and networked digitally even though they are personally and locally produced. Users and audiences have access to an expanding landscape of 'people, things and data' that communicate memories. 'Globital memory' is, then, as much about geography and physics as it is about sociology, culture and psychology. What then are the consequences of thinking about memory as 'globital'?

Think here about physical geography and the ways in which we might consider the memories we record on mobile phones from family outings to terrorist bombings. We can now easily digitise and network these recordings, bypassing traditional media channels and connecting through the Internet to other mobiles and websites. Yet this now simple practice raises interesting questions for media and memory. Where is territory? What happens to time? How do we experience speed? Where are the buildings, cables, wires, masts, satellite dishes and (cloud) computers? How are these produced and under what circumstances? Do they fade from our experience of sharing these memories? How much energy is needed to keep us connected? What is the carbon footprint of running my Facebook page? How much time do I waste or save connecting the experiences I have captured on my phone to the phones and computers of others? How much of the life I am narrating and remembering online will I want to forget and self-edit? Is this absorption in connecting memories and creating archives taking up too much of my time? How authentic is the representation

of myself that I am making to the world? These are the pressing questions in a new phase of studying media and memory and ones that will frame the case studies in Part 2 of this book.

Let us return to our example at the beginning of this chapter: the death and funeral of Princess Diana and focus upon the post-1997 memorialisation of Diana through media. Alongside personal recollections of this historical event and the ceremonial participation enacted or witnessed through media, we also locate the impact of satellite broadcast technologies of 'global' reach as an estimated 2.5 billion people across the world watched the funeral on television. As with the later live televised broadcast of the terrorist attacks on America of 11 September 2001, global media technologies have changed the way personal and collective memory is produced, shared and archived for future generations to access. More recently, websites such as Youtube. com and Gonetoosoon.org both provide creative mashups (or remixes of digitised data) of footage of Diana's televised funeral alongside photographs, soundtracks and user postings that dynamically archive and continually connect old and new audiences. These user-generated practices perform a different kind of habit memory, one that remediates, to use Jay David Bolter and Richard Grusin's concept (1999). The remediation of Diana's image, like the photograph of the Falling Man on 11 September, 'tends to solidify cultural memory, creating and stabilizing certain narratives and icons of the past' (Erll 2008: 393). Thus Andrew Hoskins has recently defined a 'diffused memory' in the new media ecology (2010). In the following chapter I explore the shifts in production and consumption as broadcasters, institutions and private citizens all engage in the process of making memories with media.

Notes

1. Family history programming has become a marketing opportunity for personal memory services such as www.ancestry.com, sponsors of the US version of *Who Do You Think You Are?*, which offers essential, premium and worldwide memberships for a monthly fee and allows access to data and archives.
2. Henry Jenkins' theory of fan culture shows just how engaged in practices of memory and nostalgia fans are. He says 'there's an argument in semiotics that seems to imply that meaning can be derived from a text and then you throw the text away. The difference is fans don't throw the text away, that there's an emotional connection to the text that survives any generation of meaning from it' (2001: n. p.).

3. 'Of those polled, 77% said they believed that people besides Lee Harvey Oswald were involved in the killing. And 75 said there was an official cover-up in the case' (*New York Times*, 4 February 1992).

Exercise

Students of media and memory can usefully employ Annette Kuhn's reflective practice upon a childhood photograph around four analytical approaches which I have reproduced, in part, below. Considering the radical changes that have taken place in the last decade through smartphones, undertake Kuhn's exercise with analogue and digital examples:

1. Start with a simple description of the human subjects in the photograph and then take up the position of the subject yourself. It is helpful to use the third person. To bring out the feelings associated with the photograph, you may visualise yourself as the subject as s/he was at that moment, in the picture.
2. Consider the picture's context of production. Where, when, how, by whom and why was the photograph taken?
3. Consider the context in which an image of this sort would have been made. What photographic technologies were used? What are the aesthetics of the image? Does it conform to certain photographic conventions?
4. Consider the photograph's currency in its context or contexts of reception. Who or what was the photograph made for? Who has it now, and where is it kept? Who saw it then, and who sees it now?'

(Kuhn 2002: 7–8)

Further Reading

Bennett, Jill and Kennedy, Rosanne (2003) *World Memory: Personal Trajectories in Global Time*. Basingstoke: Palgrave Macmillan.

Halbwachs, Maurice (1992) *On Collective Memory*, trans. L. A. Croser. Chicago: University of Chicago Press.

Hoskins, Andrew (2001) 'New Memory: Mediating History', *Historical Journal of Film, Radio and Television*, 21: 333–46.

Irwin-Zarecka, Iwona (1994) *Frames of Remembrance: The Dynamics of Collective Memory*. New Brunswick, NJ: Transaction Books

Kuhn, Annette (1995) *Family Secrets: Acts of Memory and Imagination*. London: Verso.

Lundby, Knut (ed.) (2009) *Mediatization: Concept, Changes, Consequences*. Oxford: Peter Lang.

van Dijck, José (2007) *Mediated Memories in the Digital Age*. Palo Alto, CA: Stanford University Press.
van House, Nancy and Churchill, Elizabeth F. (2008) 'Technologies of Memory: Key Issues and Critical Perspectives', *Memory Studies*, 1 (3): 295–310.

3 Using Media to Make Memories: Institutions, Forms and Practices

Until the lions produce their own historian, the story of the hunt will glorify only the hunter. (African proverb)

Media can represent lions or hunters. However, powerful media and cultural institutions whose business it is to record, archive and make accessible the everyday life, major events and social and cultural heritage of nations and communities, invariably write those narratives in ways that glorify not only themselves but the cultural hegemony of the societies they serve. They need to keep their customers, readers, audiences and users happy. They control their own archives even if they are actually only the custodians and not the full rightful owners of a nation's heritage. This is the case with the publicly funded broadcaster in the UK, the BBC, and I shall consider the BBC's opening up of its archive in more detail in Chapter 5.

The last chapter explored the key concepts of memory as they have developed in relation to media and cultural studies. However, media are not neutral phenomena. When studying media and memory we need to keep in mind the context of media power and that 'institutions will try to preserve the problem to which they are the solution' (Clay Shirky, cited in Kevin Kelly's 'The Shirky Principle', 2010). If 'the problem' is private and public memory (its retrieval, recording, archiving, dissemination and accessibility) and that institution is a media company, then we need to do two things. Firstly, we need to critique the role of media institutions in the production and consumption of public and personal memories. Secondly, we need to highlight the new media discourses, forms and practices that have moved from the margins to the centre in making and preserving memories without the need for media organisations at all. Therefore the local, national and international complexity of media organisations means that only certain memories get mediated. For instance, Channel 4's *My Big Fat Gypsy Wedding* (18 February 2010) sponsored by Honda is more likely to be seen as a profitable, watchable representation of

Gypsy, Roma and Traveller (GRT)[1] heritage than a documentary that focuses on the memories of those communities whose members were exterminated in the Nazi concentration camps. It plays on the audience's memory of the title of the film *My Big Fat Greek Wedding* (2002) and takes a less than serious approach in its portrayal of rituals that are fundamental to the heritage of a largely invisible community. Likewise, only memories produced in certain ways (e.g. scriptwriters associated with guilds, professional technicians not amateurs) and through certain processes (e.g. funded by governments and production companies with vested interests) will be produced to a high standard and broadcast widely. At least that is still the case at the time of writing and the proliferation of media freed from national apparatus could herald significant changes.

If these are just some of the factors involved in the way media institutions make memories it is no wonder that something as creative and innovative as human memory could be defined in terms of 'cognitive surplus' (Shirky 2010a). This connects with Anna Reading's most recent research on a 'right to memory',[2] which (in theory) should supersede all other rights. What would such a right to memory look like and what is the role of media in articulating this right? Reading locates it in the UNESCO Declaration Concerning the Intentional Destruction of Cultural Heritage (Article 21, 2003), which seeks to protect the human past and the right to communicate about it. Those without a history, whose memories are being rediscovered through a variety of media institutions, forms and practices, need a bigger law, the right to remember and be remembered. Reading (2010) argues that where memory has been erased – war, genocide, trauma, destruction of sites, demolition of communities for the development of capitalist projects – media can and ought to provide opportunities for preserving what individuals and communities need in order to survive. Lately, online digital media, community media and creative technologies allow such communities to operate outside media organisations that have ignored or not represented those who need remembering most.[3] Such projects are not driven by financial success but by bearing witness to the past in collaborative and creative ways.

However, before we celebrate the democratisation of memory-making too loudly, we do need to acknowledge the role of institutions, corporations, commercial organisations and industries that are heavily involved in recording, producing, storing, archiving, creating and making accessible memories of local, national and global significance. Some argue that 'public broadcasting [for example] should define itself as an influential factor in cultural reproduction and renewal' (Blumler

1993: 406). In the context of commercial pressures and digital choice, offering audiences access to cultural heritage becomes increasingly tricky. However, there is clearly an emotional value to it, as Roger Smither has argued about the relationship between television and war. It is a 'complex interaction' between media and the past, not simply in the televising of history but in the 'exploration of personal histories within families and communities' (Smither 2004: 63). Thus the collective memories formed around the institutionalised practices of national broadcasters producing content on two World Wars also encourages 'the veteran or survivor at home to tell his or her story [. . .] stimulat[ing] or respond[ing] to an atmosphere of more general sharing of memories' (Smither 2004: 63). This is a positive outcome but Marita Sturken poses a more problematic one in her reprinting of the words of Veteran William Adams:

> When *Platoon* was first released, a number of people asked me, 'Was the war really like that?' I never found an answer [. . .] what 'really' happened is now so thoroughly mixed up in my mind with what has been said about what happened that the pure experience is no longer there. [. . .] The Vietnam War is no longer a definite event so much as it is a collective and mobile script in which we continue to scrawl, erase, rewrite our conflicting and changing view of ourselves. (Adams 1988: 49)

This exposes the roles of memory institutions, memory forms and memory practices in producing personal and collective memories of war experiences. Veteran William Adams is drawing attention to different ways in which media and memory come together and are not separable. There is a sense that media institutions have to represent the past responsibly. What is interesting with regard to this book is meaningful, memorable, valuable and profitable mediated memories are not fixed in time but are rewritable.

Therefore three key dynamics of memory are explored in each of the sections below:

- *Dynamic 1.* Media as recording of events and as a record of the past is the driver of *institutions* of memory from news corporations, newspapers and news broadcasters to museums, heritage industries and archives. It also forms the backbone of the film industries when productions focus upon history, documentary and re-enactment. Example institutions would be the British Library Sound Archive, the BBC, the numerous Holocaust museums around the world (especially Steven Spielberg's), the

thousands of broadcaster archives, Microsoft's MyLIfeBits or the Oral History Association (US)/Society (UK).

- *Dynamic 2.* Media *forms* are memory aids, tools or devices thus making media mnemonic, mnemotechnical or mnemotechnological (see Stiegler 2003). Key examples of this are quite obviously the computer, the smartphone and the camera as well as less obvious examples such as photocopiers, video diaries and Google Street View. Such forms are structured into everyday life with little critical reflection and appear to extend the memory capacity and performance of ordinary citizens beyond what was possible only a decade ago. In fact, as Viktor Mayer-Schönberger has highlighted in *Delete: The Virtue of Forgetting in the Digital Age* (2009), the digital realm remembers everything, even what is better forgotten.

- *Dynamic 3.* Media as memorial or as working through the past are the key driver of memory *practices* both publicly and privately. From Diana's death, to Holocaust websites, two World Wars to 11 September, online memorials to digital storytelling and recorded witness testimony – this dynamic moves individuals and communities from the past into the future on emotionalised journeys. Cutting across all three of these dynamics of making memories with media are issues of commercialism, rights, creativity, local/national/global heritage, culture industry practices, national and international policy and the impact of digitisation.

Taken together, these three dynamics form a media ecology of great complexity which is constantly changing and being challenged by human creativity and innovation. It produces what Michael Rothberg (2009) has described in another context as 'multidirectional memory in a transnational age'. This, unlike the 'zero-sum game' of 'memory competition' whereby my memory wipes your memory from the landscape, allows Holocaust memory, for example, to sit alongside appropriations, recyclings and mashups of Holocaust memory as a 'larger spiral of memory discourse' (2009: 11). We are back to Veteran William Adams' point above concerning the rewriting of the Vietnam War through cinema. Thus controlling collective memories is pretty important and the professionalisation and institutionalisation of cultural memory through media (particularly broadcast media) that has characterised the twentieth century has structured how citizens participate, create and recreate a nation's past. Some argue that top-down, professional, concentrated mechanisms of media production in the developed world may represent the ingredients for choking the

creativity 'of the millions' out of the production of content (Lessig 2007). While most of us are becoming interested in the new media tools we have at our disposal (at least in developed countries) the vast majority are still tied to traditional notions of how to produce and consume media content. What is interesting for this book is the idea that we could move from a 'read-only' memory (produced by media institutions) to a 'read-write' memory (produced by millions of creative citizens) as 'amateur culture' that is produced 'for the love, not the money' as democratised cultural memory (Lessig 2007).

Dynamic 1: Institutions

Attention to media in early accounts of how memory was being conceived as popular, social or cultural seems lacking. In a significant early anthology *Making Histories* from Johnson et al. (1982), Bommes and Wright proclaim that:

> Memory has a texture which is both social and historic: it exists in the world rather than in people's heads, finding its basis in conversations, cultural forms, personal relations, the structure and appearance of places and, most fundamentally [. . .] in relation to ideologies which work to establish a consensus view of both the past and the forms of personal experience which are significant and memorable. (Bommes and Wright 1982: 256)

No mention of media. From October 1979 to June 1980 the Popular Memory Group, as they were named, met and discussed the limits of history and produced a theory, politics and method for popular memory in the same volume of *Making Histories* that Bommes and Wright contributed to.[4] What Johnson et al. (1982) ignored at that time is precisely the focus of this book: news, television, film, radio, music, information technologies and popular culture in general. Johnson et al. were keen to hammer home 'the power and pervasiveness of historical representations, their connections with dominant institutions and the part they play in winning consent' (1982: 207). They did not acknowledge the role of popular culture and media as contributing to the private and institutionalised representations of the past. As Tara Brabazon has argued in her insightful book *From Revolution to Revelation: Generation X, Popular Memory and Cultural Studies* (2005):

> Popular memory should have been a far more visible and significant part of contemporary Cultural Studies [. . .]. Popular culture is the

conduit for popular memory, moving words, ideas, ideologies and narratives through time. (2005: 66, 67)

Thus there is a politics to how media and memory have been culturally and socially researched as well as produced. Steven Anderson has described it as 'best understood as a site of discursive struggle' (2001: 22) clearly drawing upon Michel Foucault's theorisation of popular memory and history from below which resist institutional knowledge:

> Since memory is actually a very important factor in struggle, if one controls people's memory, one controls their dynamism. And one controls their experience, their knowledge of previous struggles. (Foucault 1977: 22)

Let us not get too carried away with Foucault's pronouncement here. Foucault is seen, within media studies, as a theorist of power and institutions often used by media scholars to critique corporate media and ideologies of gender, race and class. However, Foucault is no fan of media in its relationship with pure social memory. Thus popular memory up until the early 1990s is more *of the people* than *of popular culture* per se and as yet had not engaged with media on an equal footing. In what follows, I explore the more recent appreciation of the complex and interacting ways that media, history and memory come together. What is important to note is that media institutions or institutions that make memories with media are both powerful producers of collective memory as well as powerful conduits through which challenges to collective memory can be produced.

For example, we could turn to the notion of 'world memory' (Bennett and Kennedy 2003), which is transcultural and is offered to negotiate the historical trauma that has defined the cultures of memory of the twentieth and early twenty-first centuries. Here, we can think of world memory in terms of cinema: from the nuclear bombs of the Second World War (*Hiroshima Mon Amour*, 1959), to the Nazi Holocaust (*The Boy in the Striped Pyjamas*, 2008), to the Stolen Generations of Australian aboriginal children (*Rabbit Proof Fence*, 2002, based on Doris Pilkington's novel *Follow the Rabbit-Proof Fence* 1996), to the South African Truth and Reconciliation Commission (*Country of My Skull*, 2004), to AIDS (*Blue*, 1993) and 11 September (*World Trade Center*, 2006). Bennett and Kennedy borrow the term 'world memory' from Gilles Deleuze to 'echo the globalizing tendency of media reports emanating from the cultural and economic centres' (Bennett and Kennedy 2003: 5). So, it seems that 'the world' is a narrative constructed by a dominant minority. Here, 'world memory'

evokes the connections and disconnections between nation states, their histories and their narratives of the past that may be dominated by a Euro-American dogma. As such, this concept of 'world memory' is rooted firmly in trauma studies as if when we think of 'the world' we can only do so through a prism of bad, repressed or unspeakable memories: wars, genocide, terrorism.

Western media then, and in particular film and television, have been institutionally and commercially led by certain ideologies that use trauma and pain in their production of memories as marketable products for audiences to consume. These then have been used as platforms for institutionally archiving that trauma and pain for future generations to experience and possibly purchase, the main example being the war-drama *Schindler's List* (1993), which established from 52,000 interviews between 1994 and 1999, Spielberg's USC Shoah Foundation for Visual History and Education. Other examples include the History Channel's 40th Anniversary website special of videos, interviews, archival photos and documents surrounding the assassination of John F. Kennedy. Alongside, the History Channel promoted their major TV series *JFK – A Presidency Revealed* (aired November 2003). Subsequent events have added to this mediated memory culture of trauma and theorists of media have not left these unquestioned in terms of the role of institutions, corporations and commercialisation.

For instance, Marita Sturken has covered two major traumatic events in American history in her seminal book *Tangled Memories: The Vietnam War, the AIDS Epidemic, and the Politics of Remembering* (1997). The physical objects of veteran memorials and memorial quilts as well as the spectacles of cinematic docudrama and television news become woven together to make a kind of collective memory fabric. Drawing upon Michel Foucault's theorisation of power and the role of institutions in the production of the self, Sturken says, quite simply, that '[w]hat memories tell us, more than anything, is the stakes held by individuals and institutions in attributing meaning to the past' (1997: 10). Let's go further and suggest that Sturken's book adds to a wealth of research from the mid-1990s onwards that institutionalises media and memory research in terms of trauma. In fact, one can see in a collection such as Cathy Caruth's (1995) *Trauma: Explorations in Memory* that media, in the form of Claude Lanzmann's *Shoah* (1985), plays a significant part in making the equation between memory, trauma, film and the Holocaust. Some argue that trauma and memory provide a kind of template for guaranteeing the success of key media productions such as Spielberg's film and the archive that came from the film.

One such critic is Andreas Huyssen, whose work is among the

first to look directly at the relationship between culture, trauma and memory. In fact, he says that the last two decades have seen a 'culture of memory' that is fuelled by trauma discourse. It 'radiates out from multi-national, ever more ubiquitous Holocaust discourse' and 'is energized, at least in the US, by the intense interest in witness and survivor testimonies, and then merges with the discourses about AIDS, slavery, family violence, child abuse and so on' (Huyssen 2003b: 16). In all these cases, our understanding of testimonies comes in, from and through an institutionalisation of memory-making with and through media. Screen media, in particular, invite trauma and pain (see Miriam Bratu Hansen's (1996) definition of the Holocaust as evoking a 'screen memory'). For studying media and memory, it is important to recognise the positioning of memory-making and memory representation within this powerful paradigm of trauma, such that we are aware that certain mediated memories have a market while others do not. This does not mean that only Holocaust memories sell because this event is 'widely thought of as a unique and uniquely terrible form of political violence' (Rothberg 2009: 11). It means that the institutionalisation of the Holocaust aesthetic within and through media offers 'a metaphor or analogy for other events and histories' (Rothberg 2009: 11) to emerge, compete, offer solidarity, countervail, engage and disengage. This allows readers, audiences and users to take memories in multiple directions, while at the same time connecting back to a Holocaust template.

Therefore discourses of witnessing and testimony (integral to trauma) are powerful producers of media content for radio, television, journalism and film. Journalism itself has a long history of war correspondence and bearing witness to war, from the nineteenth century to the mobile-video-camera-phone-enabled embedded journalists of more recent conflicts. News items have national and international resonance across generations as audiences remember news reports transnationally and over time (see Volkmer 2006). Likewise, it is photography, argues Barbie Zelizer, that moves individuals from the traumatic shock of the incident into a post-traumatic space of memorialisation (2002: 49). In the days that followed 11 September, stills and photographs of every aspect of the event dominated television and print media. In fact, institutionalised templates were in evidence that journalistically produced the event along the same lines as the Holocaust. In both cases, argues Zelizer, images of atrocity, shock and tragedy were designed as a 'call to bear witness', to assist 'people "to see" what had happened' and thus to help people 'respond to horror, trauma and the aftermath of other atrocious events' (2002: 53–4). In

the case of 11 September, there were many photos of people watching the events on television, a good example of which graces the cover of Zelizer and Allan's (2002) *Journalism after September 11*.

Jeffrey Shandler makes a similar argument in *While America Watches: Televising the Holocaust* (1999) in which he reproduces a powerful photograph featuring German prisoners of war in a movie theatre at Halloran General Hospital, New York, June 1945. Taken from the back of the auditorium, the viewer can clearly see the backs of the heads of hundreds of German POWs watching a film of the liberation of the camps and on the screen piles of naked dead bodies. Some POWs are covering their eyes while the majority are facing the screen. This image of witnessing says Shandler represents not only how the footage functions as a memorialisation but how it was later used for postwar propaganda and courtroom evidence. The carefully selected US documentary film reels of the liberation of the camps have not only 'loomed over subsequent presentations of the Holocaust' (Shandler 1999: 18) but we can see today that they provide the template for curating memory at the US Holocaust Memorial Museum. The website at the time of writing provides an interactive rolling of four banners that utilise the same photographic templates:

- *Banner 1.* A black-and-white image of liberated Jews in striped pyjamas at a wire fence, followed by a black-and-white image of American soldiers liberating a camp and raising the American flag with the words *Days of Remembrance, Stories of Freedom: What You Do Matters, April 11th–18th 2010. Honoring the 65th anniversary of liberation.*
- *Banner 2.* No image, rather two alternating banners, one with the words in white against a black background: 'The Future Can Be Different', and the other with the words in red and grey against a white background 'From Memory to Action: Meeting the Challenge of Genocide'.
- *Banner 3.* Image of a Nazi in uniform with the title 'State of Deception: The Power of Nazi Propaganda: Visit the Special Exhibition'.
- *Banner 4.* 'Support the Museum: Donate Now'.

What is important here in terms of institutions within the domain of the 'many-to-many' Internet is the use of historically and culturally familiar memory templates from 'one-to-many' media such as cinema and broadcasting. Thus Zelizer's argument becomes deeply problematic for both theorists and producers of media content making memories. In terms of recording, producing and disseminating visual

images of horrific events, she is highlighting a dominant 'Holocaust aesthetic' (Zelizer 2002: 54). This provides the media template for all subsequent reportage of traumatic events. It is one structured through a top-down institutionalised cinematic and broadcast media and that may take audiences along known pathways rather than somewhere new. Similarly, Hoskins (2004a) has argued that media templates of the Vietnam War (considered the first living-room war) structure the production of war reporting in the later Gulf War (1991). Such structuring may have a narrowed photographic template if the event is in a country where media are not powerful (such as Cambodia, Rwanda, Bosnia) or it may have an extremely powerful effect as in the aftermath of 11 September:

> There was a certain mission driven into the display of photographs that went beyond the aims and goals of journalism. [. . .] the repetitive display of photos accompanied the onset of war that was a retaliation after the fact. Photos of ruin, victims, and memorialisation were central to mobilizing support for the political and military response yet to come. (Zelizer 2002: 57)

There is a very contentious point to be made here for those entering the media business in future. Media industries have saturated audiences with traumatic memory, with unearthing past injustices and with discovering lost stories and this may have a powerful effect on those new to the business that continue to recycle the same cultural memories. In fact, Gavriel D. Rosenfeld (2009) has argued that memory studies, post 9/11, needs to focus on the present and the future, not the past. 'The past went that-a-way', proclaimed Marshall McLuhan in *The Medium Is the Massage* (1967: 74–5) and '[w]hen faced with a totally new situation, we tend always to attach ourselves to the objects, to the flavour of the most recent past. We look at the present through a rearview mirror. We march backwards into the future.'

Focusing upon the media representation of trauma as do textual analyses, Holocaust films can ignore the corporate mechanisms by which that trauma is produced, consumed, reproduced and reconsumed. For example, it is corporate journalism that comes under the spotlight in Robert McChesney and John Nichols (2002) *Our Media, Not Theirs: The Democratic Struggle Against Corporate Media*. In a scathing polemic against US media (very generally) McChesney and Nichols argue that what should have been a media system for the people and of the people 'fails to provide basic support for citizenship' because it is owned by a 'handful of enormous conglomerates that have secured monopoly control of vast stretches of the media landscape'

(2000: 24). For making memories, this does not bode well. Likewise, in David Cannadine's (2004) excellent collection *History and the Media*, Oscar-winning producer David Puttnam asks 'Has Hollywood Stolen Our History?' Memory does take a backseat in this volume because the contributors are concerned with history with a capital 'H'. Yet, such critical questions are important for thinking about how film and broadcast institutions engage in the production of memories and how the templates they create are recycled for new audiences in new media forms.

Dynamic 2: Forms

> The human memory system is remarkably efficient, but it is of course extremely fallible. That being so, it makes sense to take full advantage of memory aids to minimise the disruption caused by such lapses. (Baddeley 1999: 200)

If we accept Baddeley's argument concerning the need for memory aids then what are media if not ways of aiding human memory? Unsurprisingly, events, according to Williams et al. (2008: 61), 'are better recalled if they are unique, important, and frequently rehearsed' and media have a key role to play in doing just this. Media are recording devices – audio, video, photographic, digital; they are mnemonic – verbal, visual, kinaesthetic and auditory aids to help us remember; and, of course, representational – creative, manufactured and artificial techniques for making emotional connections with visualisations of the past. Personal and collective memories rely upon media for their production, storage and consumption as they become so complex and differentiated that the passing down of oral histories may not be adequate to conserve them.

As such, media function as 'extensions of man' in Marshall McLuhan's ([1964] 1994) sense of the phrase, as technologies (from pens to computers) that mediate our communications, with a focus upon form rather than content. Form in the context of mediated extensions of memory could be print-making, cameras, photocopiers, voice recorders, telephones and digital archives such that it was 'not the machine but what one did with the machine, that was its meaning or message' (McLuhan [1964] 1994: 7). The media forms that record, produce and deliver cultural and personal memories are vital to explore because of the 'psychic and social consequences of the designs and patterns as they amplify or accelerate existing processes'. For the 'message' of any medium or technology is the 'change of scale or pace

or pattern that it introduces into human affairs' (McLuhan [1964] 1994: 8). In his later polemic *The Medium Is the Massage*, McLuhan is both prophetic and clear:

> The medium, or process, of our time – electronic technology – is reshaping and restructuring patterns of social interdependence and every aspect of our personal life. It is forcing us to reconsider and re-evaluate practically every thought, every action, and every insti-tution formerly taken for granted [. . .] Societies have always been shaped more by the nature of the media by which men communicate than by the content of the communication. (1967: 8)

McLuhan is emphasising modes or modality here and this is important because not everyone wants to remember or be remembered in the same way using the same format.

The modes are constantly changing and at speed but does this mean the media forms produce remembering or forgetting? Michel Foucault argued that 'a whole number of apparatuses have been set up to obstruct the flow of this popular memory [. . .] effective means like television and the cinema. I believe this is one way of reprogram-ming popular memory which existed but had no way of express-ing itself' (Foucault 1977: 22). This idea of reprogramming echoes Veteran William Adams' statement at the beginning of this chapter concerning his inability to remember the Vietnam War outside of cinema. Similarly, and much later, Richard Dienst places television and memory in the same relationship, with the former eradicating the latter:

> Television survives through flow, whose transmission washes away the particularity of its messages along with the differences between them, and whose reception drains perception of its resistant holding powers of distance and memory. This flow absorbs the entirety of the television textual process. (Dienst 1994: 33)

But do Foucault and Dienst have this right? Is there something about the form of cinema and television that works against memory? With the emergence of a new Vintage TV digital channel to be launched in the UK in September 2010, it seems that baby boomers have very clear and particular memories of television from the 1940s to the 1980s that has not been washed away by time.

Therefore we must consider that the forms by which memories are produced from audio recordings to digital storytelling, cinema to video games, are just as important to critically analyse as their content. Along these lines, Douwe Draaisma has stated that '[a]coustic, visual

and other sensory impressions leave their traces in the neuronal register of the brain' such that the computer has become the 'dominant metaphor for the human mind' (2000: 231). Thus '[r]eflected in theory, the memory came to look like the technologies it was modelled on' (Draaisma 2000: 231). A good example of this is to consider the impact of Google Street View (GSV) on exploring spaces and places through 360-degree immersive photography. Childhood homes can be revisited to see how much our past memories are refreshed by recent image-capturing and storage. Future places we would like to visit can be traversed and memories of using GSV's mediation of space can be matched with the reality when we do visit those places. It is worth noting that this interfacing of memories and mediations of place is not limited to GSV, we are already used to this experience without realising it.

If we take one of the most filmed cities in the world, New York, cinematic remembrance actually structures the real experiences should we ever visit. New York is an already familiar place. In fact many people remember how to navigate New York from playing *Grand Theft Auto* games. Cinematic triggers, lines from films, scenes, frames, shots up the avenues, images of the Statue of Liberty, the Brooklyn Bridge, Manhattan and Staten Island have featured in film, television and games to the extent that New York becomes a character itself. The relationship between media, memory and New York is so significant that oral history techniques have been digitised to produce the City of Memory project (www.cityofmemory.org), funded by the Rockefeller Foundation and the National Endowment for the Arts. Here New York is presented as an online aerial grayscale map with blue and orange hyperlinked dots denoting stories. The introduction states:

> Welcome to this grand, new repository for all of New York City's stories and experiences. Explore this interactive urban story map yourself to meet many of the city's greatest characters, visit its diverse communities, and enjoy its most amazing stories. Things that happened forty years ago or something that happened to you this morning – all are welcome in the City of Memory. (City of Memory 2010)

This is 'prosthetic memory' as Alison Landsberg would term it in her seminal work *Prosthetic Memory: The Transformation of American Remembrance in the Age of Mass Culture* (2004). Cinema offers audiences memories of places and experiences through which they have not lived and yet shape their identity and affect them. Film (and museums), says Landsberg, offer sites for experiential encounters between the

recorded past and the person. This produces a new form of public cultural memory 'by making possible an unprecedented circulation of images and narratives about the past' (2004: 2) that allow audiences to create 'deeply felt memor[ies] of a past event through which he or she did not live' (2004: 2). Online media seems to intensify this prosthetic memory by providing more and more emotional encounters with the past. However, if we think about the speed of media delivery system, development from, for example, audiocassettes to compact discs to solid-state recorders, we are faced with a real problem of transferability from and access to past formats. This problem can be felt as a loss not simply of content but of experiencing the form.

Consider your own sound collections. In my loft I have a few cherished audiocassettes, painstakingly recorded and mixed from cassettes of friends in the 1980s (from the 1970s to the1990s mix tapes were a feature of everyday music consumption, and the practice is memorialised in the book-to-film *High Fidelity* (2000)). I could search iTunes and buy some of the rare mixes for an iPod or mp3 player but I cannot entirely recreate the collection in digital format. As audio recordings on cassette, transferability is limited if not impossible and playability is becoming difficult. This is not the point though, as it is not the content I nostalgically mourn, as the Internet will provide me with digitised replacements. It is the remembered practice of physically handling the cassettes, reading the handwritten titles, pushing in and ejecting from the stereo and impatiently waiting for the track I love to come around again. All this experience with the format is structured into my memories of being young and social.

I am definitely not alone in this memory. Research funded by the Netherlands Organisation for Scientific Research (NOW) at Maastricht University (2006) explored this phenomenon in the Sound Souvenirs Project, which resulted in the groundbreaking collection edited by Bijsterveld and van Dijck (2009) *Sound Souvenirs: Audio Technologies, Memory and Cultural Practices*. In this book, Bas Jansen explores the phenomenon in his analysis of over one hundred stories of mix tapers or gift tape recipients in 'Tape Cassettes and Former Selves: How Mix Tapes Mediate Memories' (2009). Mix tapes function as a 'frozen mirror' or a 'time capsule' transporting the person back in time to a younger self (Jansen 2009: 52). Ironically, rapid changes in digital media development have both taken away this experience and provide a powerful memory of this experience. Now, digital sound allows media, cultural institutions and creatives to experiment with memory and nostalgia through mixing, spatialisation, fragmentation, playback, recording, overlay of spoken word material with archival sounds and

other objects or images. This occurs online, in museum installations, heritage exhibitions, in film, on television and in games. As a form, sound is finally being creatively and critically acknowledged as just as vital for mediated memories as images. It is important to acknowledge that 'people make use of audio technologies to elicit, reconstruct, celebrate, and manage their memories, or even a past in which they did not participate' (Bijsterveld and van Dijck 2009: 11). I shall return to the importance of sound for memory in Chapters 5 on radio and 7 on popular music. What is important to emphasise here is that 'newly emergent memory forms' have arisen that 'enable non-linear links and personal navigation through a combination of sounds, moving images, photographs and texts' that lead to newly emergent practices (Garde-Hansen et al. 2009: 77).

Dynamic 3: Practices

Mediated memory appears as a kind of insurance policy or audit trail of experience. It guards against 'the transience in the mortality of memory', as Douwe Draaisma argues in his excellent book *Metaphors of Memory: A History of Ideas about the Mind*, by producing 'artificial memories' (2000: 2). From writing (antiquity onwards), to photography (1839), to cinematography (1895), to the phonograph (1877), to 'numerous "artificial" memories [which] are available for the eye and ear to take in [. . .] Image and sound are transportable in space and time, they are repeatable, reproducible, on a scale that seemed inconceivable a century ago' (Draaisma 2000: 2). Numerous technologies of memory have been and are being developed to provide a whole range of media practices in what might be described as a 'post-broadcast era' (see Turner and Tay 2009).

In the previous chapter, I noted that Andrew Hoskins was already rethinking 'collective memory' as a 'new' collective memory in the context of a rapidly changing technological media landscape (2003: 8–10). It seems that the concept of a collective, read as political, is at odds with discourses of individuality that contemporary globalised media encourages. As Tara Brabazon puts it: '[c]ollective memory such as that formed by and with working class communities, women or citizens of colour, can hold a radical or resistive agenda' but it 'is often forged by unpopular culture and is the "minority report" of an era' (2005: 67). A collective in popular media culture might be the Borg in *Star Trek: First Contact* (1996) of homogeneity, conformity, control and lack of individuality. Thus collective memory may have a reduced currency in our popular culture of new media technologies, where

homogeneity is systematically critiqued and individual taste and choice are positioned as fundamental (see Hebdige 1979; Kellner 1995; Carey 2009; Jenkins 2006a). In fact, Andrew Hoskins (2010) has argued most recently that we are witnessing the end of collective memory altogether. If we are, then this may be due to the way we now use media to make memories. The media audience of collective memory (think of the televised Moon landing in 1969) has been transformed into shifting and various roles as spectators, viewers, users, consumers, prosumers, fans and now digital creatives who have the tools of media production at their disposal. As William Merrin has described 'Media Studies 2.0':

> In place of a top-down, one-to-many vertical cascade from centralised industry sources we discover today bottom-up, many-to-many, horizontal, peer-to-peer communication. 'Pull' media challenge 'push' media; open structures challenge hierarchical structures; micro-production challenges macro-production; open-access amateur production challenges closed access, elite-professions; economic and technological barriers to media production are transformed by cheap, democratised, easy-to-use technologies. (Merrin 2008)

With this in mind, it is easy to see why recent scholarship on media and memory is proffering a relationship that is wholly transformed because of the new opportunities to practise media literacy skills.

This increased media practice coming from the bottom up has an impact for understanding how social and cultural heritage and history is changing. Ordinary people are engaged, not just in genealogical research but also in civic and community entrepreneurship activities. In their seminal survey research of how 1,500 Americans think and feel about history, Rosenzweig and Thelen (1998) concluded that respondents were fascinated with the past, not ignorant and apathetic but genuinely and actively intrigued with history. Defined as popular history-making, Rosenzweig and Thelen noted that personal memory practices have taken precedence over collective memory practices. In fact, while everyone is making history, all the time, everyday, only some of these practices are being collectivised and legitimised. Paul Grainge added to this position that Americans 'tend to construct a more privatised version of the past', that private memory practices atomise individuals and that this is 'an obstacle to collective politics' (Grainge 2003: 145). There was caution concerning institutionalised media's impact, for 'the commodification of memories through history films, television, museums and the Internet threatens to construct pasts

that are privately satisfying rather than publicly useful' (Grainge 2003: 145). More recently scholarship has come to acknowledge the powerful ways in which citizens can increase media literacy and actively engage in constructions of their own past. For example, Jenny Kidd's work with the BBC's Capture Wales project (2001–7) discovered the real use-value of 'the infinite creation and re-creation of memory' for individuals not well-versed in media practice. Her research concluded that 'it is increasingly likely that this growing practice will result in the creation of multiple narratives more truly reflecting the fragmentary nature of self, complicating the idea of the collective and frustrating the idea of the knowing archive' (Kidd 2009: 180). I shall focus on such archives in the next chapter.

Digital storytelling has become a powerful media practice for producing personal and community memories. Developed by Joe Lambert at the Californian Center for Digital Storytelling during the 1990s, the model was introduced into the UK by Daniel Meadows in 2000 and has become the focus of Knut Lundby's international research project Mediatized Stories – Mediation Perspective on Digital Storytelling among Youth (completed 2010). Two key works have emerged centred on digital storytelling: Knut Lundby's edited collection *Digital Storytelling, Mediatized Stories* (2008) and John Hartley and Kelly McWilliam's edited collection *Story Circle: Digital Storytelling Around the World* (2009). It is the emphasis on practice that each of these volumes celebrates, in particular practice from below, not from the professionals, institutions or corporations. It espouses an aesthetics of memory that Joe Lambert saw as 'an art of social commitment, an art of public education, an art of therapeutic recovery, an art of memorializing the common victim of historical/social tragedies [. . .]. Shared by all these artistic practices is the central value of personal experience and memory' (2009: 79).

In a similar way to oral history, digital storytelling involves the more communal sharing and writing of narratives with digital practice in mind, because the writer of the personal story will record that short narrative, scan photos (if they are analogue) and create through simple software packages such as iPhoto, iMovie and iTunes a 2–5 minute story that overlays voiced narrative with photographs and other images. For many, oral history sound recording still offers an unmediated and authentic mediation of personal memory practices. In the context of the Oral History movements in the US, UK and Australia recording the human voice, creating stories and sharing these offline and online has become an increasingly significant form of remembrance for individuals and communities. War memories, indigenous memo-

ries, intergenerational communication, folk memories, memory work for human rights, memories of natural disasters, migrant and refugee memories and contested memories all find in oral history training and production through the medium of sound and sometimes video an easy and powerful way of collecting and archiving memories. Unlike digital theories the emphasis is upon documentation rather than personal creativity. This can be found in explorations of diaspora in Vietnamese women voicing their memories (Nguyen 2009), in the videoed voices of those involved in the Voices from the Rwanda Tribunal Project (2008) or in the memories of marginalised South Africans and other nationalities in the Silence Speaks Project (1999 onwards).

To consider such practices democratically we can turn to the recent ideas of Clay Shirky who articulates the notion of 'cognitive surplus' that is a combination of digital media tools and human generosity mentioned at the beginning of this chapter. One must understand that

> there is one compensating advantage for the people who escape the old system: when the ecosystem stops rewarding complexity, it is the people who figure out how to work simply in the present, rather than the people who mastered the complexities of the past, who get to say what happens in the future. (Shirky 2010b)

The movement within media history and development of 'one-to-one', 'one-to-many' and now 'many-to-many' forms of communication mean 'social media can make history' because, says Shirky, innovation is happening everywhere. In fact he argued at a presentation at the US State Department in June 2009 that 'the moment our historical generation is living through is the largest increase in expressive capability in human history' (Shirky 2009). With such a transformation comes a series of practical issues and problems that pertain to media and memory practices in the twenty-first century. Much of these involve the relationship between the personal consumption of media and the corporate and commercially owned media. I shall explore this in more depth in the next chapter and in Chapter 6 but suffice it to say here media and memory practices inevitably involve remix (Lessig 2007; Manovich 2002), convergence (Jenkins 2006a) and remediation (Bolter and Grusin 1999), all of which involve clashes between media creativity and big business.

Notes

1. The components that make up the acronym GRT are not cultural equivalents but I am using it to offer the broadest and most

inclusive terms for defining a group of people. The term 'Gypsy' or 'Gipsy' has a pejorative origin but has largely been reclaimed by UK Gypsies in particular. Roma has come to dominate European definitions but as a term has been resisted by those travelling communities who do not define themselves as Roma or Romani. Traveller incorporates those who may have chosen a travelling lifestyle or do not define themselves in terms of a specific heritage or ethnicity.

2. Anna Reading's paper 'Mobile and Static Memories in Gypsy, Roma and Traveller Communities' was presented at the *Media, Memory and Gypsy, Roma and Traveller (GRT) Communities Symposium,* hosted by the Research Centre for Media, Memory and Community, University of Gloucestershire, UK (22 June 2010).

3. For an insightful review of recent research projects on the uses of digital media for memory-making and archiving see the e-book edited by Maj and Riha (2009) that draws together papers from the 1st Global Conference on Digital Memories, Salzburg, Austria (17–19 March 2009).

4. This edited collection provided a real starting point for establishing a politics and methodology for oral history-making, private memory research and community practice.

Exercise

Follow up the research above on digital storytelling. The Center for Digital Storytelling, California has produced a Digital Storytelling Cookbook. Why not follow the guidelines and make your own digital story and show it to family and friends for feedback?

Further Reading

Crownshaw, Richard (2000) 'Performing Memory in Holocaust Museums', *Performance Research*, 5 (3): 18-27.

Landsberg, Alison (2004) *Prosthetic Memory: The Transformation of American Remembrance in the Age of Mass Culture.* New York: Columbia University Press.

Reading, Anna (2003) 'Digital Interactivity in Public Memory Institutions: The Uses of New Technologies in Holocaust Museums', *Media, Culture and Society*, 25 (1): 67–86.

Rosenzweig, Roy and Thelen, David (1998) *The Presence of the Past: Popular Uses of History in American Life.* New York: Columbia University Press.

Sturken, Marita (1997) *Tangled Memories: The Vietnam War, the AIDS Epidemic, and the Politics of Remembering*. Berkeley: University of California Press.

Volkmer, Ingrid (ed.) (2006) *News in Public Memory: An International Study of Media Memories across Generations*. New York: Peter Lang.

4 Digital Memories: The Democratisation of Archives

Media and the development and history of media from the printing press to the blogosphere have been caught in a tension between democracy and control. Pierre Nora has argued that a 'democratization of history' can occur if emancipatory versions of the past surface: 'Unlike history, which has always been in the hands of the public authorities, of scholars and specialised peer groups, memory has acquired all the new privileges and prestige of a popular protest movement' (2002: 6). Therefore a free and creative media brings with it democracy, or at least the possibility of democratisation. New media technologies of digital and online media are thought to be key players in this process of freeing information and knowledge. Nicholas Negroponte in *Being Digital* (1995) thought so and his book provided many prophetic statements about the power and positivity of digital creativity we see today. Yet digital culture brings with it a great paradox whereby it contributes as much to amnesia and collective forgetting as to remembering, 'What if', asks Andreas Huyssen, 'the boom in memory were inevitably accompanied by a boom in forgetting? What if the relationship between memory and forgetting were actually transformed under cultural pressures in which new information technologies, media politics, and fast-paced consumption are beginning to take their toll' (2003a: 17)?

Do digital and online media speed up or slow down our memory-making? Do they create amnesia or do they prevent us from forgetting? Are they simply used to market nostalgia and target niche audiences or do they offer new and alternative experiences of grassroots and popular pasts? The current memory boom that Andreas Huyssen identifies is most certainly intensified by rapid developments in digital media. As Garde-Hansen et al. argue:

> The existing paradigm of the study of broadcast media and their associated traditions, theories and methods, is quickly becoming inadequate for understanding the profound impact of the supreme

accessibility, transferability and circulation of digital content: on how individuals, groups and societies come to remember and forget. (2009: 3)

Good examples can be found in the areas of the heritage and culture industries that incorporate media in terms of discourse, form and practice. The rise of vintage gatherings, revivalist shows, reinvention tours, retro-acts, come-back performances and fan memorabilia conventions all speak to a voracious culture of nostalgia which Paul Grainge identified as a hallmark of postmodernism, defined as a 'yearning' for the past. Contemporary nostalgic enterprises such as the Vintage at Goodwood Festival 2010, celebrating five decades of British Cool from the 1940s onwards, accesses and creates audiences through a retro use of digital media, online networking and the repurposing of music, fashion, film, art and design archives. I shall be focusing upon nostalgia and archives in Chapter 7 on 'The Madonna Archive' where I draw upon Svetlana Boym's ideas in *The Future of Nostalgia* (2001). Here she argues that '[o]n the blue screen two scenarios of memory are possible: a total recall of undigested information bytes or an equally total amnesia that could occur in a heartbeat with a sudden technical failure' (Boym 2001: 347).

The Internet is distributing memories into personal, corporate and institutional archives. As more media digitally converge (television, mobile phones, video and photography) there are increased opportunities for museums, broadcasters, public institutions, private companies, media corporations and ordinary citizens to engage in what the philosopher Jacques Derrida once described as archive fever (1996). Digital memories are archived in virtual spaces as digital photographs, memorial websites, digital shrines, online museums, alumni websites, broadcasters' online archives, fan sites, online video archives and more. 'Keeping track, recording, retrieving, stockpiling, archiving, backing-up and saving are deferring one of our greatest fears of this century: information loss' (Garde-Hansen et al. 2009: 5). With all this in mind, this chapter will integrate theories of memory and archives with theories of digital media and digital cultural heritage. Who controls the archive is a very important question for the twenty-first century. Is it closed or is it open? Is it within institutional walls or outside them? Such questions have been asked by philosophers who have defined archives as produced when memory is under threat (Derrida 1996) and answered by archivists of the Internet itself:

[W]ithout cultural artefacts, civilization has no memory and no mechanism to learn from its successes and failures [. . .]. The

Internet Archive is working to prevent the Internet – a new medium with major historical significance – and other 'born-digital' materials from disappearing into the past. ('About IA' (2010) http://www. archive.org)

Therefore, this final chapter of Part 1 unpacks digital media, memory and archiving by thinking about the relationship in four integrated ways:

- Firstly, through *digital media producing an archive* of history, heritage and memories. Prominent examples would be family photographs and videos, Steven Spielberg's Shoah Foundation, David Lynch's *Interview Project*, the British Library's Digital Lives Project, Second World War archives, the BBC's Capture Wales Project and 11 September 2001 memorial websites.
- Secondly, through *digital media as an archiving tool*, power and technology. Here online music and sound recording collections, Google and Wikipedia might be considered good examples of digital media's archiving power.
- Thirdly, through *digital media as a self-archiving phenomenon*. Newspaper archives, blogs, twitter, folksonomies, digg.com, Google Trends and the Internet Archive are prime examples of media forms and practices that use themselves to remember themselves.
- Fourthly, *digital media as a creative archive*. Here creativity comes to the fore when broadcasters take a backseat and user-generated content provides the material for Facebook, Flickr, smartphone applications, citizen journalism and video game add-ons such as *9/11 Survivor* or the Facebook profile of the six-year-old Holocaust victim Henio Żytomirski.

Digital Media Producing an Archive

There is a wider theoretical debate to take into account that practical approaches to democratising archives tend to ignore. Before exploring the key theorisations and approaches to digital media producing archives, we have to attend to museums and heritage organisations in general, which have, as Fiona Cameron and Sarah Kenderdine highlight in their edited collection *Theorizing Digital Cultural Heritage* (2007), 'institutionalized authority to act as custodians of the past in Western societies. As such, they hold a significant part of the "intellectual capital" of our information society' (2007: 1). The last chapter explored how media make memories in terms of a Holocaust aesthetic

or template, which references Norman Finkelstein's critical approach to a Holocaust Industry (see http://www.normanfinkelstein.com) as noted in Chapter 2. Here, we have a similarly politicised question about the explosion in archives per se that speaks to a heritage industry: see theorisations from Robert Hewison's *The Heritage Industry* (1987), to Raphael Samuel's *Theatres of Memory* (1996), to Patrick Wright's more recent *Living in an Old Country* (2009). Critical attention to nostalgia, sentimentality and revivalism are fundamental to memory studies. In fact the journal *Memory Studies* has recently devoted a Special Issue to 'Nostalgia and the Shapes of History' (2010: 3 (3)). Yet the heritage industry in the last two decades has tended to focus upon museum, resource and repository management. Media have come in here as a producer of archives in the service of personal, local and national pasts. Use of or reflection upon media has been instrumentally driven rather than seeing media as a critical reflection upon heritage industries' powerful constructions of personal, local, national, global, collective memories. For research in this particular area see Ross Parry's excellent book *Recoding the Museum: Digital Heritage and the Technologies of Change* (2006), Cameron and Kenderdine's comprehensive collection *Theorizing Digital Cultural Heritage: A Critical Discourse* (2007) and Lyons and Plunkett's historically informed collection *Multimedia Histories: From the Magic Lantern to the Internet* (2007).

This does not mean to say that archives are like bales of wool from which large samples are drawn to pull over the eyes of the masses so that they conform to a national identity. Rather, in thinking about digital media, archives and their democratisation we need to keep one eye on the institutions, forms and practices referred to in the previous chapter. 'Cultural manipulation', argues Patrick Wright, 'pervades contemporary British society' (2009: 5), for example, and the UK heritage industry has its own role to play in this. Yet students of media studies should be aware that audiences are not simply passive but active producers of meaning (see David Gauntlett's *Ten Things Wrong with the Media 'Effects' Model* at http://www.theory.org). In their everyday lives audiences creatively use mediated archives to understand themselves in relation to multiple worlds: home, school, workplace, leisure spaces, community, nation, the world, the universe and even virtual worlds. In her research on kitsch objects such as snow globes and memorial teddy bears, Marita Sturken has focused upon how ordinary people mediate memory through 'cultural objects that have been traditionally considered to be beneath scholarly scrutiny' (2008: 76).

Therefore it should come as no surprise that simple home movies figure as an important starting point for thinking about archives of life

lived around the world, as presented by Ishizuka and Zimmermann (2007) in *Mining the Home Movie: Excavations in Histories and Memories*. Likewise, José van Dijck analyses home movies as 'memory objects', 'acts of memory', and not simply 'family portraits captured in moving images' but as constructing 'cinematic hindsight' (2007: 127). These more 'neuroaesthetic' accounts of memory as 'cinema of the brain' (Hansen 2004: 194) suggest that family archives of home media actually mediate lived experience on an everyday level through sight, sound, movement and touch in order to create a multi-modal self-archive. They share with local and national archives a desire to create meaning from (re)collection and evoke nostalgia on an everyday level. As Thomas Elsaesser has argued:

> In our mobility, we are 'tour'ists of life: we use the camcorder in our hand or often merely in our head, to reassure ourselves that this is 'me, now, here'. Our experience of the present is always already (media) memory, and this memory represents the recaptured attempt at self-presence: possessing the experience in order to possess the memory, in order to possess the self. (2003: 122)

The problem is that, in a digital age, home movies have taken on a different register. Elizabeth Churchill's research in 2001 into families' use of digital video 'revealed that much footage remained on unviewed tapes. Family videographers were stumped by the processes of downloading, editing and sharing – and by how much computer memory video requires' (van House and Churchill 2008: 297). Almost a decade later the issues of computer memory and digital storage are high on the agenda with cloud computing appearing to hold the solution. Now the issue is not so much a lack of media literacy but 'curatorial overload: too much information, too difficult to organize and retrieve' (van House and Churchill 2008: 297).

One way of overcoming this problem has been to share one's personal archive of photographs and videos with others and by doing so we consciously select, organise, display and curate our lives. The archive of the self becomes opened up and democratised as it moves out of the private sphere and into the public sphere. Many of us use social networking sites to archive and save our memories. Here then we usher in 'new hybrid public-personal digitised memory traces that although open to immediate and continual reshaping are also resistant to total erasure by even, and especially, the authors of these digital archives of self' (Garde-Hansen et al. 2009: 6). We are actively preserving our lives in digital archives[1] and we do not yet appreciate the archiving power of the Internet.

From personal collections to national repositories, the main issue is *access*. Who can have it, how to get it, what they can get to and what they want to do with the contents once they have them? It is fascinating to understand the unstoppable desire to access archives as portrayed in a short film by Laurie Hill, *Photograph of Jesus* (2008), about the Getty Images Archive. Beautifully animated with narrative voice-over from a Getty archivist, the exploration of thousands of boxes of millions of photographs in the archive is propelled by a public request for a 'photograph of Jesus'. This is impossible and the film is structured around equally ludicrous public requests for photographs of: 'a Victorian lady in the Edwardian era', 'Hitler at the 1948 Olympic Games in London', 'Jack the Ripper', dog-fights above London during the Second World War, 'a dodo out in the wild' and all twelve astronauts who landed on the Moon pictured together! The film humorously explores the irritation of members of the public with the Getty archivists who either do not have such photographs or seem to deliberately block access. There are serious points here about our understanding of media and archives: that history be entirely and fully accessible through media even though they may not have been invented and that history is so mashed up and mediated in our minds we lack a chronology. The integrity of historical and cultural archives and their contents are key because in a smash-and-grab digital world where one man's idea of freeing information is another man's notion of free information to make a profit from, what is made available to the public becomes one of the most pressing concerns for archive builders.

All this supports the theoretical research of Lynn Spigel who analysed why individuals and public and private institutions have saved TV content, why TV nostalgia networks construct canons of saveable content and what researchers find in TV archives. Her research was conducted using case studies of the Academy of Television Arts and Sciences (begun in the 1950s and now on permanent loan at the UCLA Film and Television Archive, http://www.cinema.ucla.edu/), New York's Museum of Modern Art's (MoMA) display of television as art from 1952 onwards and the never to be realised Hollywood Museum (1959). Invariably, says Spigel, archivists focus on 'pragmatic issues of space, financing, copyright laws, donors, and advances in recording technologies, [. . .] general methods of preservation, cataloguing, and selection' (2005: 68), while ideologically television content has only been preserved if it matches 'concepts of public service, art, commerce, and public relations' by the industry and by institutions such as libraries, museums and universities 'in order to extend their own cultural authority' (Spigel 2005: 70). Historians and students rarely

find what they imagine might be there. Why? The first reason is because it is only recently that television has been considered worthy of saving by broadcasters or libraries. There is little content archived pre-1960s and what there is you are as likely to find on YouTube from a fan's personal collection they have digitised as you are in the Library of Congress. This goes for a whole range of media content not considered socially or culturally significant to future generations: news items, live broadcasts, cartoons, magazines, comics and popular music are examples. The second reason is because the logic that drives the archiving of content by major institutions has been less interested in what media means personally, emotionally and memorably to you or me. In order to get access to these kinds of archives we rely upon fans, private individuals and interest communities to provide the material through their use of digital media as archiving tools.

Digital media as an archiving tool

There are two fundamental concerns regarding the democratisation of archives that pertain to the archiving power tools of media and communications: forgetting and the inability to forget. Let's take the first issue and deal with the inability to erase memories at the end of the chapter. The positive side of digitising memories, history and heritage in order to preserve and make retrievable a mediated past can be found in a range of examples. *Images for the Future* (http://www.imagesforthefuture.org) seeks to preserve the audiovisual heritage of the Netherlands. The BFI archive of world screen heritage has *Rescue the Hitchcock 9* (http://www.bfi.org.uk/saveafilm.html), which aims to restore the director's silent films through digital media. PrestoPRIME is a European project to develop a digital preservation framework for audio-visual content and digital media objects (http://www.prestoprime.org/). At the time of writing, the US National Archives have made some of its vast collection available on the photo-sharing site Flickr. The British Library has digitised and made available 44,500 Archival Sound Recordings (http://sounds.bl.uk/). The British Library's UK Digital Lives Research Project (http://www.bl.uk/digital-lives/index.html) finds a hub of activity exploring issues regarding collecting and preserving national heritage. Personal collections in manuscript, audio and digital format held in the library pose all sorts of challenges to curators as well as citizens desiring access. If '[f]or centuries, and indeed millennia, individuals have used physical artifacts as personal memory devices and reference aids' then 'fundamental new issues arise for research institutions such as the British

Library that will be the custodians of and provide research access to digital archives and personal collections created by individuals in the 21ˢᵗ century' (Digital Lives Project, 2009). Apart from the technical and management concerns, what are the critical and theoretical issues that pertain to such projects?

Firstly, it is best to consider them in the terms of the British Library's mission statement as the portal 'to the world's knowledge'. In *Digital History: A Guide to Presenting, Preserving, or Gathering the Past on the Web* (2005) Daniel Cohen and Roy Rosenzweig attend to *maintaining historical integrity* while building archives on the web. How archives present their contents online is vital and they track the development of key archives such as the Library of Congress' Civil War Photographs from 1992 to their American Memory archive. The latter was a pilot program begun in 1990 on CD-ROMs, transferring to the World Wide Web in 1994, and at the time of writing now comprises more than nine million items that document US history and culture. It 'played an important early role in spreading digital archives in the United States' (Cohen and Rosenzweig 2005) providing 'free and open access through the Internet to written and spoken words, sound recordings, still and moving images, prints, maps, and sheet music that document the American experience' (Library of Congress, 2010).

Secondly, it is vital to critique, in studying media, memory and archives, such projects in terms of control and ownership. For example, in terms of control, Cohen and Rosenzweig offer practical advice to creators of historical archives on the web. In order to make content accessible, they promote the production of genres or expectable forms in order to reach audiences. Media producers are immersed in creating genres, markets and audiences. In fact, media forms tend to fix and stabilise content as presentist. In his research on how media is used in the Imperial War Museum, London, Andrew Hoskins noted that a 'video or audiotape, a written record, does more than just record memory; they freeze it, and in imposing a fixed, linear sequence upon it, they simultaneously preserve it and prevent it from evolving and transforming itself over time' (Hoskins 2004a: 7). Similarly, when media are then archived online as part of a Holocaust Museum exhibition, Anna Reading (2003) found that, regardless of the numerous opportunities to interactively explore the museum archive online, visitors clicked links that they were familiar with. 'The newness of the web', argued Cohen and Rosenzweig only five years ago, 'requires historians to be much more deliberate about what we are doing and why we are doing it' (2005). Thus historians and archivists are using

the powerful tool of digital media to archive in powerful ways that may not challenge visitors and users to explore widely and variedly.

This deliberateness means control. In our keenness to celebrate the democratisation of archives by large institutions such as the Library of Congress and other online national archives across the world, we should also bear in mind that these are professional archives: coherent, organised, constructed, regulated and (although freely accessible online) top-down in their production of the past. They may be a part of Open Archives Initiatives but they are also in control of those archives in the same way that old-media broadcasters and newspapers are in control of theirs. I shall return to what Cohen and Rosenzweig (2005) define as 'invented archives' created by amateurs at the end of this chapter. Suffice it to say here, Cameron and Kenderdine also note the tendency in discourse on digital cultural heritage and digital technology to be 'descriptive and introspective, focusing on projects and their technical considerations' (2007: 3). They see 'collecting organizations' as 'vehicles for the enduring concerns of public spectacle, object preservation, shifting paradigms of knowledge and power' (2007: 3). They also see 'digital technologies' as an 'impressive array of virtual simulacra, instantaneous communication, ubiquitous media, global interconnectivity, and all their multifarious applications' that the cultural heritage sector has not 'fully imagined, understood, or critically explored' (2007: 3).

In terms of ownership, we enter the slippery space where an old-media and a new-media economy meet. This is more tricky because almost everything published after 1923 remains under copyright until 2018 in the United States and this fact, say Cohen and Rosenzweig (2005), means that only the 'commercial digitizers [. . .] can easily bear the upfront costs of converting paper into marketable bits'. It is the commercial and corporately funded effect on democratising archives that is having the greatest impact in the last five years. Internet giants such as Google, who appear to face constraints on copyrighted works and seemingly err on the side of caution, also view the rights issue as King Canute trying to hold back the waves of 'free' culture. Google Books, while offering snippets, user-tracking software and other restrictions on viewing content, has scanned over ten million books, most of which are out of print. In terms of the democratisation of knowledge this 'publish and be damned' approach to making archives available is only possible because Google has the corporate and financial might to deal with lawsuits on infringements of rights.

It is at this point in considering the democratisation of archives that we would do better to consider digital memories as digital treasures. In

fact, the language of mining, free-content scavenging, sifting, discovering rich seams of information, digging and hidden gems permeates how the past is viewed from a digital culture perspective. Indeed, in the UK, the Arts Council recently hosted Digital Treasures: Re-thinking the Archives for a Digital Age (16 November 2009). Keynote speeches came from the then Shadow Minister for Culture Ed Vaizey and the BBC's Tony Ageh (a BBC executive whose work I shall return to in Chapter 5). Vitally, this event pivoted around key opportunities and stumbling blocks not limited to the UK arts and media landscape, which I summarise below:

Opportunities
- The nation is sitting on vast quantities of unrealised and valuable archival material for which there is a huge appetite internationally.
- Media archives are rich seams of fuel which can be used to power the network revolution.
- Universal access and tagged and shareable content can generate entrepreneurship and knowledge creation to rejuvenate creative economies.

Stumbling blocks
- There is a lack of collaboration and partnerships to make exploitation of local and national archives possible.
- Organisational structures are top-down.
- Content is locked up in rights issues.

Yet for users of the Internet everything seems possible to retrieve and with Internet gurus such as Joi Ito (CEO of Creative Commons and early-stage investor in Twitter, Six Apart, Technorati, Flickr, Dopplr and more) navigating issues of control and ownership, the future of archives appears open access. This idea of 'treasure', which suggests something we value emotionally as well as financially, describes the commercialisation of archival content by digital technologies. Thus not all the examples of digital media as an archiving tool, power and technology are equal. Some are not-for-profit ventures (museums), others rely on donations from fans, members and philanthropists (BFI), some are user-generated in a collaborative exercise (Wikipedia) and others seem non-commercial (YouTube). Yet, in the latter case, William Uricchio argues: 'Google's massive investment in YouTube and its hope of transforming user-generated content into money' may seem fraught but within 'four short years, YouTube has

found a large participating public' and 'attracted an astounding level of financial investment' (2009: 24–5). How, then, can sites such as YouTube and Wikipedia be understood in terms of a self-archiving phenomenon?

Digital media as a self-archiving phenomenon

In 1996, the cultural theorist of technology Hal Foster imagined the emergence of a 'database of digital terms, an archive without museums' where 'techniques of information [. . .] transform a wide range of mediums into a system of image-text' (1996: 97). Jens Schröter in 'On the Logic of the Digital Archive' (2009) reminds us of Foster's concept of an archive without museums to describe YouTube. Schröter is contributing to *The YouTube Reader*, edited by Pelle Snickars and Patrick Vonderau (2009), in which we are presented with a range of scholarship that positions YouTube as an archiving tool for producing a mashup culture. Alongside metaphors of a laboratory, a library or a television channel, it is the discourse of YouTube as an archive that is really useful in terms of media and memory.

YouTube (started in 2005) is now the third most visited site after Google and Facebook. It is producing artistic citizens, social impact advocates, creatives, entrepreneurs and self-marketers without the infrastructures of institutions, forms and practices of the old-media economy. Like Flickr, it has become one of the 'default media-archive interfaces' of the twenty-first century – so much so, say Snickars and Vonderau, that during 2009 'the Library [of Congress] announced that it would start uploading millions of clips to YouTube [thus] using highly frequented sites [. . .] may give content added value' (2009: 14). Rick Prelinger,[2] in 'The Appearance of Archives' from *The YouTube Reader* (2009), states that 'the most striking aspect of YouTube, Flickr and other similar "media-archive" sites is that they actually offer the media storage and distribution model of the future' (2009: 271). Like many, he is positive about the possibilities that democratising archives through such digital platforms bring. However, Snickars and Vonderau, quite rightly, warn that old-media players have not left the stage of this new mediascape. 'Mining the vaults of an estab-lished media archive remains subject to corporate interests as well' (2009: 14). Likewise, Robert Gehl in his journal article 'YouTube as Archive: Who Will Curate this Digital Wunderkammer?' argues that the democratisation of archives and the lack of centralisation leave YouTube with no authoritative 'curator of display'. This 'sets the stage for large media companies and entrepreneurs to step into the

curatorial role and decide how each object in YouTube's archives will be presented to users' (2009: 43).

This unresolved debate aside, for clearly YouTube belongs to a rapidly changing mediascape that is grappling with the frameworks of an old-media economy, we should note that 'the popular imaginary of the Internet is that of an archive of archives' (Snickars 2009: 292). It is this self-archiving phenomenon that YouTube encapsulates. If one takes, for example, one of the most watched videos on YouTube, 'Charlie bit my finger – again!' posted 22 May 2007 from the UK, we find a simple, amusing and effective short home video of a baby biting his older brother's finger. Twenty years ago such a video would have been recorded on an analogue camcorder, remained in a home-movie collection to be viewed a few times by family members and the siblings as they grew up (if they converted it to digital format). At the end of 2010, it has 218,560,344 views and 383,024 comments. After two years on the site the last comment posted 21 seconds ago (at the time of writing) is 'Haha sooo süß <3 Das ist echt das beste Kindervideo, was ich je gesehen hab'. More than this, YouTube now hosts over 2,000 'Charlie bit my finger' remakes. Thus the site not only acts as an online media platform that archives other media and archival content, it creates space for users to remake media from its own archival contents.

I shall return to this creativity phenomenon in the next section as well as in more detail in Chapter 6 '(Re)Media Events: Remixing War on YouTube'. Suffice it to say at this point, YouTube is providing a platform for distributing content in ways that make everyday memories instantly storable and retrievable. It belongs to a mediascape that is user-generated and seeks to meet the needs of new media collectives. Wikipedia also informs our cultural heritage in such a way that Christian Pentzold has defined it as 'a global memory place where locally disconnected participants can express and debate divergent points of view and that this leads to the formation and ratification of shared knowledge that constitutes collective memory' (2009: 263). Other user-generated online tools speak to memory and archiving in terms of democratisation by suggesting the same discourse of digging for treasure noted in the previous section. The user-generated filter Digg.com digs up content, allows users to give it the thumbs up (i.e. dig it) or bury it. This action puts that content on the front page so that thousands of people can see it. Delicious acts in a similar way: again content is tagged or bookmarked by users and that tagging goes back to Delicious on a particular list of interests, to be distributed out to users. Likewise, Technorati allows users to log the blogosphere, counting the number of times an item is blogged and thus rating and scoring

the user-generated commentary. This ensures that in a digital culture where nothing is forgotten and everything is archived a user can act as curator in a process of social tagging. This process is researched in more depth by Isabella Peters in *Folksonomies: Indexing and Retrieval in Web 2.0* (2009). Thus users are increasingly taking on the traditional role of professional archivists, trying to overcome curatorial overload together.

This ongoing collaborative management of digital culture is necessary if the Internet and the content it enables is to be archived for future generations. The final report of the UK's Joint Information Systems Committee (JISC) on its Digital Repositories and Archives Inventory Project (DRAI, 2008), which aimed to provide 'a comprehensive snapshot of digital resource provision in the UK, found the landscape hugely complex and varied'. Many digital collections were not included in major information sources, collections were produced individually on an ad hoc or 'one-off funding' basis, which led to fragmentation, extremely complex relationships between collections, 'parent' repositories and collection owners (Abbott 2008: 3). This should come as no surprise. Cohen and Rosenzweig (2005) noted the way in which search engines themselves become part of history as the enormity of Yahoo's current history web directory' revealed its incompleteness. Thus, they drew attention to the emerging need to preserve digital history and digital culture itself. In fact, in 2003, UNESCO issued its Charter on the Preservation of Digital Heritage, which viewed digital heritage as a common heritage. Toward this end, the Internet Archive has proven to be one of the most significant examples of digital media as a self-archiving phenomenon. It provides access to a web archive called the 'Wayback Machine', which contains an index of about 85 billion web pages from 1996 to the present.

At this point, we might be thinking that an Internet archive is a both necessary and brilliant idea. However, in 'A Fair History of the Web? Examining Country Balance in the Internet Archive' (2004) Thelwall and Vaughan found significant national differences in the Internet Archive's coverage of the web, with US sites over-represented while China was under-represented. Even in 2010, a site such as Wikipedia, which claims to have more than 91,000 active contributors working on more than 16 million articles in more than 270 languages, may not be representing Christian Pentzold's (2009) global collective memory fairly. Mark Graham (2009) of the Oxford Internet Institute maps out the spatial contours of Wikipedia in his blog posting 'Mapping the Geographies of Wikipedia Content' and notes that the country with the most articles is the United States (almost 90,000) while small

island nations and city states have less than 100 articles. Likewise, in his TEDTalk 'Listening to Global Voices' technologist Ethan Zuckerman (2010) states that social networks structurally produce users that only interact with other users who are like them, offering only 'imaginary cosmopolitanism':

> This was not how the Internet was supposed to be. [. . .] The prediction was that the Internet was going to be an incredibly powerful force to smooth out cultural differences [. . .]. The world is, in fact, getting more global [. . .] and our media is less global by the day. [. . .] This tends to give us a very distorted view of the world. [. . .] It turns out that new media is not helping us all that much.

So how can this problem be solved? How can the archives from the dark spots of the world be brought into the public domain? How can personal and collective memories be better democratised through digital media?

Digital Media as a Creative Archive

> National memory cannot come into being until the historical framework of the nation has been shattered. It reflects the abandonment of the traditional channels and modes of transmission of the past and the desacralization of such primary sites of initiation as the school, the family, the museum, and the monument: what was once the responsibility of these institutions has now flowed over into the public domain and been taken over by the media and tourist industry. (Nora 1998: 363)

Nora identifies the public domain of media as providing one key space in which frameworks of national memory will be democratised. Yet, Alisa Miller head of Public Radio International, shows a News Map of the world from 2007, with the US as a bloated landmass of news only about itself (2008). One could take Miller's map and apply it to any country and find that nations mostly tell stories about themselves to themselves. In the context of digital archives, digital memory and digital cultural heritage, we need to accept that the old-media frameworks of traditional transmission and consumption continue to have authority. Should one look to user-generated content on sites such as YouTube for grass-roots communication and archives of 'real' memories? Mike Wesch, in 'An Anthropological Introduction to YouTube' presented at the Library of Congress (23 June 2008) notes that media mediate human relationships and when media change then it follows

that human relationships change. He provides numerous examples of user creativity on the site from online 'smart mobs' to in memoriam messages. However, we should note the 90-9-1 or 1 per cent rules that have framed discourses around creativity and participation online since 2006. The principle states that 90 per cent of users are the passive audience, 9 per cent of users are editors, modifying and adding to but not creating content, and 1 per cent are the creators who 'are driving a vast percentage of the site's new content, threads, and activity' (http://www.90-9-1.com).

Therefore, when Cohen and Rosenzweig discussed digital cultural heritage in 2005, did they know they were advising only that 1 per cent on how to produce the past online? Does it matter that the past might still be in the hands of a media-literate minority? What is the minority doing with archives? Cohen and Rosenzweig noted that 'website producers create their own virtual collections, often mixing published and unpublished materials in ways that "official" archives avoid' (Cohen and Rosenzweig 2005). They offer the example of the Valley of the Shadow (1993–2004) – the first of the invented archives that fictionalised two communities in the American Civil War. An academic project, it belongs to the early days of top-down digital cultural heritage. Nevertheless, the concept of invented or virtual archives is important because it frames the way remix and mashup culture exploits media archives to produce new and exciting content. Van House and Churchill note that our 'collective and personal memories are rapidly becoming more digital. [. . .] In fact, one could say that memory has been central to the digital information revolution: improvements in digital memory [. . .] dovetail nicely with a seemingly voracious human appetite for creating, capturing, circulating and keeping more information, faster' (2008: 300).

One such example of digital media as a creative archive can be found on Facebook. Andrew Hoskins (2010) has argued that social networking sites 'facilitate a continuous, accumulating, dormant memory' that the associations made are passive. Similarly, Richardson and Hessey (2009: 25) in 'Archiving the Self? Facebook as Biography of Social and Relational Memory' found that the site acts as 'a dormant archive of relationships that would have dissipated without these technologies'. But how passive and dormant is memory on Facebook? Facebook has allowed not only social networking but the sharing of what was once a family album, as explored by Annette Kuhn in *Family Secrets: Acts of Memory and Imagination* (1995), noted in Chapter 2. While much mobile phone photography is now becoming less archival 'being used for image-based communication, in effect visual or multimodal mes-

saging' (van House and Churchill 2008: 298), Facebook and Flickr provide spaces for archiving the self, online. I shall be focusing on camera phone photography in the final chapter of this book. For now, though, it is important to stress that Facebook offers a site where only the most significant of the many thousands of photos taken every year by one individual can be displayed and shared as a record of a life lived. More than this, a logic is assumed: that the photographs offer an authentic, unadulterated and newsworthy version of one's life.

Facebook forbids the production of fake profiles, largely because spammers, virus writers, cybercriminals or malicious individuals produce them. Fake profiles are frequently created in non-serious ways through the production of celebrity and historical figure pages (e.g. Barack Obama, Bill Gates, Adolf Hitler, Satan). However, it is clear that the site can be used to create invented archives with digital content that speak to national and collective memory. During 2009–10, the Warsaw City Council in Poland commissioned an educational campaign from San Markos PR Company to disseminate the history of the Warsaw Uprising of 1944 (over 200,000 victims, average age eighteen years old) to young people in the twenty-first century. It desired to achieve the following:

> Our challenge: How to revive the history and protect it from turning into a dusty card? How to make young people today understand what their counterparts felt 65 years ago? [. . .] we have decided to reach them where they spend most of their free time [. . .]. The Solution: We have created two fictitious profiles Sosna, 24 and Kostek, 23, a couple of young Warsaw inhabitants who by bending time tell the story of their 1944 everyday experiences live for 63 days, 24 hours non stop as if it happened today. By the end, they die'.
> (Europe's Premier Creative Awards (EPICA) Gold Winner 2009, Cat. 27 Media Innovation Showreel)

Using Facebook tools, the PR and marketing company created a virtual diary on Polish Facebook, remixing archival material with mashed up media: archival photographs, music from the time, films shot with mobile phones, typical Facebook quizzes and online conversations. Over 3,000 young people, celebrities, artists and journalists, joined the page, experienced historical archives and the death of their 'friends'. Thus, as Cameron and Kenderine have noted: 'In a symbiotic relationship, cultural heritage "ecologies" also appropriate, adapt, incorporate, and transform the digital technologies they adopt' (Cameron and Kenderine 2007: 1). This repurposing of the past using social networking tools is only possible when new

kinds of creative entrepreneurs (PR companies, marketing, advertisers, animators, interactive media specialists, game designers, virtual reality producers, festival managers) enter the archives and create a digital cultural heritage that may not be historically accurate, yet feels emotionally authentic to those who experience it. The production of museums, heritage sites, memorials and monuments in the online virtual community Second Life with its one million dedicated residents is another good example of digital media as a creative archive. In Chapters 6 and 7 I explore these ideas in more detail but for now I want to return to the idea of forgetting in a digital age.

Notes

1. There are new national initiatives on saving heritage and personal digital memories emerging at the time of writing this book. During 9–15 May 2010 it was Preservation Week in the USA and the American Library Association and Library of Congress raised awareness through 'Pass it On: Saving Heritage and Memories'. The National Digital Information Infrastructure and Preservation Program (NDIIPP) provides extensive guidance on personal archiving (at http://www.digitalpreservation.gov) and on the importance of preserving digital culture.
2. Prelinger founded Prelinger Archives in 1983 in New York City (acquired by the Library of Congress in 2002), a collection of vintage material, not-for-profit film, community videos, youth media, trade media and group interest footage, which was offered to the Internet Archive for open access from 2000.

Exercise

The Problem of Forgetting and Not Archiving
In the section 'Digital Media as an Archiving Tool' above I stated that there are two fundamental concerns regarding the democratisation of archives that pertain to the archiving power tools of media and communications: forgetting and the inability to forget. There is an emerging theoretical argument that is particularly important to acknowledge in the context of media, memory, archiving and new technologies. In the first issue of the journal *Memory Studies*, Paul Connerton proposed 'Seven Types of Forgetting' (2008: 59). What was so counter-intuitive in his argument was the idea that forgetting is not always a failure. In fact, he argues forgetting can allow individuals, communities and nations to move on into the future unhampered by the past. In the

context of new media technologies, where everything, even the most embarrassing and humiliating aspects of our lives, are archived, Viktor Mayer-Schönberger in *Delete: The Virtue of Forgetting in the Digital Age* (2009), proposes 'an expiration date for information'. We must 'appreciate' he says that 'information has a lifespan' and that we need to 'remember how to forget in the digital age' (2009: 15). So, consider these questions/actions: How many of us have hovered over that delete button in our e-mail archives, Facebook pages or favourites lists? Dare we press it? Will we regret it and yearn for that lost piece of data? Have you ever tried to delete your Facebook page? Try it one day if you dare and see what Facebook does next.

Further Reading

Cohen, Daniel and Rosenzweig, Roy (2005) *Digital History: A Guide to Presenting, Preserving, or Gathering the Past on the Web*. Online at http://chnm.gmu.edu/digitalhistory/.

Derrida, Jacques (1996) *Archive Fever: A Freudian Impression*, trans. E. Prenowitz. Chicago: University of Chicago Press.

Garde-Hansen, Joanne (2009) 'MyMemories? Personal Digital Archive Fever and Facebook', in Joanne Garde-Hansen, Andrew Hoskins and Anna Reading (eds), *Save As … Digital Memories*. Basingstoke: Palgrave Macmillan, pp. 135–50

Gehl, Robert (2009) 'YouTube as archive: who will curate this digital Wunderkammer?', *International Journal of Cultural Studies*, 12 (1): 43–60.

Mayer-Schönberger, Viktor (2009) *Delete: The Virtue of Forgetting in the Digital Age*. Princeton: Princeton University Press.

Parry, Ross (2006) *Recoding the Museum: Digital Heritage and the Technologies of Change*. London: Routledge.

Schröter, Jens (2009) 'On the Logic of the Digital Archive', in Pelle Snickars and Patrick Vonderau (eds), *The YouTube Reader*. London: Wallflower Press, pp. 330–46.

Snickars, Pelle (2009) 'The Archival Cloud', in Pelle Snickars and Patrick Vonderau (eds), *The YouTube Reader*. London: Wallflower Press, pp. 292–313.

Part 2

Case Studies

5 Voicing the Past: BBC Radio 4 and the Aberfan Disaster of 1963

> Voice does not simply persist at a different level with regard to what we see, it rather points to a gap in the field of the visible, toward the dimension of what eludes our gaze. In other words, their relationship is mediated by an impossibility: ultimately, we hear things because we cannot see everything. (Žižek 1996: 93)

There is a tendency within media studies to ignore sound. The visual image has dominated: art, photography, advertising, film, television, video games, online media, mobile phones. Just compare the amount of scholarly texts on television to radio, on cinema and gaming rather than soundtracks and soundscapes. Even the mobile phone, which is essentially a listening device, has only become interesting to media studies since it has a screen interface of applications, games, graphics, e-mail, photos and videos. When it comes to memory we assume that the visual dominates and structures our understanding of the world. We do not assume that sound is memorable and yet musicology tells us otherwise. Music anthropologists, researchers and practitioners of folk music know all too well the importance of sound for memory in terms of individuals, communities, geography (space, place and landscape), heritage and nostalgia. However, these are areas of studying sound and memory in terms of music and art rather than media and popular culture (see Snyder 2000).

When students analyse well-documented mediated events of such historical and traumatic importance as the terrorist attacks of 11 September 2001, emphasis in classrooms is put on the visible and the visual: CNN news, cinematic re-enactments, television documentary or the image of the Falling Man. Less emphasis is placed on the sounds that permeated that day and how memorable those were to witnesses and audiences, for example the soaring sound of a plane on a trajectory toward the first tower in the opening sequence of Jules and Gedeon Naudet's documentary film *9/11* (2002) which follows the New York Fire Department, or the growing roars and rumbles of both towers

disintegrating and collapsing upon themselves recorded by news broadcasters worldwide. These two examples have become part of our mediated memories of the event but they are anchored by images, as we hear what we can also see. Slavoj Žižek suggests in the quotation above that sound also stands in for what we cannot see.

For example, when I show Jules and Gedeon Naudet's documentary film to students, there is one particular sound that always evokes a physical reaction. At first they do not know what it is, a loud smashing, thud-like crash occurs randomly around the firefighters gathered in the lobby of the North Tower as they struggle to create a command post from which to start rescue operations. It makes them jump at the same moment we visibly see the firefighters jump and look uneasy. We learn it is the sound of those jumping or falling to their deaths from the top floors. These memorable sounds still make me jump when I watch that footage a decade later. I cannot *see* these horrific deaths but the recorded sounds of them I can *feel* in my body, if only for a moment. These sounds are not of the past but create traumatic feelings in the present and continually renew the experience of horror and fear each time I hear them. Sound, then, has the ability to move us emotionally and memorably, time after time after time. In fact, the UK broadcaster BBC Radio 4, which is well-known for its openness to experiments by mixing naturally produced audio with recordings of voices, produced Nikki Silva and Davia Nelson's *The Twin Towers: A Memorial in Sound* (2002) as a 45-minute experimental soundscape of voices, answering machine messages, music and newsreel soundtrack. Guy Starkey notes that this memorial in sound 'can be read as a moving tribute to the people and the human activity that once existed there' (Starkey 2004: 213). Such experiments speak to the creativity possible in 'how ambient sound may be used to illustrate a more deliberately articulated narrative' and how in assembling 'a sound picture without narration' producers can 'foster a greater awareness of the descriptive potential of sound' (Starkey 2004: 214).

These points above run counter to the position that radio, for example, because it is a medium without images, is somehow deficient. Take, for example, this influential theoretical position on radio's relationship to memory and remembering:

One of the essential deficiencies caused by radio's invisibility is that of memory. Memory often works visually or, at least, we have a tendency to remember images better than words. Consequently, the events of a radio narrative tend to be more difficult to recall than those of a stage-play or film [. . .]. Given that sounds, particularly

words, are less likely to be remembered as readily or accurately as images, radio producers have to accept the basic principle of radio drama: that is that the overall storyline needs to be stripped down to a basic and easily comprehensible structure. (Shingler and Wieringa 1998: 82)

This chapter fundamentally disagrees with Shingler and Wieringa's argument here. I would argue that radio's invisibility is its strength in terms of memory; as Andrew Crisell argues, 'radio is good at creating drama out of situations in which there is literally nothing to see' (1994: 155). Thus, in mediating the past, especially personal and collective memories, where there may well be literally nothing to see, radio can step in to voice the past.

Without visual distraction listeners are afforded the opportunity to exercise their memories and imaginations. Numerous researchers, theorists and practitioners of radio have all emphasised the importance of the lack of visuality to the medium and the need to remember sound and radio as significant to cultural history (see, for example, Crisell 1994; Pease and Dennis 1995; Weiss 2001; Hilmes and Loviglio 2002; Starkey 2004). In opposition to television, Frederic Raphael noted in 1980 that the BBC's privileging of radio as the true engine of British broadcasting at the heart of the corporation fuelled the professional understanding of radio as pure, akin to literature, and the listener as a fruitful participant, like a good reader. 'Words, isolated in the velvet of radio, took on a jewelled particularity. Television has quite the opposite effect: words are drowned in the visual soup in which they are obliged to be served' (Raphael 1980: 305). Such ideas have not disappeared in the last thirty years. More recently, in the wake of webcams and trans-platform approaches to radio, Gillian Reynolds bemoans the new applications of images now added to radio programmes:

> I am suspicious of webcams in radio studios or, generally, shoving pictures onto radio's words so that new audiences are more likely to grab them on their phones. Good radio is always rich in images, made richer by the pictures being of the listener's own building, unconstricted by a camera's narrow eye, focused by active attention. (Reynolds 2008)

I discovered this about radio for myself on a car journey one afternoon on 1 July 2004 while listening to Radio 4 and thinking about the new course on Media and Memory I was to teach in September. The *Open Country* series was broadcasting a repeat of its Sunday programme. I was aware of *Open Country* as a long-standing Radio 4 representation

of country life in the UK, with an emphasis upon rural England. For city dwellers, *Open Country* offers voices and sounds of wildlife, rural pursuits, farming-related items, village heritage and a sense of landscape and place. The programme suggests organic production techniques, natural ambient sound and little post-production is implied due to the need to express country life as unconstructed. Minimal interference from the presenters, limited post-production and allowing country-dwellers to speak for themselves in their own ways offer the listener an unadulterated impression of rural life. Thus *Open Country* exemplifies certain criteria that have been put in place for radio production to be effective in terms of holding audiences' attention toward a documentary: simplicity, authenticity, repetition, consistency and minimal use of voices with fairly limited background noises. These criteria have secured radio's position as being close to listeners: offering intimate portraits of communities, individuals and characters.

In this chapter, I want to privilege radio's ability to be memorable without images. Thus in what follows I will draw attention to the production context of *Open Country*'s 2004 Aberfan Disaster radio programme in order to better understand how it successfully interwove oral history interviewing with archival material to evoke emotional responses in the community of Aberfan, among listeners and in the production staff. This case study is based upon two key critically reflective industry interviews conducted in 2010 with the presenter of the programme Richard Uridge (who at the time of writing continues to present the *Open Country* series for BBC Radio 4) and the producer of the programme, Benjamin Chesterton, who went on to become Country Director of the BBC World Service trust in Ethiopia and now co-runs his own photofilm production company. What I highlight is the production dynamics between producer, presenter and audience that together provide a differentiated experience of memories of producing and listening to this programme, which stands, in itself, as a mediatisation of memory.

The Aberfan Disaster in Wales occurred on 21 October 1966. That Friday morning, after days of heavy rain, fifty years' build-up of tipped coal waste moved quickly down the Merthyr mountainside and buried Pantglas Junior School killing 116 children and twenty-eight adults. Memorable accounts of the Aberfan disaster have been archived by academic researchers Iain McLean and Martin Johnes (1999) and in 2007 a member of the public produced an online memorial webpage on http://www.gonetoosoon.org to list all the names of those who died and to which have been added black-and-white childhood photos of

some of the victims. The politicisation of this horrific post-industrial event that wiped out half of the children in the school in a matter of minutes continued right into the 2000s. Finally, Tony Blair's UK Labour government offered modest compensation to families who at the time were only paid £500 per lost child by the National Coal Board (which accepted responsibility only after a lengthy tribunal). Thus the disaster was an unusual topic for the BBC Radio 4 *Open Country* series to cover for a number of reasons. It did not fall into their ordinarily 'gentle' programming ethos. According to the producer Benjamin Chesterton, the programme covered the horror of the event from the perspective of those involved, the terrible days of rescue that followed, the politics of the government of the time, the injustice that the community were tasked with paying for the clearing of the tips, the subsequent suicides of young people and finally the pressured apology from the Prime Minister almost thirty years later (interview with author, 1 December 2010). Thus the programme was industrial not rural in nature. It was a traumatic, tragic piece of social history that became memorable to me as a listener, not only because I too had interviewed members of the Aberfan community but also in the ways it departed from the usual series ethos, structurally mixing dramatic and heart-wrenching contemporary interviews with archival news broadcasts from the time. It was this mixing of old and new that stood out, as Richard Uridge (the presenter) noted:

> It was a pretty out-of-the-ordinary programme for the series. I cannot think of one programme in the five years before or the five years since that was like this one. It was not a typical *Open Country* programme. It relied so heavily on the archival material of the time. (Interview with author, 23 November 2010)

Uridge remembered that it was more constructed, not so organic, less conversational and thus, because of the inclusion of the archival material, it had to be 'put together in a mosaic' largely because 'the archival materials are fixed in stone, cannot be changed, they can be topped and tailed, but you cannot do too much jiggering around with them' (interview with author, 23 November 2010). This meant that the contemporary interviews with members of the public were clearly framed as personal and emotionalised memories while the archival material was juxtaposed as official broadcaster material that represented collective or official records of the event.

The producer, Benjamin Chesterton, was also keen to emphasise the ways in which the production process was different. Largely, because the *Open Country* series is presenter-led, this edition relied

on post-production. I was keen to understand how the production of contemporary memories of a tragic event and BBC radio news footage had materialised. In my interview with Chesterton, he claimed that this decision to produce the programme in this way was not planned (a statement corroborated by the presenter). Rather, it had occurred because, according to the producer the presenter left the production. Chesterton stated that the presenter was unhappy with the subject matter after interviewing two of the community members (the elderly father who lost two daughters and the local school teacher). In my interview with Uridge, I had got a sense of an unspoken issue but he did not in anyway suggest that he had not completed the programme and according to the BBC website, which archive's the programme contents, Uridge is named as the presenter of this edition. Nevertheless, Chesterton claimed that:

> I got the archive as a way of solving a production problem. They were old records through an archive search at the BBC. I realised this was some astonishing archive by any standard. The reporting [at the time] was very unusual [it] was so emotional. [It] was a way of taking you back alongside the boy who was pulled out. The archive brought the story alive. (Interview with author, 1 December 2010)

I shall return to the issue of producer-power and presenter-power that can determine how media productions represent their content later. For now, though, it is this juxtaposition of personal and collective/official memories of the event that is the focus of this chapter. Ordinarily, 'radio documentary', as it has come to be known, is as successful as film and television documentary in capturing human experience because it embraces subjective experience. As John Biewen defines the process in *Reality Radio: Telling True Stories in Sound* (Biewen and Dilworth 2010), radio documentary uses the 'narrative power of the spoken word', for 'the best documentaries gravitate toward the close-up portrait' and offer stories that explore the space between the ears' (Biewen and Dilworth 2010: 4, 5–6). Therefore interviewing in order to elicit those stories or in such a way as 'to let people speak for themselves and tell their own stories' (Biewen and Dilworth 2010: 6) is vitally important and increasingly possible as the medium becomes inexpensive, lightweight and mobile. Benjamin Chesterton corroborates this theory in his production experience on this project. His memories of producing the Aberfan documentary focus on 'the story' and of the edition as being much more narrative driven than the usual style of *Open Country*. 'No one has ever accused me of being mawkish, I let people tell their stories,' he stated (interview with author, 1 December 2010).

Radio interviewing members of the public on their recollections of the past has a close relationship with oral history-making. Personal recollections of the past can have profound effects locally and nationally. The individual and his or her memory are inextricable from the community's memory and vice versa. The interviewer and the radio production team must, as Biewen recommends, 'plant themselves in a place and observe, peeling back layers rather than flitting over surfaces. Instead of venturing into the world and "reporting back," these producers seek to take the listener along' (2010: 7). Benjamin Chesterton's approach to the Aberfan community certainly conforms to this theoretical understanding of how radio producers undertake interviews and document human experience through the spoken word:

> The father still lived by the cemetery and tends it. When people talk to you they give something of themselves and your job as a producer is to do the best you can with what they give you. [. . .]
>
> I was very concerned for the young guy and I rang him back the next day. He paid an emotional cost for recording that programme. As a producer you have a duty of care to people you work with. If you are going to talk about something deeply personal then you don't just run off afterwards. (Interview with author, 1 December 2010)

The Aberfan Disaster programme centred on two contemporary interviews that can be regarded as oral history interviews: one with a survivor of the tragedy now a grown man (the young man to whom Chesterton refers above) and the other with the father who had lost two daughters (again referred to by the producer above). It is as an outdoor broadcast, recorded in Aberfan itself with traffic noise, dogs barking, passers-by talking and with the interviewees taking the interviewers on a tour of the community (to the school, to the mountainside and to the graveyard). Thus, by extension (through what Alison Landsberg might describe as 'prosthetic memory'), the programme takes interviewers (who act as conduits of memory) and the listeners along on the journey. The ambient noise gives the listener the sense they too are standing and moving in the place the interviewees are describing, walking up the hills, inside the school and travelling into the scene of the past devastation. Even when the programme cuts to and fades in archival clips of news broadcasts of the disaster we are still anchored in this location. When I interviewed Richard Uridge about the fact *Open Country* essentially maintains outdoor noises that radio producers would ordinarily omit or juxtapose, he was keen to

emphasise that the series had a particular philosophy regarding natural sound:

> The best radio listens very carefully to the sounds. In *Open Country*'s case it is the sound of the countryside. [...] People occasionally complain that the sound effects get in the way of their listening, we gently remind them that the series does not do this. No sound effects are recorded and juxtaposed. If natural sound gets in the way, it gets in the way. (Interview with Richard Uridge, 23 November 2010)

In production terms the Aberfan Disaster programme includes interview material that conforms to the *Open Country* values in that everything was done to make it clear the interviewees were outside, in their community and in the places they have lived their lives. We are not in a studio now. Although standard equipment was used in terms of microphones, backing off the sound from the source just a little meant that having the microphone slightly further away from the interviewee picked up that important ambient sound. At times, the interviewees are out of breath as they walk and climb hills and describe the roar of the coal waste hurtling down the mountainside (a sight no one at the time could have seen due to low-lying fog but everyone there could hear). It is clear they are leading the interviewers through the community as they point out the landmarks past and present. The listener, whether young or old, can relate to being a 'child at the time' or a 'parent at the time' as the sense of a historic tragedy occurring in this small community is explored and explained physically, geographically and emotionally.

Interestingly, the presenter Richard Uridge described the broadcast as 'not an enjoyable listen, quite traumatic really, the speed of the disaster. We recorded in a school in Aberfan and imagined the roar of the slurry. The awful silence. The content of the interviews was focused upon those sounds' (interview with author, 23 November 2010). This accords with what the listener understands from the interviewees as both convey the sounds of the roaring and the deathly silence that followed – which is then produced post-production through fades to silence that exemplify this for the listener. In particular, the long fade to silence at the end of the programme while the father is still talking of his grief exemplifies for the listener the notion that this is an unresolved narrative, a memory that will never fade and that the interviewee will be talking about this long after the BBC have left.

What is also worth noting about how this broadcast presents a mediatised memory to the listener, which it does through both con-

temporary and archival radio footage, is that the narrative is presented as a process of digging for or unearthing the truth, not only of the horrific memories of the interviewees but of the response of the National Coal Board and of Harold Wilson's Labour government in power at the time. The listener is then afforded mediatised memories, where the mediatisation is kept to a minimum, allowing the memories to establish themselves really strongly as personalised and emotionalised. These memories must be pieced together alongside the archival material to create a historical account of the event that includes memory in both personal and collective forms and shows up very clearly the relationship between the two. At times, the personal testimonies confirm the content of the archival material while at others the voices of past and present jar in their juxtaposition. Thus the BBC's approach to producing and presenting the Aberfan Disaster bears witness to Maurice Halbwachs' argument about the relationship between the individual and the social:

> [I]ndividual memory is nevertheless a part or an aspect of group memory, since each impression and each fact, even if it apparently concerns a particular person exclusively, leaves a lasting memory only to the extent that one has thought it over – to the extent that it is connected with the thoughts that come to us from the social milieu. (Halbwachs 1992: 53)

This social milieu is doubled: for those being interviewed it is Aberfan and for the listener it is their own time and place. Therefore, in such a broadcast, the listener is *led by the ears* through the locations of a tragedy, and transported to another social milieu where collective memories have been formed around a personal and national tragedy. This gives the programme a sense of a memory tour that is dynamic and mobile and gives credence to Marita Sturken's (2007) notion of tourists of history. Part of that memory tour is for the contemporary listener to re-experience the news broadcasts that those at the time would have listened to. Hence the inclusion of the archival footage provides an emotional juxtaposition. When I play this programme to my students they find the archival footage difficult to comprehend because of the strange idiom of well spoken, formal BBC newscasters narrating the scene of the tragedy. While the quality of the archival broadcasts is not poor, the listening experience is certainly challenged by the unfamiliarity of radio presentation techniques that were conventional in the 1960s but have changed considerably since. Thus, unlike in film or television, where the past is signified by black and white images (either archival or manufactured retrospectively), in

radio that sense of the past is signified to the listener through anti-quated speech patterns, idioms and conventionalised presenter styles. As the presenter Richard Uridge stated:

> Archival material does transport people back to a certain time, newsreel stuff, old newspapers, photographs; there is a kind of quality to the idiom that changes, and that conjures up a 'black and white' era. It is like black and white but in sound, *it sounds old* and provokes memories of a black and white era. (Interview with author, 23 November 2010)

It is important to emphasise that despite the different versions of events that the producer and presenter represented to me, they both do agree on the importance of sound and radio for creating and re-creating personal and collective memories. For Uridge the printed word, the spoken word and sound effects can conjure up in the listener's mind a classic projected television screen image when thinking about how memories are mediatised. Radio, on the other hand, 'renders in the detail and it can be one thousand different things to one thousand different people. Television is fussy and requires pictures, less engaging, and reduces the scope of the listener's imagination (interview with author, 23 November 2010). Similarly, Chesterton was keen to stress the importance of the Aberfan radio programme for the listener, the community and himself in successfully producing the emotional and political impact that he was striving for. This does not mean, however, that the programme was successful institutionally. Both the producer and the presenter referred to 'a few raised eyebrows' at the BBC because this was not considered the normal *Open Country* programme of romantic, English, rural life.

It is perhaps the extent of the post-production that was determined by the desire for a clear narrative with a social purpose which is at stake here. For Uridge the post-production was at odds with the *Open Country* ethos of an extemporised style of recording. For Chesterton, who found the series tenuous in its presentation of rural life and issues, the value of the BBC archive took over and began to determine how the personal memories of the interviewees would be presented to the listener. However, Chesterton was aware of the implicit tension that exists in the relationship between media and personal memory. For the presenter Richard Uridge the task was simple: 'Why get in the way of somebody's good story. You need to ask questions as tactfully and unobtrusively as possible' (interview with author, 23 November 2010), which accords with Biewen's theories of reality radio (Biewen and Dilworth 2010). Yet, for the producer, the task was far more com-

plicated for you 'know that you are doing something highly manipulative – editing is highly manipulative – to have an effect on the audience and you know that the interviewee will listen to that back afterwards. All good producers deal with this tension' (interview with author, 1 December 2010). Thus the organic conversational style of previous *Open Country* programmes was seen by the presenter to be replaced with a programme that was 'more constructed, not so organic, it could have been informal and it would have been a different treatment. However, the archival material determined how the rest of the stuff was put together' (interview with author, 23 November 2010). In fact, Chesterton highlighted that there were in fact two versions of the programme: a long one that had music (mostly choir and religious music) and the short one without music that I (and my students) listen to. He admits that the long programme's use of music changed the whole tone of the programme and was deliberately designed to 'ramp up the emotion' (interview with author, 1 December 2010). In the end, it was the producer's vision of how to produce these memories of the Aberfan Disaster that prevailed and in many ways Chesterton's approach of mixing past and present media content has become a standard method of representing memory spatially and temporally. What is fascinating about comparing these interviews with the presenter and producer of a programme produced six years before and reliant upon what one might term media production memories as industrially reflexive talk is their very different memories of the same production process. In fact, the producer reflected on the disparity in the following way:

> If the people working on it [the programme] cannot even have the same memory of the same event then that tells you a lot about the relationship between media and memory from the production side of things. There is a lot of that goes on. Listening to people. Then working really, really, really, fast. (Interview with author, 1 December 2010)

At the time of the Aberfan Disaster programme the BBC was in the midst of developing a portfolio of work in pioneering oral history, archive projects and digital storytelling in the UK and particularly in Wales through their Capture Wales (2001–7) project. This drew upon the media and memory work of the Californian Center for Digital Storytelling (see Garde-Hansen 2007; Kidd 2009; Meadows and Kidd 2009). The BBC was being seen as instrumental in the performance of memory for and with communities through media in the UK, thus seeking to enrich its relationship with the licence-fee payer. In fact, over the last decade, it has come to be realised that the BBC stands

as the custodian of a nation's heritage with the resource, skill and
technological bases to continue mapping, documenting and archiv-
ing the social and cultural history of that nation. Therefore, devoting
broadcast hours to personal memories that show up the importance
of memory for communities (particularly ones hitherto poorly served
by mainstream media or whose stories were in some way forgotten)
was high on the BBC's agenda as it approached its decennial Charter
Review in 2007.

Therefore, if 'both personal and collective memory rely in part
on the records of the past and on our technologies and practices of
remembering' (van House and Churchill 2008: 295) and the BBC has
produced and houses those records with the means to technologise
and practise them on behalf of UK citizens, then it is incumbent upon
the broadcaster to make its archive as accessible as possible. That does
not mean simply using its archive for the production of more content
to be archived further. Rather, it means that, as a national archivist,
the BBC's archives ought to be opened up to the licence-fee payer
to be used creatively and educationally. Media and the technologies
of memory, as van House and Churchill describe them above, form
the main communication methods of the last one hundred years for
creating and disseminating narratives of the past (see Ingrid Volkmer's
News in Public Memory, 2006). National archives use media as the
primary vehicle for communicating their contents from traditional
broadcast media to new media technologies. They function as reposi-
tories for what Maurice Halbwachs would call memory from the per-
spective of the group. Those groups, in the context of the BBC, can be
the community members of Aberfan, the production staff who worked
on the BBC Radio 4 *Open Country* series or the UK listenership.

How and what to mine from the rich coal seam of a nation's past
becomes central to a media producer who is every second, every
minute and every hour of every day recording and archiving personal,
local and national experiences and events. The BBC has recorded a
great deal of content with taxpayers' money since the 1920s. This
public service broadcaster of international standing is currently cus-
todian and holder of one of the most important archives for the UK,
not just sound and moving image archive material but hidden archives
of correspondence, production notes, research material, documents,
photography, artefacts, costumes, design materials and interview
scripts. Not only that, the BBC has a living archive of memories: of
employees in the broadcast studios and administration, of producers,
set designers, camera technicians, location scouts, extras and witnesses,
some of which the BBC owns, some of which is owned by licence-fee

payers, some of which is owned by a whole range of producers and artists who have worked together to produce content over the years.

Suffice it to say here, it is no surprise that the BBC is currently grappling with the problem of how to make its archive available to its UK audiences and how much of it, while taking into account the audiences it has worldwide who do not pay a UK licence fee. The current controller of archive development at the BBC is Tony Ageh, a self-described 'creative strategist' who in his twitter feed, on BBC blogs and at keynote speeches throughout the UK from 2008 to 2010 has asked and seeks to answer the questions I have summarised below:

- What is the future of the BBC's archive?
- What is the maximum value of the BBC's archive?
- How can the BBC reinvent the relationship with the licence-fee payer?
- What will the BBC allow users (including non-licence-fee payers considering the global reach of the Internet) to do with the archive?
- In the face of rising piracy how will the BBC protect its archival content?

At the time of writing Ageh is proposing the Digital Public Space as one answer, a second layer of Internet where BBC content could be freely available for non-commercial use. For students and researchers, public access to BBC TV output can be currently accessed at the British Film Institute (BFI) and the British Library Sound Archive provides access to BBC Radio. However, with the introduction of iPlayer (a project led by Tony Ageh) comes the opportunity to view and listen to hundreds of thousands of hours of programming such that in the future a million hours of footage could be made available daily (perhaps only, though, for seven days). Not only that, this footage could be supplemented by the BBC Written Archives and oral history interviews with current and retired staff, fans, researchers and members of the public. If this content were available, freely, to digitally literate citizens it would mean that members of the Aberfan community would not need to wait for mainstream media to record their memories, edit those memories with archival material and broadcast them twice in 2004 with the only copies available to those who wish to visit the British Library Sound Archive. Rather, they would be able to take the same archival content that Benjamin Chesterton discovered (and more), record their own memories in their own ways (creatively and digitally) and edit together their own programmes to be broadcast across different platforms (freely and accessibly). This could even

come in the form of a memorial tour, as a downloadable mobile app for visitors to Aberfan, or it could be a digital story from a survivor uploaded to YouTube. The opportunities for individuals and communities to voice their past in audio and audio/visual media are now tangible. In the UK, this has been due, in part, to the pioneering work of the BBC with their audiences.

Exercise

As noted in Chapters 2 and 4, media collect, store and archive memories (privately and publicly). Yet what if the records of your community's past were absent from the archives? What if those who controlled archives ignored you? How would you feel if only the memories of those who felt included in a nation were broadcast and magnified? Explore any media form – journalism, radio, film, television or the Internet, for example – and find examples of communities that are using media to represent themselves. They should be communities that you hitherto knew nothing about and would be unlikely to encounter through mainstream representations.

Further Reading

Biewen, John and Dilworth, Alexa (eds) (2010) *Reality Radio: Telling True Stories in Sound*. Chapel Hill, NC: University of North Carolina Press.

Crisell, Andrew ([1986] 1994) *Understanding Radio*, 2nd edn. London: Routledge.

Crook, Marie (2009) 'Radio Storytelling and Beyond', in John Hartley and Kelly McWilliam (eds) (2009) *Story Circle: Digital Storytelling Around the World*. Oxford: Blackwell, pp. 124–8.

Hilmes, Michele and Loviglio, Jason (eds) (2002) *Radio Reader: Essays in the Cultural History of Radio*. London: Routledge.

Kidd, Jenny (2009) 'Digital Storytelling and the Performance of Memory', in Joanne Garde-Hansen, Andrew Hoskins and Anna Reading (eds), *Save As . . . Digital Memories*. Basingstoke: Palgrave Macmillan, pp. 167–83.

Pease, Edward C. and Dennis, Everette E. (eds) (1995) *Radio: The Forgotten Medium*. Piscataway, NJ: Transaction.

Shingler, Martin and Wieringa, Cindy (1998) *On Air: Methods and Meanings of Radio*. London: Arnold.

Starkey, Guy (2004) *Radio in Context*. Basingstoke: Palgrave Macmillan.

6 (Re)Media Events: Remixing War on YouTube

One of the key ways in which mediated memory has transformed in the last decade is through the developments in digital and online media. Wulf Kansteiner (2002) has persuasively argued that when considering the production of personal, collective, cultural and social memory in the early twenty-first century we need to fully embrace the methods and tools of media studies and understand this production in terms of the increased media literacy of audiences:

> As a result, the history of collective memory would be recast as a complex process of cultural production and consumption that acknowledges the persistence of cultural traditions as well as the ingenuity of memory makers and the subversive interests of memory consumers. (Kansteiner 2002: 179)

At the time of writing this book a new horizon for understanding the relationship between media and memory beckons. The tools of communication and media studies have themselves broken free from the academic rules of objectified critical analysis. Media researchers are now participatory, creative, innovative and respectful of the media literacy of the former audience who are actively engaged in the consumption, production and dissemination of knowledge and information. These new media citizens not only challenge the hallowed arenas of media professionals but are also the ingenious and subversive memory-makers to whom Kansteiner refers. We can no longer speak of audiences and consumers but of active, critical and creative citizens of media, culture and society who have access to cheap and effective communication technologies even in the poorest circumstances (see, for example, Hopper (2007) on the rapid global uptake of the mobile phone).

Consider your own use of screen media to make memories. Like you, media literate citizens are self-reflexively producing and integrating their identities in and through the same practices. The explosion in First Wedding Dances on YouTube during 2009–10 is a good example

of this. On one level these videos are personal, autobiographical and emotional, but on another level they are collaborative, connective and creative. They are also re-presenting the hegemonic discourses of normality, heterosexuality and marriage, acknowledging the persistence of cultural traditions, to which Kansteiner refers above. Thus this chapter focuses on that tension between the personal desire to represent and consume memorable events as *we* see them using the media at *our* fingertips, and the criticism that the way we *see* those events is still shot through with powerful ideologies. Do we simply move old ideas in new ways? Does it matter more that we *own* those ideas rather than media producers? What new things are we doing today with the images, texts, sounds and footage of the past?

Here, I will be using the theories of Daniel Dayan and Elihu Katz (1992) in *Media Events: The Live Broadcasting of History*, Jay David Bolter and Richard Grusin (1999) in *Remediation: Understanding New Media* and Andrew Hoskins in *Televising War from Vietnam to Iraq* (2004a) to understand how past media events have been remembered and remediated in a digital age. Neither Dayan and Katz (1992) nor Andrew Hoskins (2004a) could have foreseen the impact of the post-broadcast era on the re-articulation of the televised Live Event when they were developing their theories of media's relationship to collective memory. Television and film archives now exist in sliced, spliced, sampled montages of edited footage (some faithfully, some creatively, some of dubious quality) on YouTube. The boundaries between television and film have become blurred as past 'media events' are remediated cinematically by amateur directors. Scholars, politicians, ideologues, students and surfers can access the Gulf War (1991), for example, in constantly buffering sound/vision memory bytes that are syntheses of CNN footage, Hollywood films with a variety of soundtracks.

Therefore, this chapter analyses the ways in which YouTube provides a platform for (re)mediated history through creative editing of archival media texts. Some of this (re)mediated history comes from broadcaster archivists themselves, while much is mycasted into an ironic, playful and performative critical reflection upon the past. Raiding the media archives, ignoring copyright infringement, some YouTubers have played fast and loose with media events in order to make their memorable point: that the mediation of history has been (and still is) a creative act in the hands of a powerful few. This speaks to the democratisation of media archives addressed in Chapter 4 and the exploitation of media institutions, forms and practices in Chapter 3. Media corporations are engaging in these two processes as much

as media literate individuals. Overall, it draws attention to the multi-directionality of memory as postulated by Michael Rothberg (2009), whereby we might frame the examples in this chapter as performing 'competitive memory' as one version of the past is seen to be arguing with another. I will not be making value judgements about different versions of mediated historical events (amateur or professional, factual or fictional) as more truthful, authentic, real or meaningful. Rather, as Rothberg strenuously argues:

> The greatest hope for a new comparatism lies in opening up the separate containers of memory and identity that buttress competitive thinking and becoming aware of the mutual constitution and ongoing transformation of the objects of comparison. (Rothberg 2009: 18)

What YouTube does is provide a platform for the production of separate but connected containers of events, memories and identities and offers viewers an ongoing transformation of collective memory as a mosaic of media. In the context of the mediatisation of war (Cottle 2002), it is now for the user (and former audience member) to determine the parameters of real wars, hidden wars and virtual wars.

However, we cannot ignore the social, cultural, political and corporate institutions that underwrite YouTube that allow users the right to participate and take those rights away if rules are infringed. On the one hand, the philosophy of the Internet is premised on ideologies of free information, open access, sharing, collaboration, creativity and inclusion (see Charles Leadbeater 2008 and Clay Shirky 2008). On the other hand, the Internet is one of the most regulated mediated spaces in the world (see James Boyle 2008), where copyright laws, digital rights management, inaccessible databases and pay-per-view confuse users and may entrap them in legal issues they never encountered with the old media. For those same users, keeping the past is no longer an expensive business. Digital media technologies provide cheap data storage and ease in terms of searching, retrieving and turning data back into new representations to be uploaded. Digital and mobile networks allow for unprecedented global accessibility and participation in the creation of (new) memories. Should fear of copyright infringement hold back the raiding of media archives for creative use? Should users who wish to critically represent media events in ways meaningful to them be disallowed to do so because the footage they have consumed does not, in fact, belong to them?

YouTube contains millions of videos of archival media footage (some of which infringes copyright) and is a rich repository of cultural

life. New deals with traditional broadcasters are constantly being signed so as to use the site to distribute archival content for nostalgic audiences (for example, the 2009 deal with Sony to make accessible movies and TV shows). YouTube belongs to a 'let it all out there' culture of free expression, everyday creativity and new media literacy. Yet it also needs to turn a profit and uphold national legal frameworks. Content is not stored and distributed by YouTube because it ideologically conforms to the logics of art, commerce, industry standards and exceptional quality identified by Lynn Spigel (2005) in Chapter 4 or demonstrates the public service values of participatory media. Rather, everything is there unless it is issued with a takedown notice for breaching the terms of the US Digital Millennium Copyright Act 1998. What is there, which has never been revealed before, is a growing and obvious desire to tell and share stories of ordinary people. As in the Interview Project of David Lynch (2009–10), YouTube has engendered a desire to document everyday life. Therefore, through a range of key examples of YouTube videos that centre on media events such as the Gulf War or on key figures of collective memory such as Adolf Hitler, I will show how alternative versions of history connect and disconnect with the concept of collective memory. At stake is the question of whether Kansteiner's prophetic statement about collective memory has become a reality:

> For the first time, narrative competency and historical consciousness will be acquired through fully interactive media, which will provide consumers of history products with an unprecedented degree of cultural agency. Historical culture will be radically rewritten and reinvented every time we turn on our computers. Once we pass this threshold, which I fully expect to happen before these lines are published, our collective memories will assume a new fictitious quality. (Kansteiner 2007: 132)

Essential to understanding this new fictitious quality to collective memories is to briefly consider two areas: firstly, the contextual theory surrounding the mediation or mediatisation of historical events (especially war events that are protracted rather than singular); and secondly, the specific theory concerned with a process of remediation whereby new media repurposes old media.

Mediating Events

It is perhaps common sense to say that a nation's success depends upon its promotion of a narrative that is socially constructed and invested

in by its citizens. But how are these narratives practised and remembered? Media and cultural archives, full of stories of battles won from war to football, are widely circulated and recycled in many societies. National broadcast media, in particular, across the world tend to tell self-aggrandising stories about a nation to that nation. When it comes to 'media events' that Dayan and Katz argue interrupt the normal, daily schedule then 'passive spectatorship gives way to ceremonial participation. The depth of this involvement, in turn, has relevance for the formation of public opinion and for institutions such as politics, religion, and leisure. In a further step, they enter the collective memory' (1992: 17).

We can see this in the UK in 1953 with the coronation of Queen Elizabeth II. The catalyst media event for the issuing of millions of television licences, the coronation had all the hallmarks of Dayan and Katz's concept. It monopolistically transformed daily life into something special by transmitting live an event hitherto outside media (1992: 5). It was beyond the grasp of ordinary people and remote from the majority in terms of class and culture. It also ensured that those present also remember it as their first encounter with the new technology of television: small wooden boxes hanging from village hall ceilings with tiny, barely viewable black and white screens. If you were wealthy, then you got to see the event in the comfort of your own home, with this new television placed, for the first time, in the corner of the sitting room. Television has, then, a special relationship with memory explored by Marita Sturken (2002), Myra Macdonald (2006), Andrew Hoskins (2004a, 2004b, 2005) and more recently Amy Holdsworth (2010).

However, as noted in Chapter 1, in writing the first draft of history television news media have been found guilty of crimes against history, even of technological fraud if we are to be influenced by critical commentary on the role of CNN in authenticating the Gulf War. The 'CNN effect' (Livingstone 1997) or 'CNN look' (Bolter and Grusin 1999: 189) has come to mean manufacturing events as immediate, transparent and filling up 'the screen with visible evidence of the power of television to gather events' (Bolter and Grusin 1999: 189). Audiences' understandings of and reactions to major events of historical importance have been shaped by 'sanitizing language and images that afford a less shocking view [. . .] and produce a more manageable past' (Hoskins 2004a: 1). It was the philosopher Jean Baudrillard who caused a storm of controversy when he claimed that because we only saw the targeted, smart, clean bombing through a media-military complex of highly sanitised television news it felt like *The Gulf War*

Did Not Take Place (1995). It was not real because of the 'professional and functional stupidity' of what he termed 'the CNN types': the 'would-be raiders of the lost image' who 'make us experience the emptiness of television as never before. [. . .] In this manner, everyone is amnestied by the ultra-rapid succession of phony events and phony discourses' (Baudrillard 1995: 51). Hiding the reality of war and ignoring the hidden wars that are going on all the time outside of media templates and frames is an inevitable consequence of the hypervisibility of crisis reporting in the twenty-first century post-11 September.

In his research for *Televising War from Vietnam to Iraq* (2004a) Andrew Hoskins concludes that as 'new and more immediate ways are found to document wars and other catastrophes, the media accumulate ever more images that contribute to a collapse of memory' (2004a: 135). Delivering mostly a 'memory of convenience' television is criticised by Hoskins for glossing over the past (2004a: 135). However, Susan Sontag (theorist of photography) has argued in *Regarding the Pain of Others* (2003) that if one is to be moved by an image then 'it is a question of the length of time one is obliged to look, to feel' (2003: 122). How long we look at the infamous image of the Falling Man from one of the Twin Towers taken on 11 September 2001 is also determined by the aesthetics and reproducibility of the image. Does, then, the medium of television not allow us to linger? Traditionally determined as constant flow by Raymond Williams (1975) or as segmented by John Fiske (1987), either way fixating the viewer on television images (however recordable) seems too fleeting for memory compared to the still photographic image. Are other forms of media better suited to ensuring that mediated events are remembered? What of Dayan and Katz's television audience engaged in ceremonial participation: do they not remember participating? What can be done with television news if it is to counter the criticism that it only offers highly stylised, manufactured content, ephemeral and trivialised in nature, of some of the most memorable events in human history?

War is perhaps the media event (or rather a series of protracted media events) that has monopolistically interrupted media broadcasting and consumption in the last half century. It has also become increasingly mediated and mediatised (see Cottle 2009). From the first television war of Vietnam and Cambodia (1955–75) to the latest events covered by embedded journalists in Iraq and Afghanistan, we find *collectivity* an overarching principal to mediating war. As Susan Sontag argues in *Regarding the Pain of Others* '[w]hat is called collective memory is not a remembering but a *stipulating*: that this is important, and this is the story about how it happened, with the picture that locks

the story in our minds' (2003: 86). However, there are multiple pos-
sibilities for mediating war. The notorious My Lai Massacre of 1968
where American soldiers murdered hundreds of Vietnamese civilians
is remembered visually though the infamous colour photograph taken
by Robert Haeberle, the US Army photographer. The photograph
from his personal camera (authorised black-and-white versions of
the offensive were taken on his US Army camera) had a momentous
impact when published by news organisations throughout the world
in December 1969. The image shows women and children shot, and
their mangled bodies piled up and strewn across a rural lane between
two fields: the most harrowing aspects being the naked dead babies.
Haeberle's photographs were subsequently used in criminal proceed-
ings as evidence that the events took place. Media acting as witness.

The collective memory of this living-room war, taking place on the
other side of the world, was being formed by 'official' media releases
to news and television from government and military sources. It pro-
duced the Vietnamese civilians as subhuman insurgents and soldiers
as heroes (not dissimilar narratives circulated around detainees at
Abu Ghraib prison and Guantánamo Bay from 2004 onwards). The
Haeberle photograph from a personal memory collection provided a
counter-memory to that narrative and mediated the realities of war. It
marked the difference between personally mediated and collectively
mediated memory. It is noteworthy that as the war progressed televi-
sion played a significant role in providing American audiences with
'graphic and daily pictures of the real and bloody consequences of war'
that was to shape 'military–media relations' to come (Hoskins 2004a:
13–14), not generally, though, as graphic as the My Lai image. The
collective memory of a successful campaign in Vietnam was possible
– at the beginning – through the structures of television: sanitised
images, editing, brevity and framing. However, this memory did not
last long (perhaps because such official footage passed by in the flow
of information). Television's lack of permanence meant that the social
memory of Vietnam has been since cemented more by images such as
Haeberle's and, argues Hoskins, by Nick Ut's *Vietnam Napalm* (1972)
as 'flashframes of memory' (2004a: 19). Even though these were not
the kinds of images shown on television news at the time (see the
Museum of Broadcast Communications, 'Vietnam on Television',
at http://www.museum.tv), they have overwritten televisual memory
(through films such as *The Deer Hunter* (1978) and *Coming Home*
(1978)). Television (which was in its infancy) has since been popularly
considered to blame for the loss of the war and the negative stere-
otyping of Vietnam veterans. Thus what is important to understand

in terms of mediating war events is what Andrew Hoksins termed the 'ethics of viewing'. How then can we 'substantially reconfigure the existing television record' (Hoskins 2004a: 10)? One option is through remediating events.

Remediating Events

In 2004, Andrew Hoskins was able to pitch television and photography in competition with each other, with the latter more powerful and resistive to forgetting. Drawing on Susan Sontag's work, he argued that 'photographic memory' of the Vietnam War offered the 'visual images that haunt the mediated memory of Vietnam today' (2004a: 18). In *The New Yorker*, Sontag wrote:

> [W]hen it comes to remembering, the photograph has the deeper bite. Memory freeze-frames; its basic unit is the single image. In an era of information overload, the photograph provides a quick way of apprehending something and a compact form for memorizing it. (2002)

The photograph of nine-year-old Kim Phuc burned by napalm taken by Nick Ut achieved this in 1972 and still does if searching Google Images is an indication of the speed and compactness of this memorable image as it moves through our online media ecology. Arguably, photojournalism has been afforded more gravitas (culturally and aesthetically) than television news. It seemed 'to carry greater cultural and historical weight than the moving image' (Hoskins 2004a: 19). It also now offers infinitely reproducible and taggable images for movement through networked media. By comparison, television did not allow people to look for as long as they wanted, they could not go back to the images, its content was not always worthy of archiving, and so the images were not seared into personal and collective memories.

One can though disagree with the general thesis that '[t]elevision survives through flow, whose transmission washes away the particularity of its messages along with the differences between them, and whose reception drains perception of its resistant holding powers of distance and memory' (Dienst 1994: 33). At least I can disagree now that I have YouTube, which is remediating Vietnam (as well as past and present wars) everyday. Here television does not survive through flow or through segmentation but through being a memory of itself. Using YouTube's archival power it ensures we can linger for longer on moving images of mediated events that audiences struggled to comprehend at the time. A good example of this is 9/11, which challenged

crisis reporting to its very core as journalists and news broadcasters struggled to transmit accurate information while audiences could see with their eyes the reality of the event before them. Footage (broadcast, professional, amateur and courtroom evidence) of this event is ripe for remediation, mashing up and remixing in order to tell and retell the event in different and conflicting ways.

Remediation according to Bolter and Grusin, writing a decade ago, has occurred throughout visual representation from medieval manuscripts to today's computer games. They argue that 'new media are doing exactly what their predecessors have done: presenting themselves as refashioned and improved versions of other media. [. . .] No medium today, and certainly no single media event, seems to do its cultural work in isolation from other social and economic forces' (1999: 14–15). The online ubiquity of the Nick Ut photograph of a napalm attack, its subsequent renderings and the visual updating of Kim Phuc in contemporary media as a Canadian citizen in her forties and peace activist show the interplay between past and present. Versions of mediated events in archives are repurposed, which is 'to take a "property" from one medium and reuse it another' (Bolter and Grusin 1999: 45). This remediation, or repurposing of the mediated past, occurs frequently online and has become the *raison d'être* of media corporations keen to engage audiences in new ways. It also forms the backbone of YouTube's serious content.

> With reuse comes a necessary redefinition, but there may be no conscious interplay between media. The interplay happens, if at all, only for the reader or viewer who happens to know both versions and can compare them. (Bolter and Grusin 1999: 45)

More and more online media provides this interplay. Forty years later *The Plain Dealer* newspaper of Cleveland, Ohio that broke the story of the My Lai Massacre, using Cleveland-born Robert Haeberle's photograph, remembers its own mediation of the image though digitising its archive. The reader/viewer can compare the original image, with a scanned front page from 1969, with more recent interviews with Haeberle. We have his personal memories of the event and of photographing the massacre, of destroying the photographs that showed fellow soldiers in the acts of killing, and reflections on himself as a guilty participant (Theiss 2009). We can, thus, linger even longer on a photographic image and understand the context of its production and consumption alongside what it traumatically represents over time. This is also the case with Nick Ut's *Vietnam Napalm* (1972) photograph, which is remediated by BBC News Online on 17 May

2010 to show Kim Phuc reunited with Christopher Wain, the ITN correspondent who helped save her life. The article covers Wain's personal memories of the event and provides the reader/viewer with an interplay between the original black-and-white photograph of Kim Phuc arms outstretched and screaming with a smiling image of her in the BBC studio holding Wain's hands.

Interestingly, this redefinition of one of the most memorable images of the Vietnam War is possible because of a repurposing of television news archives through YouTube. In his interview with the BBC, Wain reveals that:

> We were short of film and my cameraman, the late, great Alan Downes, was worried that I was asking him to waste precious film shooting horrific pictures which were too awful to use. My attitude was that we needed to show what it was like, and to their lasting credit, ITN ran the shots. (Lumb 2010)

This news broadcast is probably not memorable to anyone who viewed it in 1972 in comparison to the Pulitzer Prize winning photograph. Yet the interplay between Ut's image and the cameraman's footage now accessible online redefines the cultural memory of Vietnam. The photograph begins to have less bite when I position it next to archival broadcast footage from ITN Source of the same event uploaded to YouTube as *Vietnam Napalm* from 'The Collection, Vietnam Tape 2, TX 9.6.72: Kim Fuc [*sic*]' at http://www.itnsource.com. It is worth drawing attention to the differences between the two media representations of the same event.

There is a 'quality of authenticity ascribed to monochrome', says Paul Grainge (2002: 76) and Nick Ut's black-and-white image conveys a visual memory of nine-year old Kim Phuc, running in terror, skin burning but frozen in time. Like the Falling Man image from 11 September, Kim Phuc's vulnerability is suspended and the viewer can take time to imagine the horror before and after the image was taken. Numerous news discussion boards reiterate that this is an iconic image. Yet, on *YouTube*, I now have the facility to linger on archival television footage and understand the contextual information that falls outside the frame of Ut's image. I can examine closely the 1 minute 32 seconds of footage from Downes' camera (as I was not alive in 1972 I have no living memory to compete with this footage). I can play it again and again to reveal the context and development of the event. The footage is in colour, without journalistic narration, the only sounds being those of the environment: planes overhead, the bombing, children shouting in Vietnamese, a woman sobbing. Strangely, when I first viewed this I

thought it was staged. My cultural memory was so fixed by Nick Ut's monochrome memory that the colour television news footage seemed too modern to be real. As the camera zooms in on the explosion in the road, at 00:50 secs the camera cuts to Kim Phuc running alongside the rest of the children with army personnel following behind. Curiously, Kim Phuc does not look terrified, in shock perhaps but calm and receiving water and aid from personnel. It is at 1:15 secs that the cameraman captures the most haunting footage. Kim Phuc's grandmother carries her baby grandson dying in her arms, whose charred skin hangs from his body. The camera provides a close-up of the skin. Passing by, the camera follows and records her walking alone sobbing mournfully, struggling to carry the child toward the barricades and crowds of onlookers.

The interplay between the photograph and the ITN footage is even more possible as I am able to compare and contrast the two representations on my computer screen. I pause and play the news footage, mapping the photograph and news onto each other. 'What is new about new media comes from the particular ways in which they refashion older media and the ways in which older media refashion themselves to answer the challenges of new media' (Bolter and Grusin 1999: 15). Archival news footage backward-engineers our understanding of the past by using that footage from news broadcasters to re-educate and re-think iconised pasts. YouTube provides the platform for this process of re-education. While Nick Ut is a 'star witness' (Sontag 2002) as war photographer, repetition and re-enactment of the event through the repurposing of television provides the building blocks of memory:

> Indeed, television's reenactment is much closer to the fluid ways in which memory operates not as a stable force but as a constantly rewritten script. Renarratization is essential to memory; indeed, it is its defining quality. We remember events by retelling them, rethinking them. (Sturken 2002: 200)

How, then, is war remediated on YouTube today?

YouTube's Mashup War Memories

During the 2008 US Presidential Election campaign Republican nominee John McCain encapsulated the collective memory of a nation defined by the Vietnam War. A naval aviator, he was shot down in 1967 and captured by North Vietnamese forces, to be a prisoner of war until 1973. In 2007 he attended a Veteran's gathering in South

Carolina and to the tune of the Beach Boys' 'Barbara Ann' (1961) sang out to the audience 'Bomb bomb bomb, bomb, bomb Iran'. Video clips of this event can be found on news websites as well as YouTube. Unwittingly, McCain had created his own impromptu repurposing of a media text to make a political joke. A decade ago media commentators speaking on behalf of the audience would have critiqued and analysed McCain's performance in local/national coverage. In the age of YouTube, McCain's 'Bomb Iran' joke became a notorious mashup, taking McCain's joke and adding it to a performance of the Beach Boys song, with new lyrics. Repurposed by the audience, it sought to make a further political joke that critically reflected upon how collective memories circulate and coalesce. The YouTuber letsplaytwister uploaded a ' "Bomb Iran" song (from John McCain's joke)' on 20 April 2007 (two days after McCain's blunder hit the news). Providing a creative, full-length, satirical version of the song, the video shows a young male singing with guitar with a hastily prepared, paper US flag taped to the wall behind him (a new kind of YouTube news anchor):

> Oh bomb Iran, and Pakistan. Oh bomb Iran, and Pakistan. You got me hiding in my bunker, crying for my children. Bomb Iran. I went to Iraq and the Communist Block. Didn't like that so bomb Iran. (letsplaytwister 2007)

Such mashups are common on YouTube. The infamous fan-created mashup *Vader Sessions* (2007) by Steven Frailey of akjak.com mixes sound clips of the voice of James Earl Jones from his other films and edits these into scenes of Darth Vader from *Star Wars Episode IV: A New Hope* (1977). It produces a new reading of the plot as a racial and political discourse of Darth Vader having a nervous breakdown. Shaun Wilson (2009: 192) has argued that *Vader Sessions* may be 'a playful attempt at contributing yet another popular culture-themed mash-up on YouTube' on the surface but it also establishes a condition. It is not simply about adding one part to another to make a new whole; rather, argues Wilson, it forms 'a rupture of narrative by replacing part of a dialogue with another' while 'the weighted memory of an original image is repositioned through its facsimile' (Wilson 2009: 192). This repositioning of the memory of the original is important because we see the mediated past in a new light. While this example concerns popular culture, it represents the creative possibilities of simple DIY editing available for use on any media text from profound media witnessing to repurposing fictional films, a good example being from the film *Downfall* (Hirschbiegel, 2004) about Hitler's last days, through which the YouTube Hitler parodies caused a storm of controversy as

Constantin Films took action for their removal. YouTubers responded with more innovative ways to remix Hitler using scenes from the film. There are now so many versions of Hitler's rant from *Downfall* that it is impossible for a non-German speaker who has seen the parodies to watch the seriousness of the original scenes without ironically remembering the mashups. This does lead to an important problem with regard to the relationship between the original media representation of a historical event or person and the proliferation of new versions:

> With the need to remember diminished, a remixing culture might create a situation where much of our daily media content has ultimately been reshaped so many times that the history of a first and second past may completely vanish altogether leaving the over-versioned artefact weighted with incalculable layers of forgotten history. (Wilson 2009: 193)

It seems all media texts are created equal when viewed from the perspective of the remix video-maker playing with sound, image, text and graphics. Wilson (2009: 186) notes that collective memory is a version of the past and that YouTube houses artefacts that are also versions of the past, which are themselves then remixed or mashed up into something else to create more versions of the past. This 'edit desire', says Wilson, 'risks the possibility of "dumbing down" memory because there is very little need to engage memory when histories of all manners can be accessed with a few clicks' (Wilson 2009: 193). What then can we see going on in terms of collective memory through the remediation and the mashing up of powerful mediated memories? Why do DIY editors undertake these creative acts? Are the results important or unfaithful reproductions? How do the new versions speak back to or with their originals?

Television news texts of the past can be actively selected, downloaded, edited and mashed up to form a political revisionist critique of news media itself, as is the case with http://www.foxattacks.com and http://www.outfoxed.org that contain Fox news footage edited to criticise the political bias of news broadcasters. Similar projects can be found at http://www.bravenewfilms.com and in localised accounts of how the past is reported, for example in *Who Are you Angry At? A Katrina Ballad/CNN Mashup*. What is interesting in all these examples is that the video-makers are trying to oblige you to look longer at the segmented flow of television news texts and to engage more with the content.

A good example from YouTube is *CNN's hoax on America. REAL VIDEO PROOF!! NO BS!!!* by YodadogProductions uploaded 28

October 2008 with over 94,000 views to date. It seeks to challenge CNN's contribution to the collective memory of the Gulf War in 1991 by exposing the 'alleged' fabrication of a news broadcast from Charles Jaco, now a Fox 2 reporter. Essentially it is a DIY video that elucidates Jean Baudrillard's thesis that the Gulf War was both a virtual war and a technological fraud only ever authenticated by CNN. YodadogProductions adds subtitles to Charles Jaco's report from the 'frontline' to draw the viewer's attention to the studio-like setting, a seemingly fake Scud missile attack live on camera and cut-in outtakes of Jaco appearing to ridicule the public for believing the footage. The argument is clear that the public were duped and that even CNN operatives had to watch CNN to know what was going on. Regardless of its validity and amateur construction, the YouTube video accomplishes what Baudrillard tried to achieve in his criticism of the representation of the Gulf War at the time. It exposes the manufacturing of media events by re-manufacturing those media events. It makes viewers look more closely and deeply at the media text in ways that the original broadcast would not have allowed because of the flow of television.

Exercise

Explore the news archives at ITN Source (http://www.itnsource.com) for clips related to war. Consider how you might use such news clips in creative ways. How might you edit such footage alongside other media texts of the same events to produce a different version of that war? While you would not be able to upload copyright material to online video platforms, you could think about how you might use footage in the future on projects that seek to rethink past wars and their journalistic representation using the increasing archival material available online.

Further Reading

Bolter, Jay David and Grusin, Richard (1999) *Remediation: Understanding New Media*. Cambridge, MA: MIT Press.
Cottle, Simon (2009) 'New Wars and the Global War on Terror: On Vicarious, Visceral Violence', in *Global Crisis Reporting: Journalism in a Global Age*. Maidenhead: Open University Press, pp. 109–26.
Dayan, Daniel and Katz, Elihu (1992) *Media Events: The Live Broadcasting of History*. Cambridge, MA: Harvard University Press.
Hoskins, Andrew (2004) *Televising War: From Vietnam to Iraq*. London: Continuum.

Rothberg, Michael (2009) *Multidirectional Memory: Remembering the Holocaust in the Age of Decolonization*. Palo Alto, CA: Stanford University Press.

Snickars, Pelle and Vonderau, Patrick (eds) (2009) *The YouTube Reader*. London: Wallflower Press.

Sontag, Susan (2003) *Regarding the Pain of Others*. New York: Farrar, Strauss & Giroux.

Sturken, Marita (1997) *Tangled Memories: The Vietnam War, the AIDS Epidemic, and the Politics of Remembering*. Berkeley: University of California Press.

Wilson, Shaun (2009) 'Remixing Memory in Digital Media', in Joanne Garde-Hansen, Andrew Hoskins and Anna Reading (eds), *Save As . . . Digital Memories*. Basingstoke: Palgrave Macmillan, pp. 184–97.

7 The Madonna Archive: Celebrity, Ageing and Fan Nostalgia

The previous case study chapters have drawn upon particular examples of memory being articulated through the broadcast media of radio and television as well as post-broadcast media platforms such as YouTube. The emphasis has been on the mediation (van Dijck 2007) and mediatisation (Livingstone 2008) of history and memory in terms of local, national and international events or persons. As each chapter has progressed, so too has the consideration of the level and extent of audience involvement in the construction of making mediated memories. It would be very easy for any book on media and memory to get stuck in the field of 'representation' only by examining how specific events in cultural and political history are mediated and remediated. Chapter 5 covered production cultures but it would be remiss not to consider fans and their memories. In fact, Wulf Kansteiner (2002) argued in his critique of the methodologies of memory studies that the danger of a memory research boom is that 'audiences' would be ignored in favour of textual/object/subject analyses and observational approaches to memory discourses, forms and practices. As a response, this chapter considers popular music fans and on one figure in particular: Madonna.

I am old enough to remember the release of Madonna's 'Like a Virgin' (1984). As a young, Catholic, female teenager I found the track provocative and when it was played on the radio I would get embarrassed by the lyrics. Yet when I saw Madonna perform on the BBC television music show *Top of the Pops* (1964–2006) in 1984 with pink wig and black and gold jacket, I was impressed by Madonna's style and confidence. This ambivalence has carried on throughout my partial commitment to Madonna's career over the last twenty-five years. In 2010, I discovered young British students recycling the fashions from that track and peers my own age engaging in fashion nostalgia. When I view the 3½-minute video on Madonna's official YouTube channel today or watch the archival footage from the BBC's website, I can recall the mixed feelings I had at the time. I watch it now with

a more academic eye for understanding Madonna's playfulness with sexuality and her performance of femininity as a cultural construction. However, I still feel nostalgic about this track and the music video and I still have powerful memories of it influencing my ideas of what becoming a woman might and could be about.

It is noteworthy that YouTube provides space for 640 comments about 'Like a Virgin'. Many of these express love for the song and for Madonna as *the* Queen of Pop, some exclaim Madonna a 'whore' and others, obviously from fans, provide detailed commentary on the track's production. One in particular is striking in terms of evoking and connecting with my own nostalgia:

coursestudent 1 week ago
She will always be THIS Madonna for me. This is when I, and most of the world, first really took notice of her. I was a ten-year-old boy in Catholic school just beginning to get a sense of the wonder of 'woman', and she represented all women for me.

MTV asked her what the people of Venice thought of her while she was filming this video. She said with a laugh, 'What do you think they thought? "PUTA!" I mean, come on, a girl dancing in her underwear?' Funny that some words are universal. (http://www. youtube.com/watch?v=s__rX_WL100, posted 13 August 2010)

Another poster retrospectively analyses the archived video and draws attention to the production cultures:

scottp118, 5 days ago
Wow . . . been playing the drums for over 25 years, and used to hear this song all the time in my mid-teens . . . and only NOW am I noticing how absolutely fabulous the drumming is on this (Tony Thompson, I believe.) Put some decent headphones on and feel where he puts the kick drum. Great room sound in his hi-hats at 2:55. He and the bassist create a great vibe. Kudos to Madonna for picking such talent. (http://www.youtube.com/watch?v=s__rX_ WL100, posted 14 August 2010)

What is to be made of online fan interactions that take remnants of archived popular music tracks and undertake personal memory work on them? How important are these comments for academic scholarship? How does the Madonna business involve fans in the production of memories and archives?

The relationship between popular memory and popular music has had little attention. Tara Brabazon in *From Revolution to Revelation: Generation X, Popular Memory, and Cultural Studies* attempts to

remember the 'intense relationship between popular culture, politics, place and time' (2005: 2) that characterised Cultural Studies from the 1970s onwards. She notes that:

> Popular culture is different, being seldom marked as significant or important. The memory of shoulder pads and lip-gloss, Raybans, fingerless gloves and Wham, grasps an ordinariness and banality that is rarely useful for museum curators or historians. This is the role of Popular Memory Studies – to translate and transform past popular culture into relevant sources in the present. (Brabazon 2005: 70)

Popular culture cannot, of course, escape the critique that it is suffused with commodity culture and as such when popular cultural memory is evoked it is often nostalgic. Nostalgia, writes Michael Bull, 'is frequently treated as a structural and contemporary disease of the present, as a set of ersatz experiences promoted by the culture industry's intent of stealing not just the present, but also the past from consumers' (2009: 91). Therefore, is the Madonna Picture Project (2010) from the official Madonna website, in which thousands of images of fans' cassette/CD/laserdisc/DVD collections, souvenirs, promotional items, photographs, stickers, concert tickets and vintage items are displayed on Flickr, stealing the past from consumers? Or is this the industry acting as popular culture curator for the benefit of future researchers of pop music at the turn of the century? Is this the establishment of popular music icons as heritage industries while they are still alive?

In their excellent collection *Sound Souvenirs: Audio Technologies, Memory and Cultural Practices* (2009) Karin Bijsterveld and José van Dijck position nostalgia as important to sound and memory, which are

> inextricably intertwined with each other, not just through the repetition of familiar tunes and commercially exploited nostalgia on oldies radio stations, but through the exchange of valued songs by means of pristine recordings and recording apparatuses, as well as through cultural practices such as collecting, archiving, and listing. (2009: 11–12)

Therefore long-standing artists like Madonna, who have been celebrated for reinvention and innovation, have been left unanalysed for how they are able to continually rearticulate their pop music archive through fan memory. Is it that academic research cannot keep abreast of the new technologies that are being used to deal with curatorial overload as fans digitise their collections for the world to see? If, as Brabazon argues, 'popular memory is an itinerant (and playful)

amalgam of media' and that the 'passage of time is volatile, fragile and passionately heated, not objective, predictable and linear' (2005: 70), then it is no wonder that academics stay clear of fan reminiscences of Madonna in public online domains. This chapter makes the case that exploring online fan memories of Madonna provides valuable research data on the bridges that people build between their own lives, their identities, the collectives of shared histories and the culture of popular consumption.

Firstly, it is important to note some key theory on consumption, popular music and fandom. One can say, with some assuredness, that Madonna was made and remade in an old-media economy: a pop music culture industry where the record label, artist and production culture reigned supreme and the fan was treated simply as the consumer. Clearly, the Madonna Picture Project of more than 2,000 photos of Madonnaphernalia on Flickr is visible evidence of those consumable items purchased and owned by fans with the categories of Tour Tickets, Magazine Covers, CD Singles and Posters containing the most images (http://www.flickr.com/photos/madonnaphotos/sets/). In defining such a culture industry, David Gauntlett draws upon the theorisations from the Frankfurt School (Institute of Social Research) and the work of Theodor Adorno in particular:

> The teen 'rebels' who are fans of [Gangsta Rap for example], Adorno would suggest, are just consumers: buying a CD is not rebellion, it's buying a CD. The tough guy who has just bought the latest angry rap CD, takes it home and plays it loud, may be thinking, 'Yeah! Fuck you, consumer society!' but as far as Adorno is concerned, he might as well say, 'Thank you, consumer society, for giving me a new product to buy. This is a good product. I would like to make further purchases of similar products in the near future.' (2002: 21)

Here audiences are categorised, passively marketed to and socially controlled. However, students of media studies know from the seminal work of John Fiske in *Understanding Popular Culture* (1989a) and *Reading the Popular* (1989b) that while audiences are consuming they are at the same time creating personal meanings (and memories) that may be collectively articulated but are unique to them.

The focus upon fan collectivity through the celebratory work on fans by Henry Jenkins (1992, 2006a) and Matt Hills (2002) and the less celebratory work from Andy Ruddock (2001) suggests that there is room for notions of collective and personal memory in audience research of fan behaviour. In a recent blog posting, Henry Jenkins, the foremost theorist of fan cultures and participatory digital media,

declared that Fiske inspired his own research. He 'struggled to get us to look closer at the lives of ordinary people and the ways in which they struggled to assert aspects of their own needs and desires through their relationship with mass produced culture' (Jenkins 2010).

Fiske, who came out of retirement as an antiques dealer in Vermont, gave one last lecture to a reunion of his students at the Fiske Matters Conference 2010 at the University of Wisconsin-Madison. He declared that 'antiques were physical reminders that people had thought and lived differently in the past and that they had often done so in ways which were meaningful and satisfying [. . .] there were always alternatives to the current configuration of culture and power' (Jenkins 2010). With Fiske's ideas in mind, I want to argue that it is important to understand how Madonna's fans construct her archive through three key modes: memory, ageing and nostalgia. It is through these modes that Madonna's fans and audiences produce physical and virtual reminders of how *they* have lived in popular culture in meaningful ways. At times these reminders may even challenge the configuration of culture and power that Madonna herself has produced.

Much academic attention on Madonna has analysed her output in terms of feminism, queer theory, multiculturalism and postmodernism with the work of Cathy Schwichtenberg (1993) and Faith and Wasserlein (1997) providing foundational examples. In the latter case, Wasserlein found that fans only collected and archived Madonna material that comprised vast discographies and their variant releases and ignored the production cultures of the Madonna business (1997: 186–7). 'In this case', says Matt Hills in *Fan Cultures*, 'fan categorizations of relevance/irrelevance reproduce the information flow which characterizes the commodification of Madonna-as-pop-icon' and thus 'online fan practices such as just-in-time fandom [. . .] are complicit with the commodity-text' (Hills 2002: 141). There is, then, an intimate and intense relationship between Madonna and her fans' emotional investment in her, which has existed for decades. Yet, in the eight years of digital fan culture since Hills' groundbreaking work we can, in fact, locate detailed memory and archival work where fans do not ignore the production cultures at all, as the YouTube posting cited at the beginning of this chapter shows. We can also locate digital curatorial work by the Madonna business itself as proven by the archiving of fan cultures in the Madonna Picture Project.

Madonna, wrote Fouz-Hernandez and Jarman-Ivens in 2004, 'has maintained a strong presence in the pop and dance charts in recent years' (2004: xvi). Six years later, Madonna continues to reinvent herself but has not, as Fouz-Hernandez and Jarman-Ivens

claim, avoided 'self-indulgent nostalgia' (2004: xvi). From the 2004 *Reinvention Tour* onwards, Madonna's success has been defined by some very clear strategies that help us understand the relationship between media and memory as a female pop music celebrity ages. Remix videos, musical references to her back-catalogue, recycling of 1980s fashion and culture, re-performance and transformation of old hits, use of archival media in her music videos, recurrence of musical ideas and political themes, playing with American and British heritage both in her work and private life, and maintaining a youthful self – all of these evoke media and memory, and fans can tour much of her archive with the increased availability of music videos and fan sites online. What is crucial to note is the investment of emotions and memories that fans and non-fans make to the Madonna business. In *Textual Poachers: Television Fans and Participatory Culture* (1992) Henry Jenkins sees this in terms of love and recounts the fable of 'The Velveteen Rabbit' to describe the tension between Adorno's account of how culture is commodified and the fan who makes culture meaningful through loving memories:

> Seen from the perspective of the toymaker, who has an interest in preserving the stuffed animal as it was made, the Velveteen Rabbit's loose joints and missing eyes represent vandalism [. . .] yet for the boy, they are the traces of fondly remembered experiences, evidence of his having held the toy too close and pet it too often, in short, marks of its loving use. (Jenkins 1992: 51)

Archival ventures by the Madonna business such as the Madonna Picture Project signal recognition of the grass-roots devotion of ordinary people and their desire to participate in curating popular culture. Thus, in the following sections I want to interrogate how fans produce celebrity memory and construct how Madonna will have been remembered.

Mode 1: Celebrity and Memory

Google Trends archives Internet content, and Madonna's frequency is generally steady except when key moments in her career produce intense spikes of activity, as in late 2005 with her release of *Confessions on a Dancefloor* and *Rolling Stone* magazine examined 'How She Got Her Groove Back' (1 December 2005) after the poor reception of 'American Life' (2003). From mid-2008 onwards Google Trends highlights six key mediated moments of her life from the news of affairs, to divorce and to the adoptions from Malawi. What is interesting is that

Trends notes the emergence of the terms 'queen of pop' as an intense spike in early 2006 just after Madonna's *Reinvention Tour* and more recently during 2009 to signal Madonna's continued retention of this title in spite of increased competition from a new generation of female artists.

In the context of a rapidly changing mediascape where audiences are being carved up into niches and the long tail of choice provides tailor-made entertainment, it is comforting to identify with a collective. Fan communities that centre on celebrities who are, as Carolyn Calloway-Thomas defines them, 'centred existences' (2010: 130), ensure that the celebrity is anchored in time by a collective vision of the past. The ability to remember Madonna's early days as a breakthrough act legitimates not only the fan's status as a fan but their identity as a follower over a long period of time. From the writings of John Locke in the seventeenth century to the present day, the ability to remember one's past has been crucial to understanding one's self: 'I am what I remember' (Misztal 2003: 133). Thus many fan sites and discussion boards on the web centre around legitimising Madonna as important to remember and celebrate. YouTube is rife with arguments between posters about which track is the best, how Madonna compares to Lady GaGa, Beyoncé or Britney Spears, which image of Madonna represents her iconicity and what parts of her work (music, films, books) should be remembered. Fan media memorialises Madonna as she ages and ensures that her early work is remembered even while she reinvents herself as a fifty-something pop act.

Madonna's Official YouTube Channel (Warner Bros label, 1982–2009) provides the platform for the pop star to archive some of her most memorable music videos, stage performances and interviews. Created 31 October 2005, the channel has had, at the time of writing, over six million views with a total of over 56 million upload views. It hosts 47 video uploads with the top five most viewed videos as 'Celebration' (11+ million views), 'Message to YouTube' (6 million views), 'Give it 2 Me' (5+ million views), 'Get Stupid' (1+ million views) and 'Vogue' (1+ million views). The latest album *Celebration*, released in 2009, is Madonna's third greatest hits album and is the last release under the Warner Bros label. It has revealed her legacy and her immense back-catalogue but it also stands as an archive of media texts that are memorable to fans. Before analysing the reception of the album *Celebration* in more depth in the rest of this chapter it is important to note how the mode of celebrity and memory has emerged in recent scholarship.

The journal *Celebrity Studies* (2010) was coincidently making its mark

on media and cultural studies when the death of Michael Jackson was announced. Volume 1, Issue 2, devoted its Celebrity Forum to eight articles covering the relationship between celebrity, memory, mourning, media events, iconicity, nostalgia and forgetting by focusing on Jackson as the King of Pop. Contrasting the death of Princess Diana (1997) with that of Jackson (2009), Garde-Hansen explores celebrity in terms of global memory. On the day of Jackson's sudden death, the surge in searches for the name 'Michael Jackson' caused Google to crash and the Internet search engine, that controls 75 per cent of searchable content on the web, was able to measure its Michael Jackson search activity as an overwhelming spike on a graph. In a detailed analysis of fans and non-fans' discussion postings online, Garde-Hansen shows that the memorialisation of the celebrity in and through online media has changed. 'In the social media haze of not-yet-broadcast-news possibilities the thousands of postings by members of the public [. . .] are creative, critical, argumentative and in a number of cases run entirely counter to a shared emotional response to the news of a celebrity death we are used to' (Garde-Hansen 2010: 233). Global emotion became measurable with digital media as a celebrity and his archive were remembered and mourned in (dis)connected ways.

Madonna is not dead at all, far from it, and yet the archiving, commemoration and remembering of her has already begun. Of the album *Celebration* Joey Guerra from *Houston Chronicle* claims that 'every song on *Celebration* defines a moment in time, a radio sing-along, a twirl under the glitterball. It's a pulsing testament to Madonna's often-overlooked pop prowess. [. . .] *Celebration* also marks the end of an era: it's Madonna's final release for Warner Bros, her label since 1982' (Guerra 2009). In fact, as Anna Kaloski Naylor argues in 'Michael Jackson's Post-Self' (2010), celebrities of such stardom produce a post-self while still alive, determining how they will be remembered in and through media once they are gone. While Jackson attempted to secure a luminous and eternal post-self via his videos (*Thriller*, 1982 and *Remember the Time*, 1992) and hiding behind masks in public (Kaloski Naylor 2010: 251), Madonna achieves this through her own and her fans' creative use of her archive.

A good example of this process of the co-creation of a Madonna archive by the star and her fans is through impersonation, copying or performing like Madonna. On fan impersonation of Elvis Presley, Matt Hills has noted:

[It] is a project; it represents recourse to an archive (the precisely catalogued set of jumpsuits and outfits worn on-stage by Elvis;

images of Elvis; set-lists and conventionalised details of his stage show), and recourse to a powerful set of memories; those of the fan's lived experience *as a fan*. (Hills 2002: 128)

Likewise, Lincoln Geraghty writes of television and fandom in *Living with Star Trek: American Culture and the Star Trek Universe* (2007) that '[m]emory too has been an important function in the fans' interaction with the *Star Trek* text: they write about moments when the series helped them overcome difficulties in the past or they remember the exact time that they first saw *Star Trek*' (2007: 171). This is Alison Landsberg's concept of prosthetic memory (as noted in Chapter 1) where we see 'the production and dissemination of memories that have no direct connection to a person's lived past and yet are essential to the production and articulation of subjectivity' (2004: 20).

Thus, impersonating Madonna, Madonna tribute acts, professional Madonna lookalikes, dressing up in Madonna-style clothing from key moments in her career (the *Blond Ambition* Gautier corset is one of the most iconic at costume parties) and identifying with Madonna are all pleasurable experiences that bind the fan (male or female) to the pop star emotionally, physically and memorably. These are 'sensuous memories produced by an experience of mass-mediated representations' (Landsberg 2004: 20). What is important to recognise in the context of Adorno's argument cited at the beginning of this chapter and when thinking about memory in purely collective terms is that these connections between celebrity and memory *feel real*. That 'commodification, which is at the heart of mass cultural representations, makes images and narratives widely available to people who live in different places and come from different backgrounds, races, and classes' is emotionally and politically important (Landsberg 2004: 21). Although culturally constructed and mediated by Madonna and the media representation of her, such 'prosthetic memories', Landsberg would argue, 'produce empathy' and a 'sensuous engagement with the past' (2004: 21). There is evidence of them online: discussion boards on retro music forums, general pop music fan websites, Madonna fan sites such as madonnalicious.com and madonnatribe.com, social networking profiles and groups on Facebook and MySpace, and, of course, personal blogs of music fans, a typical example being:

> I have been a Madonna Fan forever. When 'Like A Virgin' came out, is when I became a loyal fan. I have all her albums and movies. She is a Leo. We have the same Rising Sign, Virgo. We are picky, critical, worry about health, and hard-working. And we look younger than we are. She does not look 52. She looks 35.

Hail to the Queen! (24 August 2010, 12:55 p.m., http://prince.org/
msg/8/342161?jump=15&pg=1)

The emotional and memorable connections made between the fan and
Madonna are important not only for the fan's subjectivity but for the
celebrity's construction of a long-lasting identity. This means that the
celebrity is constantly contributing to a post-self image that the fan
is interacting with. If star value can be measured by what is defined
in sociology as 'symbolic immortality' (see Vigilant and Williamson's
(2003) treatment of Robert J. Lifton's foundational concept), then
Madonna and her fans are continuously producing her after-death
value through fan/celebrity memory work in the present, just as
occurred with Michael Jackson and Elvis Presley, in the following key
ways:

- Madonna's quest to remain youthful and ageless ('has [she] made
 the transition from diva to deity?' asks Simon Doonan in *Elle*
 (2008));
- through motherhood and charity work (her biological and
 adoptive children);
- through creativity (music, films, publishing);
- through spirituality and religious imagery (Kabbalah);
- through transcendence (her apparent mastery of ageing, of the
 music industry, of sexuality and of younger men).

Let's take the latter point, transcendence, and locate this within her
archive. It is captured most obviously in her post-2005 videos in which
Madonna emphasises her sexy, sexually active and youthful body
through tight leotards, hot pants and thigh high boots. For example,
in the video for the track 'Celebration', the camera is placed on the
floor and the artist gyrates above the viewer. Madonna is presented as
a powerful woman whose body and 1980s aerobic performance recycle
her past disco-inspired videos to create both new youth markets and
fan nostalgia. In *W* magazine (March 2009) she is photographed as a
predatory cougar whose object of desire is 23-year-old Jesus Luz and
in both examples she is seen to be in control of time (and men). How
then does Madonna's seeming transcendence of ageing connect with
how fans remember her?

Mode 2: Ageing

In 'Madonna's Daughters: Girl Power and the Empowered Girl-Pop
Breakthrough', David Gauntlett writes that female artists from Britney

Spears to Pink are 'obvious illustrations of the debt that today's female stars owe to Madonna' (2004: 161). Having grown up listening to her they remediate and recycle her performances, style, fashion, musical themes, videos, imagery and archive. The title of Gauntlett's paper associates Madonna with motherhood, heritage and legacy, passing down knowledge and opening doors for younger female artists to make a mark. A good example of this can be found in Britney Spears' 2003 song and video featuring Madonna 'Me Against the Music', in which Madonna as mentor appears and disappears, haunting the younger Britney's performance. Therefore Madonna's ageing is a critical path for understanding how audiences have engaged with her archive. On the one hand, MadTV's parody of Spears' track called 'Me Against Madonna' featured a caricature of the older mentor more as a stalking vampire sucking the youth out of the younger female artist. On the other hand, the *Daily Express* (UK) (16 August 2010) writes 'Birthday Girl Madonna Turns Back the Clock by Looking Half her Age' at her fifty-second birthday party at Shoreditch House, London. The newspaper article recycles references to her musical archive:

Who's That Girl? Stunning Madonna looks great for 52: Madonna proves that age is immaterial as she dazzles at an early celebration to mark her 52nd birthday party. The original Material Girl looked incredibly youthful in a slinky silver dress that showed off a figure a woman half her age would be proud of. [. . .] The Queen of Pop accessorised her look with a trademark crucifix around her neck.

'Queen of Pop' signals a positive discourse of regality and ageing femininity that has been common in celebrity culture for some time. For example, Helen Mirren and Judi Dench have both been 'classed' and cast as 'regal' or British high society. Madonna has described herself as a 'queen' in documentaries, there is the fan website http://www. queenmadonna.com, and numerous YouTube mashups are entitled Madonna: Queen of Pop, Disco, the Century or Reinvention. The attachment of this superior status to her image is important because her endurance depends upon personal and collective memories of her cultural value. In terms of the construction of a symbolic immortality, Madonna has further cemented the regal status during 2010 through her directorial work on the film *W.E.* about the abdication of King Edward VIII in 1936. Like Queen Elizabeth II, if she is to sustain her popularity then nostalgia, heritage, retro-style and raiding the archives will be necessary.

In much of her publicity shots, music videos, photoshoots for Dolce & Gabbana and magazine shoots for *W* magazine, Madonna's

bodywork to remain youthful is on display and constantly critiqued. Her raiding of her own fashion and music archive remind nostalgic audiences who have grown up listening to her of their own youthful bodies and experiences in the 1980s. This is possible through careful lighting, camerawork, hair, make-up and fashion that all remediate (see Bolter and Grusin 1999) past styles (her own as well as those of others). Madonna is careful to create and perform memories of herself and her past images on her own ageing body and face. This accords with recent theoretical work by Grayson Cooke in 'The Cosmeceutical Face: Time-Fighting Technologies and the Archive' (2009) in which he argues that the 'constitution of the face as an archive occurs in the context of the beauty industry and social expectations about gender, youth and beauty'. We want the skin, face and body of Madonna to fight time, to forget to age, to be preserved in a past image and offer us memories of our own younger faces and bodies. Interestingly, Cooke's thoughts on Botox (a common procedure in celebrity culture) that is used to preserve the face into the future by freezing facial muscles are important here in the context of Madonna's apparently ageless face:

> The future of the face under Botox, then, which is also the future of the facial archive, is one in which the archive will not function; by freezing the facial muscles and reducing the face's ability to express/im-press, the archive of the past is wiped clean at the same time as the future of the archive is emptied out as well [. . .]. This is Botox as a kind of active forgetting, of real-time recording and erasure. (Cooke 2009)

Therefore, if Madonna ages, we age, and thus we are reminded of our own mortality or, as Jan Moir rather sardonically put it in *The Telegraph* (UK) in 2008: 'Madonna will be 50 this year, setting a terrifying new physical benchmark for women. [. . .] She has become the poster girl for the kind of superior, celestial anti-ageing that only the very best clinics can provide' (Moir 2008). A good example of the fear of ageing and the memories of youthful popular culture being revealed and archived online is through the infamous unairbrushed images of Madonna on the ATRL website during early 2009. As Viktor Mayer-Schönberger has warned in *Delete: The Virtue of Forgetting in the Digital Age* (2009), the 'comprehensive digital memory' of 'perfect recall of past deeds' now accessible, stored and retrievable by 'information processors like Google' finds that 'individuals are exposed to a strangely unforgiving public' (2009: 197). The fan and non-fan reactions to images of an ageing Madonna were cruel to the point she

was described as Oldonna and Vadgesaurus across many fan sites and discussion boards. Such digital remembering that Mayer-Schönberger characterises as undermining the important role of forgetting can have a counter-productive effect for the Madonna business. Fans want to remember the Madonna of an old-media economy: young, sexually powerful and commercial.

> That is some nasty ass shit. ☺ Seriously, Im [*sic*] a huge fan but Madonna has lost some of what made her such a superstar. She clearly thinks its [*sic*] still cool for her to do crotch shots and nude shots but seriously, who the fuck wants to see this?? 😬 I hope she starts acting her age and focuses on making another good album. (Post No. 15, 18 January 2009, 'Madonna Tour Book Unairbrushed outtakes ahhhhhhhhhh!', http://atrl.net/)

Here, then, fans demand that their celebrity represent a youthful text from which they can derive pleasure and not be reminded of the realities of ageing and mortality.

Mode 3: Fan Nostalgia

In *Convergence Culture: Where Old and New Media Collide* (2006b), Henry Jenkins explores emotion and memory from the perspective of commodity culture. He draws on the concept of 'lovemarks' and emotional capital through the example of Coca-Cola's marketing campaign during 2003, which sought a new approach to connect with audiences (2006b: 68). Emotional impact, experiential marketing and an intensification of feelings enable 'entertainment content – and brand messages – to break through the "clutter" and become memorable to consumers' (2006b: 69). Jenkins references the president of Coca-Cola and the CEO Worldwide of Saatchi & Saatchi, who both make the same point about emotional capital: that 'marketers' need 'to develop multisensory (and multimedia) experiences that create more vivid impressions and to tap the power of stories to shape consumer identifications' (2006b: 70). Brands like Coca-Cola have clearly learned something from the celebrity/fan dyad. Pop stars like Madonna are brands that create and promote 'core emotional relationships' with fans, investment in celebrity heritage and deep engagement with the products, all of which engage personal and collective memory (Jenkins 2006b: 71).

'Nostalgia', writes Svetlana Boym, '(from *nostos* – return home, and *algia* – longing) is a longing for a home that no longer exists or has never existed. Nostalgia is a sentiment of loss and displacement, but

it is also a romance with one's own fantasy' (Boym 2001: xiii). Coca-Cola knows this, hence they have produced a heritage project and use nostalgia to tell Coca-Cola Stories (http://www.thecoca-colacompany.com/heritage/stories/). Here childhood memories, reminders of family, the memory of home, times with friends and romance stories are retold by the company to show how the product has affected people's lives. Boym has argued in *The Future of Nostalgia* (2001) that nostalgia 'is a feature of global culture' and the 'sheer overabundance of nostalgic artifacts marketed by the entertainment industry, most of them sweet ready-mades, reflects a fear of untamable longing and noncommodified time' (2001: xvii). So how do fans long for and yearn for Madonna and how does the Madonna industry satiate their desires for sweet ready-mades?

Good examples can be located in the current retro-1980s fashion and recycling of 1980s media at the end of the first decade of the twenty-first century. This has certainly added value to Madonna's career post-fifty, as teenagers (including her own teenage daughter Lourdes) and young adults adapt the fashions that Madonna herself brought to the stage with tracks such as 'Like a Virgin' (1984) and the film *Desperately Seeking Susan* (1985). Here we see fan nostalgia articulated as style. Paul Grainge in *Monochrome Memories: Nostalgia and Style in Retro America* (2002) draws attention to 'a growing media culture feeding on its own creations, and the broad commodification of memory within film, fashion, architectural design and the heritage industry' contribute to a culture of nostalgia from the 1970s onwards (Grainge 2002: 20). Drawing upon Paul Grainge's (2002) work on nostalgia as a consumable mode or a collective mood, it is possible to view Madonna as a 'heritage industry' who, now in her fifties, is offering a mediated space for collective and personal nostalgia, communal reminiscence, fan articulation of personal memory and ageing, and public debate over what should be the consumable contents of her pop music archive.

Madonna's third greatest hits album *Celebration*'s (2009) cover is indicative of this idea of the celebrity as a heritage industry, whose identity, history and life is explored by media literate tourists while the celebrity is still alive. Madonna and her fans are producing heritage products. A visual remix or mashup by street artist Mr Brainwash, *Celebration* remediates Madonna and Warhol's Marilyn Monroe in the street style of 1980s media. It anchors the audience in the past and restores Madonna in the present as Pickering and Keightley define nostalgia as 'not only a search for ontological security in the past, but also as a means of taking one's bearings for the

road ahead in the uncertainty of the present' (2006: 921). Thus the music videos for the *Hard Candy* album track 'Give It to Me' (2008) and the more recent track 'Celebration' (2009) both narratively and visually signal Madonna as capitalising upon her own archival power. She has produced an extensive back-catalogue and is a woman continually reinventing herself as sexually active. Thus pop music and nostalgia create a powerful marketable mix that evoke youthfulness, as Boym argues:

> At first glance, nostalgia is a longing for a place, but actually it is a yearning for a different time – the time of our childhood, the slower rhythms of our dreams. In a broader sense, nostalgia is rebellion against the modern idea of time, the time of history and progress. The nostalgic desires to obliterate history and turn it into private or collective mythology, to revisit time like space, refusing to surrender to the irreversibility of time that plagues the human condition. (Boym 2001: xv)

At the time of writing, in one time and one space, YouTube users can revisit the music videos of Madonna so that technology offers solutions and builds bridges, saving the time that the nostalgic love wastes (Boym 2001: 346). We no longer need to mourn the distance between times and spaces because record labels and fans provide audiences with content that allows us to retrospectively rebuild the biographical relationship between Madonna and our own lives. Thus 'nostalgia is about the relationship between individual biography and the biography of groups or nations, between personal and collective memory' (Boym 2001: xvi) and, I would add, between fan and celebrity.

Exercise

Reflect upon your own consumption of popular music as a teenager or, if teenage years were not too distant a memory, consider interviewing an older family member on their consumption of music while they were growing up. Consider the artefacts and memorabilia that have been archived personally or by family members. What memories do these artefacts provide? Alongside, explore the numerous archives of pop music videos online. Search for ones you remember, watch them and critically reflect upon what you think and how feel about them when you first experienced them and how you view them now. How important are these pop music memories to you and your family's social and cultural history?

Suggested Viewing

Why not explore Madonna's official YouTube channel and compare and contrast early music videos such as *Like a Virgin* and *Vogue* with more recent videos such as *Celebration* and *Give It to Me*. Can you see references to Madonna's past work in terms of her look, lyrics and dance in her more recent work. How is she evoking memory, nostalgia and longevity?

Further Reading

Bijsterveld, Karin and van Dijck, José (eds) (2009) *Sound Souvenirs: Audio Technologies, Memory and Cultural Practices*. Amsterdam: Amsterdam University Press.

Brabazon, Tara (2005) *From Revolution to Revelation: Generation X, Popular Memory and Cultural Studies*. Aldershot: Ashgate.

Frith, Simon (2007) *Taking Popular Music Seriously: Selected Essays*. Aldershot: Ashgate.

Kaloski Naylor, Anna (2010) 'Michael Jackson's Post-Self', *Celebrity Studies*, 1 (2): 251–3.

Pickering, Michael and Keightley, Emily (2006) 'The Modalities of Nostalgia', *Current Sociology*, 54 (6): 919–41.

Snyder, Bob (2000) *Music and Memory: An Introduction*. Cambridge, MA: MIT Press.

8 Towards a Concept of Connected Memory: The Photo Album Goes Mobile

My Facebook page is awash with unremarkable images of conventionality: new babies, weddings, beloved pets, children on the beach, families skiing, gatherings, nights out, concerts, gardens, home improvements and hobbies. The vast majority of these I am not in. Some of these I have felt compelled to add to but most are produced by an online collection of individuals who may or may not be networked to each other and most likely have not been connected to me in the real world for quite some time. They are 'dormant memories' as Hoskins describes them (2010). Ceaselessly streaming this data of ordinariness, I am astonished by the repetition of memorable experiences across a diverse network of 'friends' from different backgrounds, many of whom have never met each other.

What I do not notice is that the sense of 'loss' and 'longing' that Annette Kuhn (2002) isolated when analysing the studio portraits and family photograph albums of her own childhood is missing. 'Why should a moment be recorded', asks Kuhn, 'if not for its evanescence?' (Kuhn 2002: 49). Yet the ubiquity of mobile phone and digital camera images and their multiple displays on my computer screen, taggable and shareable, does not suggest loss at all. The photography no longer seizes a moment as if it has only that one chance to capture it. For Kuhn (2002), these practices in the past involved the careful and detailed production of well-chosen photographs from expensively developed equipment, lovingly and with great skill placed and preserved in an often beautifully presented bound album or framed for display. Now, the family album is carried around in our pocket instantly accessible any time, any place, anywhere. But is it a family album? Is it even an album? We need to interrogate how and why mobile phone users produce and consume their photo albums. Is this the kind of 'memory work' that Kuhn says makes possible the exploration of the 'connections between "public" historical events, structures of feeling, family dramas, relations of class, national identity and gender and "personal" memory' (Kuhn 2002: 4)? Is this private mobile phone gallery of

images linked to public memory texts and the 'collective nature of the activity of remembering' (Kuhn 2002: 4)? Is the term 'collective' even useful for undertaking memory work with mobile phone camera images?

What do we actually do with mobile camera phones? Katz and Aakhus (2002) have written of mobile phone culture as one of 'perpetual contact' while Srivastava (2005) has reiterated this 'contact' as essential for feeling 'connected' as a being in the world rather than as a being contactable for giving and receiving information. Toward this end, more recent theory has begun to really focus on the mobile phone's situatedness (positioned near the human body, close to the user's personal sphere of belonging) as much as its mobility (Richardson 2005). Therefore, what people actually do with (and are able to do with) their mobile phone in terms of its mnemonic capabilities as a visual recorder of everyday life needs to be addressed from the perspective of those who have owned a mobile camera phone from a young age.

For the age group 15–18 in 2009, mobility is more constrained, with place, location and community as very important. Unlike my own memories of photography at this age, this generation has no personal or collective memory of taking photographs with a 35 mm camera, popping the roll of twenty-four or thirty-six negatives in a plastic container, placing it in a bag and handing it to a developer to be collected hours or days later. This generation has no understanding of collecting the prints, eagerly and gingerly sifting through them while walking down the street, and discovering that many of them are wasted opportunities or even displeasing to the eye. There may be one that is kept but the rest are considered unhelpfully permanent records of daily life that are then cast aside into a shoebox. Teenagers in 2009 have a very different relationship to the family album. Like Annette Kuhn's mother in the 1950s, they remain highly selective of the images they produce and share with others but this selectivity is not a one-stop shop but an ongoing process of managing impressions. Are they aware of their new roles as life-cachers and personal information managers? Do they recognise that a whole cultural, family practice in the domestic sphere of lovingly selecting the best images and sticking them in a photo album is now disappearing?

Interestingly, Anna Reading's mobile phone participants in her 2006 research project viewed the 'family album' contained within the phone as a transient and contingent album that was either not worth keeping, transferring or producing in hard copy, or was not possible to keep due to the commercial imperative of short-term phone contracts.

However, this devaluing of the mobile phone image from the slightly older (twenties–thirties analogue) generation is not present in (digital) teenagers today. Three years later, my own research with UK teenagers finds a level of media literacy and creativity that makes demands of the industry to take account of users' desire to connect in placed, emotive and meaningful ways. Through researching the responses of UK teenagers about how they use their mobile phones for making and sharing memories, I consider how media is incorporated into the lifeworld of young people as a functional tool, a tool not available to their parents when they were growing up, for creatively recording and sharing their everyday experiences. Unlike Kuhn, these young people are in charge of creating their own memories of their family, social and school life.

Reading (2008: 356) has been keen to foreground the 'family gallery' and its wearability on the human body through what she calls the 'memory prosthetic' of the mobile phone. However, this mobile wearability should not be misinterpreted as unfixed. Mobile phone users of all ages connect to communities and use their handsets to network online and offline. Specifically, the identities they develop, perform and shore up through co-present screenings of mobile photo albums in cafes, common rooms, train stations, airports and at the kitchen table, suggest that being located is key. Place, being placed and being in the right place at the right time are integral to the functionality of mobile phone culture and practice. (How many of us know exactly where the 'blackspots' in reception are when our phones are at their most mobile, travelling by car or train?) One should not let the technological mobility of the device override our own personal activities and behaviours that need to situate our connections quite specifically. How many of us have smiled knowingly in the train carriage as a mobile phone call recipient situates himself or herself with the statement: 'I'm on the train'? Even moblogging sites such as Twitter and social networking sites such as Facebook want to know what you are doing and where you are at any given moment. Hence, the mobile phone's camera is a visual extension of 'the most intimate aspect of a user's personal sphere of objects (e.g. keys, wallet, etc.)' (Srivastava 2005: 113) and thus visualises the intimacy of the people and places that position the phone camera's owner in a specific place (like visual anchors). The increase in mobile phone apps is testament to that intimacy and situatedness.

Reading's research, conducted in 2006, focused upon women's use of the phone in the domestic sphere as a communicator of everyday life through visual imagery, for example images of children shared between caregivers (2008). Nevertheless, like Rubinstein and Sluis

(2008), she identifies the transitory nature of taking photos (being able to delete instantly) and the mundanity of images captured (again due to the delete function capability). The women in their late twenties and thirties thus used the phone as a 'portable "family album"' (2008: 361) to visually embed their daily lives and carry those visual memories with them to show to others in a co-present context. It was only two years later that such participants would be telling a different story about how they use their mobile phones. The increased mobility of the images produced, due to 3G technologies, meant that these domestic images were now circulating and travelling along networked pathways.

Hence Reading's most recent concept of 'memobilia' draws on this more recent research within the field of digital and mobile memories (Garde-Hansen et al. 2009). 'Mobile digital phone memories or memobilia are wearable, shareable multimedia data records of events or communications [. . .] which are deeply personal and yet instantly collective through being linked to a global memoryscape of the World Wide Web' (Reading 2009: 81–2). This in turn is a development of her earlier theorisation of mobile digital memory as a gendered mobile gallery possible through the wearability of the camera, which issues forth a new relationship with photography and everyday life (particularly family life). Like Reading, Rubinstein and Sluis identify that the most significant feature of the technological shift from analogue camera to digital camera phone is the drawing of the means of production and distribution closer to the individual (2008: 12). Within a blink of an eye (hopefully, depending upon the quality of the phone's camera) the object one has taken a photo of is instantly visible on a screen. Within the time it takes to critically reflect upon the image, a button can be pressed to delete, archive or send to another phone or website.

The feelings that young people, in particular, have about their camera phone as they grow up with it as a personal friend, lifeline and lifeworld will be of particular interest. Teenagers are able to document, record and archive their experiences in ways that are valuable long before they are meant to have a productive role in a capitalist economy. Those born from the 1990s onwards are part of an emerging 'make and do culture' where craft and creativity are no longer seen as outdated and antithetical to the commercial imperative or the lifeblood of a community. They, more than the generations preceding them, know that mobile phones are no longer simple communicators of voice and text but are, in fact, 'occasional or dedicated consoles of ludic and narrative connectivity, and as emergent nodes of creativity and digital art' (Richardson 2005). The creative imperative has

become far more central to their existence in a mediated world. Thus this chapter proposes that a concept of 'connected memory' (and, thus, 'connected memory studies') will have far more resonance in their everyday life than Kuhn's continuously structured flow from personal to collective memory (2002: 4).

The first thing to say is that, for teenagers who have grown up with their own mobile phone, memory is something very tangible, physical and positioned in space: they capture it, archive it, hold it, carry it around, play with it, plug it in, wire it up, showcase it, and if they do not have enough of it in their handset, then that is the difference between being connected and disconnected. Rather than emphasise mobility (Reading 2009) and itinerancy (Richardson 2005), my research into how the upcoming media-literate generation engages with mobile phone cameras finds that the key indicators of takeup identified by the Sussex Technology Group back in 1996 are clearly intensified: mobile phones 'link us together while we are apart [. . .]. The mobile phone is a significant object; it is a guarantee of connection in (and to) the dislocated social world of modernity' (2001: 205). Being and feeling connected in time and place is paramount to teenagers: to their parents, friends, youth and media culture. While Katz and Sugiyama (2006) have focused on the ways that young people in the US and Japan see mobile phones as fashionable extensions of their personal identity, Nicola Green (2002) argued that they intensify strong ties. For young people, yes a mobile phone connects a person to the rest of the world, but more importantly it connects them to friends, parents, colleagues and peers on the ground. What is the most interesting for media studies research is the fact that while capturing images with phones leapfrogs over all the traditional forms of media and communication that would have allowed that level of connectivity only twenty years previously, young people are more focused on capturing and storing everything about their own life. In fact, although teenagers in the early twenty-first century have unprecedented access to the means of production of personal, collective, public, cultural, social and historical memory, their main focus in using their phone is 'personal' and 'connective'.

Hepp et al. (2008) argue that connectivity, networks and flows are the three key defining themes of twenty-first-century media and communications. These themes may seem at odds because on the one hand they acknowledge that communication systems such as the mobile phone allow for an increasing narrowcasting and mycasting of events of personal and public significance across territories. On the other hand, your average teenager in 2009 who has had their own mobile

phone since the age of at least eleven years old knows that this same technology is a wearable, personal, friend who expresses their identity, local connections and their sense of place and personal security.

This chapter focuses upon a piece of audience/user research with over one hundred 15–18 year olds from a range of backgrounds who attended a variety of schools and colleges in the UK (mostly in the South West) and who engaged in focus groups and completed questionnaires on their mobile phone camera use during a one-year period from 2009 to 2010. As such it provides an empirical study on personal reflections of 100+ young adults and the discussion questions were attentive to how their use of their mobiles for taking photos dovetails with issues of media, memory and archiving. Questions ranged from what they do with the photos, what pictures they take, where and how they show them, who to, how they delete them, when, how, where they download them. Particular attention was paid to two key functions: the delete function and the connecting/sharing function.

In the five focus groups of 15–18 year olds (totalling ninety-four respondents with a 50:50 male to female ratio) conducted from June to November 2009, the respondents completed a questionnaire about mobile phones and taking photos with phones to focus their later discussions on how they use this tool to communicate memories. It is important to recognise that this age group needs to be treated quite differently, in terms of research techniques, than older participants. In-depth interviews and small-group work would have been unfamiliar and inappropriate. Therefore group sizes ranged from ten to twenty-five, with a teacher or a parent representative always present. A simple and easily completed questionnaire formed the basis of the discussion and I was able to circulate among the participants as they discussed their responses. During the hour-long session the participants placed their phones on the table, explored them, discovered new features, swapped and showcased them to peers. The questionnaires were then completed and these consisted of four sections: You, Communication: Your Phone, Media: Taking Photos, Culture: Sharing Photos. Once complete, the participants fed back their responses to each other and the research team, while the latter took notes on the discussions that were generated.

Of the phones in the study (34 per cent Sony Ericsson, 20 per cent LG, 19 per cent Samsung, 14 per cent Nokia, 2 per cent Apple, 2 per cent Motorola and 9 per cent other brands) all had photo, video, gaming and music capabilities, with some having an Internet access package. Just a couple of years previously, before 3rd Generation (3G) phones were commonplace, it would have been impossible to conduct

a focus group with such a well-equipped group of teenagers. What was more surprising was that not one respondent had a hand-me-down phone from a parent, and thus, by extension, an older generation handset. Rather, it was more likely that they had the more up-to-date and expensive handset than their parents who mostly used one or two features. Therefore this age group is experiencing the rapid development of the diverse applications and possibilities of mobile phone technology and learning to use them in ways that demand more of the technology. This was evidenced by the variation in responses to the question of which function do you most use on your phone. They supplied their own responses, which ranged from music, texting, photos and calls to games, video, alarm, Internet, sound recorder, calendar and calculator, with an increasing awareness of apps during the process of the research. Not unsurprisingly this age group engages in 'texting' more than any other activity (61 per cent) as this a cheap, easy form of communication that performs the digital gift-giving that is so common among young people not yet immersed in the politics of the working world.

When offered twenty-four key words that would best describe what their phones mean to them personally, the respondents were asked to choose three in order of preference (see Figure 8.1). Recurring descriptive terms in order of frequency were: entertainment (49 per cent), gadget (36 per cent), connected (23 per cent) and easy (21 per cent) from the male responses while females placed connected (53 per cent), lifeline (45 per cent), photos (36 per cent) and friend (23 per cent) as their most frequently cited descriptors. We can clearly see a gendered response here with the expectation that masculinity be defined in relation to technology as effortless, playful and boyish, while femininity is defined in terms of social ties, dependency and the visual. Both sexes had 'connected' as a key term with females favouring this descriptor above all others. The level of seriousness attached to the phone developed with age and the younger members of the group freely admitted that they used the entertainment features more (particularly music suggesting inward-facing use) than the older members for whom socialising (outward-facing use) was far more important.

A significant focus of the group discussion and questionnaire concerned the taking, storage and transferability of photos and this led to some important insights into the relationship between mobile phones and memory for this age range. The older members of the group (18 year olds) with 200+ photos had simply accrued them over time in a steady manner rather than using the phone's camera intensely over

Cool	Connected	Complicated Speed		Archive	Creative
Wearable	Lifeline	Gadget	Photos	Youth	Reminder
Small	Easy	Me	Protection	Tracking	Entertainment
Fun	Distraction	Storytelling	Organisation	Record	Friend

Figure 8.1 Descriptors in answer to the question: 'How would you best describe what your phone means to you?' The shaded descriptors designate which ones were chosen by the sum total of responses.

a short period as one used to do with a 35 mm camera on holiday. There was still a feeling among the group that some special occasions like holidays and weddings required the stability or tradition of a stand-alone digital camera (over which parents had the most control), whereas the purpose of the mobile phone was for them to take photos of friends and everyday life or, as they termed them, 'out and about' photos. Astonishing was the diversity of responses to the question asking how many photos they had on their phones at that moment in time with answers ranging from 5 to 757 (i.e. less than 20 photos = 9 female, 18 male; 20–100 photos = 19 female,12 male; 100–200 photos = 10 female, 9 male; and 200+ photos = 8 female, 4 male). Clearly, the tendency to take photos and, in fact, keep them on the phone is a gendered practice with the females in the group not only more likely to describe their phone as a 'friend' or 'lifeline', but more likely to take photos and keep them on the handset.

Regardless of gender, when asked which word best describes what the majority of the photos were of, the responses were distributed as: 'Me' (5 per cent), 'Friends' (43 per cent), 'Family' (12 per cent) and 'Everyday Life' (40 per cent). What is interesting here is that contrary to Reading's (2008) findings where an older generation was more likely to emphasise individuality and family in their production of mobile phone photos, teenagers' photos revolved around friends and everyday life, with particular emphasis in their detailed responses to what I call the three 'f's: friends, family and funny ones. Strikingly, the majority of respondents, across the five focus groups all described the content of their photos in the same ways: 'memories', 'good times', 'my friends', 'funny ones' or 'anything really'. The best way of sharing these photos for the ninety-four respondents was fairly evenly spread between 'Face-to-Face', 'Mobile-to-Mobile' and 'Mobile-to-Internet', with the last slightly tipped as the favourite.

Much discussion arose as to the whys and wherefores of deleting photos. In all cases the issue of the memory capacity of the phone was the overriding determining factor in forcing the phone users to re-evaluate their archives. Just as mail servers often only provide a limited mailbox size for e-mails, which forces many of us to reassess our inboxes and later regret deletions, memories were being managed as information. As Reading makes clear:

> Rather than the personal album or shoebox of memories in the dusty cupboard, the mobile 'archive' suggests that even in relation to their own personal memories the individual now performs the role of a public librarian or trained archivist, ordering and maintaining documents relating to the past with its concomitant status, authority and location within the public realm of the lifeworld. (Reading 2008: 362)

Reading (2008) and Rubinstein and Sluis (2008) mention in passing the significance of the delete function as being pivotal to the change in photographing everyday life. While much of my research with teenagers corroborated some of what Reading found with the older age groups, I wanted to focus more attention on the archiving power of the phone and the phone owner's management of images in the storage, maintenance and transfer of personal memories. How far teenagers actually conceptualise their mobile phones as handsets of digital treasures is vital to understand, as these users are likely to be the most creative digital generation, who will create content for the web.

The questionnaire and discussions were directed specifically at this issue of deletion, as I was keen to understand how teenagers decided when and what to delete. To the question do you ever delete photos: 67 per cent said yes and 33 per cent answered no. In terms of the latter response, the overwhelming reasons for not deleting any photos was related to memory: 'to keep memories and look back at them', 'good memories', 'I like memories' and 'I don't want to lose memories', they wrote. Interestingly, the other stated reasons were related to the memory card size or space, which was considered big enough to make deleting photos unnecessary at this time. For the majority deletion was a common and necessary practice. In fact, to rethink John Berger's early ideas on the ways of seeing inherent to taking photographs, these teenagers have the time to spend casually snapshotting their daily lives as mechanical records. They are not the photographers in Berger's sense of the term 'selecting that sight from an infinity of other possible sights' (1972: 10). Their phones seemed to contain that infinity of sights which they were then at liberty to select as they go through a

series of sometimes quick but considered rationalisations for deleting. I would like to describe these as four deletion dynamics that pertain to memory and are defined below.

The Four Deletion Dynamics
1. Not MY Memory
This was described in a number of ways and as occurring at a number of points in time. Most usually this concerned incorrect images that the phone user did not wish to take ownership of: out of focus, too delayed (some mobiles were frustratingly hesitant), poorly constructed, accidental shots (very often occurring when the phone is so wearable) or images taken by others with or without permission (an action quite common with this age group, and which challenges Reading's (2008) findings regarding the 'privacy' her older respondents maintained around other people's phones). These photos were often deleted within moments of being taken and sometimes as a group activity. In some cases the participants stated they had deleted images at a much later date because on reflection they had completely forgotten what the image was of or they did not need it anymore. In other cases they judged that the photo was now boring and insignificant, or had become so in the light of more interesting and more recently taken photos: 'they need updating'. Therefore intricate and finely tuned judgements about quality, integrity, authenticity and personal ownership are made quickly as archives of photo memories are built inside mobile phones. Users do not lovingly and with care select images for their mobile photo albums to carry around with them while the 'dud' photos are placed with the negatives out of sight as their parents had done. Rather, the participants usually instantly deleted images that did not match their standards, clearly signalling a desire to create memorable, good-quality images that were considered important at that moment of reviewing.

2. Future Memory
This leads to the second deletion dynamic that structured how the participants organised their archives, which was far more self-conscious and self-aware of how their present will be viewed in the future by their future selves. In this case, older notions of the photographic subject dominated (see Roland Barthes' *Camera Lucida* (1993)) and newer notions of how memories are mediated (as in José van Dijck's *Mediated Memories in the Digital Age* (2007)) come into play. Similar to the *not MY memory* delete action, the *future memory* delete action is that of a media literate image-maker who wishes to select specific images and evoke

particular moments for future viewing. However, unlike past methods of picking from a wallet of prints (with one print often depicting one sight) an image for the album, this future memory process happens through deletion of the many multiple images in the surrounds so that the 'selected' image emerges as memorable. At worst, a photo has escaped deletion and its status, as a future memory, is only temporary until a better image is taken at which point it will disappear. At best it has been consciously chosen as presenting the visual representation of a life in its best possible light, entirely for reflective viewing. Sometimes these 'chosen' images are considered surprise images. The speed and functionality of the mobile camera phone has allowed them to come into being. Interestingly, one participant noted that this happened best with an old mobile camera phone he had that was particularly delayed in its response to the click button: while he tried to 'select' the site, event, moment for photographing, the camera phone chose the next moment instead, leading to some memorable images.

It is noteworthy that these were the images the participants were most likely to nominate for uploading to social networking sites, crossing from the personal memory sphere of intimate viewing to the connective memory sphere of networked viewing. It is at this point that we can identify Rubinstein and Sluis's assertion that these supposedly ordinary networked and streamed images become a kind of hegemonic camouflage that escapes critique (2008: 23). However, we need to ask the right questions at the right moment in the creative and cultural circuit. If we focus on the different deletion dynamics we find that very clear personal, political and ideological decisions are being made about the marketing of the self: 'I look ugly', 'it's embarrassing' or 'I delete them at the request of friends'. These deletion decisions are made in, with and often through a co-present showcasing of the mobile phone album, as groups of friends collectively determine what is considered memorable in each other's eyes and then connect those memories online.

3. SAVE MEMORY
This third deletion dynamic seemed to be one that beset this age group the most, in which they simply ran out of room in the memory card and the pressing need to take more photos meant that at any given moment they would need to go through the archive and housekeep in order to create more space. 'Small memory space', 'memory's full', 'I have very little memory', 'when memory's filled up' and 'if I need memory' were the frequent descriptions for this state of being which was a regular occurrence. The memory capacity of the phone was then,

at this point, entirely deterministic of the need to record and remember. Memory is becoming something very tangible and technological for this age group. While they all had good to excellent specifications on their handsets, many of them simply took so many photos and were not organised enough to upload them that they would have to manage their albums as and when in an ad hoc manner. They adjusted their behaviour and personal narratives around the technologies' archiving or non-archiving power. If, as Berger argues in the 1970s, photography embodies *a way of seeing*, then mobile phone memory cards embody, through what Richardson (2005) has called the 'techno-somatic' experience of mobile media, *a way of remembering* that is also about *forgetting*. If we consider the teenagers as engaged in a techno-somatic and technomnemonic practice where they incline their bodies and minds toward the mobile camera phone, then the issue of needing phone memory to create memories becomes powerful and drives the production of mediated memories. It also compels media industries to ensure the feedback loop of human memory into digital memory and back is not interrupted.

Therefore deletion to save memory is not simply a metaphor but a necessary practice of forgetting as a gain, not a loss. When discussing the deletion dynamic to save memory, I was surprised that the majority of the teenagers were not dismayed at having to discard images they may have had in their phones for quite some time. As Paul Connerton explains of the wider social context of history but which is equally applicable to teenagers making deletion choices:

> The emphasis here is not so much on the loss entailed in being unable to retain certain things as rather on the gain that accrues to those who know how to discard memories that serve no practicable purpose in the management of one's current identity and ongoing purposes. Forgetting then becomes part of the process by which new memories are constructed because a new set of memories are frequently accompanied by a set of tacitly shared silences. (Connerton 2008: 63)

4. Transfer memory

The fourth deletion dynamic occurred at critical mass, either when the memory card was physically full or contained image(s) considered of such importance they should not be simply archived in a small, fragile box being carried around with its potential to be lost, stolen or broken. Different to the third dynamic that occurred remotely when away from a computer, this dynamic of clearing all the photos from

the handset occurred once they had been transferred to a safer more static device or uploaded to a social networking site, digital vault or photo-sharing site. In their research on teenagers and mobile phones Richardson et al. (2007: 73) discovered that moblogging, creativity and community were becoming a significant part of the media literacy of young adults who were 'well-attuned to the recent shift to under-generated micromedia [. . .] characterized by information connectedness, small-scale digital content creation and peer-to-peer file sharing'.

Let's focus in a little more detail on this activity of sharing photographs online, which 37 per cent of my participants considered the best way to share images (compared to 32 per cent mobile to mobile and 31 per cent face to face). Of those respondents who named a website they uploaded to, all stated Facebook as their site of choice. According to Facebook's press release in 2009, there are over 300 million active users (50 per cent of which log on in any given day). The average user has 130 friends on the site. Of the applications used, uploading photos far outstrips any other activity with 2 billion photos uploaded to the site each month compared to 14 million videos uploaded or 3 million events created. Mobility is a key growth area with 65 million active users accessing the site through their mobile devices, with these users almost 50 per cent more active on Facebook than non-mobile users. In fact, Facebook states that there 'are more than 180 mobile operators in 60 countries working to deploy and promote Facebook mobile products' (Facebook Press Room 2009).

The vast majority of these 2 billion photos uploaded each month function to shore up existing networks of relationships and allows users to manage their relationships in a connected, communal and emotionally rewarding way. As Campbell and Russo (2003) were keen to emphasise in the conclusion of their study on the social acceptance of mobile telephony:

> The relationship between people and technology is a reciprocal one. Just as new technologies influence the ways people live their lives, the ways people live their lives influence how they think about and use technologies. Social science research of new communication technologies should be careful not to emphasize the former part of this equation at the expense of the latter. (Campbell and Russo 2003: 334)

Thus taking photos with phones, often with the intention of uploading to social networking sites, is a creative act that is about engaging, sharing and consolidating. For teenagers, this is about their social and emotional capital and about being able to visually represent their

memories of growing up in a real-world way, not in one of Kuhn's studio portraits, framed and on a mantelpiece.

Intensifying connections through creativity is key here. Sharing photos of everyday life and the milestones of living, have a particularly important function in the new media ecology. They propagate connections very quickly, allowing relationships to be maintained and users to manage those relationships. They also provide the Facebook Data Team with the valuable 'tipping' points for understanding how social networks fade and intensify within a system of networked experiences. The core of the Facebook experience is the reaching out to each other that occurs when photos are uploaded and appear in each other's newsfeeds. The connections expand and contract as memories are created and shared. Thus, if memory has been considered in terms of a relational dynamic between personal and collective and is now understood as mediated, networked and digital, then what kinds of metaphors for understanding memory in a social networking age do we need to create? A concept of connected memory perhaps. Under what circumstances will we want our media to stop remembering us and disconnect? Noel Packard has asserted that the everyday activity of posing for the digital camera (phone) alongside 24/7 website access and cheap portable technologies means that:

> Entire digitalized histories of people from birth to death can be compiled and used by entities outside the person (the host) who 'generated' the file. But unlike the person (host) who generated the electronic file, the files live on forever, while the mortal body of the host dies. (Packard 2009: 16–17)

Exercise

Think about your mobile phone and how you use it. Then think about the multiple ways in which your mobile phone can be studied in terms of memory:

1. As a private remembering device, e.g. alarms, clock, timer, calendar, appointments, reminder notes. Without these functions and without being able to structure your daily life around this functionality where would you be?
2. As a personal media archive system, e.g. photo albums, text messages, music archives, favourite games, past podcasts. Without this archivability to access and trigger memories and emotional responses and relive activities how much experience would you lose?

3. As a connected communication system, e.g. phone calls, text messaging and mobile social networking (moblogging). Without being able to relive familial connections, recall networks of friends and organise collective experiences how disconnected from your life and those around you would you feel?

4. As a recording device, e.g. sound, voice, noise, images, video. Without footage from mobile phones during the G20 summit or the sounds we love recorded onto our handset, how would we know these things ever occurred or were experienced?

5. As a habitual friend who is close to your skin, e.g. flipping the screen, thumbing the keys, holding the handset to your ear as you walk streets at night, treasured ringtones, personalised cases and the nostalgia for old phones that we keep in our drawer, no longer useable. If we lost our phone how would we feel?

6. As a mnemonic object signalling the progress of technology. The very size, design and feel of a mobile phone denotes its time and place in history and connotes its shift in status from the preserve of businessmen in sharp suits to the ubiquity of everyone: young, old, rich and poor. What do your phone or your parents' phones connote?

7. As a carrier and conveyor of cultural and media histories and memories. For example, ringtones can be customised into polyphonic soundbytes that remediate and recycle private and public sounds from a recording of a loved one laughing to the 'Ride of the Valkyries'. Could we analyse ringtones as carriers of cultural memories?

Further Reading

Connerton, Paul (2008) 'Seven Types of Forgetting', *Memory Studies*, 1 (1): 59–71.

Garde-Hansen, Joanne, Hoskins, Andrew and Reading, Anna (2009) *Save As . . . Digital Memories*. Basingstoke: Palgrave Macmillan.

Rubinstein, Daniel and Sluis, Katrina (2008) 'A Life More Photographic: Mapping the Networked Image', *Photographies*, 1 (1): 9–28.

Srivastava, L. (2005) 'Mobile Phones and the Evolution of Social Behaviour', *Behaviour and Information Technology*, 24 (2): 111–29.

van Dijck, J. (2007) 'From Shoebox to Digital Memory Machine', in *Mediated Memories in the Digital Age*. Stanford, CA: Stanford University Press, pp. 148–69.

Bibliography

Abbott, Daisy (2008) *JISC Final Report – Digital Repositories and Archives Inventory Project* (HATII, University of Glasgow). Online: http://www.jisc. ac.uk.

Adams, William (1988) 'Still Shooting After All These Years', *Mother Jones Magazine*, pp. 47–9.

Anderson, Steven (2001) 'History TV and Popular Memory', in Gary R. Edgerton and Peter C. Rollins (eds), *Television Histories: Shaping Collective Memory in the Media Age*. Lexington, KY: University Press of Kentucky, pp. 19–36

Assmann, Jan (1988) 'Kollektives Gedächtnis und kulturelle Identität,' in Jan Assmann and T. Hölscher (eds), *Kultur und Gedächtnis*. Frankfurt am Main: Suhrkamp, pp. 9–19.

Assmann, Jan (1992) *Das kulturelle Gedächtnis: Schrift, Erinnerung und politische Identität in frühen Hochkulturen*. München: Beck.

Assmann, Jan (1995) 'Collective Memory and Cultural Identity', *New German Critique*, 65: 125–33.

Assmann, Jan (2006) *Religion and Cultural Memory: Ten Studies*, trans. Rodney Livingstone. Palo Alto, CA: Stanford University Press.

Baddeley, Alan D. (1999) *Essentials of Human Memory*. Hove: Psychology Press.

Barthes, Roland (1993) *Camera Lucida: Reflections on Photography*. London: Vintage.

Baudrillard, Jean ([1991] 1995) *The Gulf War Did Not Take Place*, trans. Paul Patton. Sydney: Power Publications.

Bell, E. and Gray, A. (2007) 'History on Television: Charisma, Narrative and Knowledge', *European Journal of Cultural Studies*, 10: 113–33.

Benjamin, Walter (1974) *On the Concept of History*. Frankfurt am Main: Suhrkamp Verlag.

Bennett, Jill and Kennedy, Rosanne (eds) (2003) *World Memory: Personal Trajectories in Global Time*. Basingstoke: Palgrave Macmillan.

Berger, John (1972) *Ways of Seeing*. London: Penguin.

Bergson, Henri ([1896] 1991) *Matter and Memory*, trans. N. M. Paul and W. S. Palmer. New York: Zone Books.

Biewen, John and Dilworth, Alexa (eds) (2010) *Reality Radio: Telling True Stories in Sound*. Chapel Hill, NC: University of North Carolina Press.

Bijsterveld, Karin and van Dijck, José (eds) (2009) *Sound Souvenirs: Audio Technologies, Memory and Cultural Practices*. Amsterdam: Amsterdam University Press.

Blair, Carole (2006) 'Communication as Collective Memory', in Gregory J. Shepherd, Jeffrey St John and Theodore G. Striphas (eds), *Communication as . . .: Perspectives on Theory*. Thousand Oaks, CA: Sage, pp. 51–9.

Blumler, Jay G. (1993) 'Meshing Money with Mission: Purity versus Pragmatism in Public Broadcasting', *European Journal of Communication*, 8 (4): 403–24.

Bodnar, John (1992) *Remaking America: Public Memory, Commemoration and Patriotism in the Twentieth Century*. Princeton: Princeton University Press.

Bolter, Jay David and Grusin, Richard (1999) *Remediation: Understanding New Media*. Cambridge, MA: MIT Press.

Bommes, Michael and Wright, Patrick (1982) 'The Charms of Residence: The Public and the Past', in Richard Johnson, Gregor McLennan, Bill Schwarz and David Sutton (eds), *Making Histories*. London: Anchor.

Boyle, James (2008) *The Public Domain: Enclosing the Commons of the Mind*. Online: http://www.thepublicdomain.org/download/.

Boym, Svetlana (2001) *The Future of Nostalgia*. New York: Basic Books Press.

Brabazon, Tara (2005) *From Revolution to Revelation: Generation X, Popular Memory and Cultural Studies*. Aldershot: Ashgate.

Brown, R. and Kulik, J. (1977) 'Flashbulb memories', *Cognition*, 5: 73–99.

Brown, Steven D. (2008) 'The Quotation Marks Have a Certain Importance: Prospects for a "Memory Studies"', *Memory Studies*, 1 (3): 261–71.

Bull, Michael (2009) 'The Auditory Nostalgia of iPod Culture', in Karin Bijsterveld and José van Dijck (eds), *Sound Souvenirs: Audio Technologies, Memory and Cultural Practices*. Amsterdam: Amsterdam University Press, pp. 83–93.

Burton, James (2008) 'Bergson's Non-Archival Theory of Memory', *Memory Studies*, 1 (3): 321–39.

Calloway-Thomas, Carolyn (2010) *Empathy in the Global World: An Intercultural Perspective*. London: Sage.

Cameron, Fiona and Kenderdine, Sarah (eds) (2007) *Theorizing Digital Cultural Heritage: A Critical Discourse*. Cambridge, MA: MIT Press.

Campbell, Sue (2003) *Relational Remembering: Rethinking the Memory Wars*. Lanham, MD: Rowman & Littlefield.

Campbell, S. W. and Russo, T. C. (2003) 'The Social Construction of Mobile Telephony: An Application of the Social Influence Model to Perceptions and Uses of Mobile phones within Personal Communication Networks', *Communication Monographs*, 70 (4): 317–34.

Cannadine, David (ed.) (2004) *History and the Media*. Basingstoke: Palgrave Macmillan.

Carey, James W. ([1992] 2009) *Communication as Culture: Essays on Media and Society*. London: Routledge.

Carruthers, Mary (2008) *The Book of Memory: A Study of Memory in Medieval Culture*, 2nd edn. Cambridge: Cambridge University Press.

Caruth, Cathy (ed.) (1995) *Trauma: Explorations in Memory*. Baltimore: Johns Hopkins University Press.

Cohen, Daniel and Rosenzweig, Roy (2005) *Digital History: A Guide to Presenting, Preserving, or Gathering the Past on the Web*. Online: http://chnm. gmu.edu/digitalhistory/.

Cohen, Gillian and Conway, Martin A. (2008) *Memory in the Real World*, 3rd edn. Hove: Psychology Press.

Connerton, Paul (1989) *How Societies Remember*. Cambridge: Cambridge University Press.

Connerton, Paul (2008) 'Seven Types of Forgetting', *Memory Studies*, 1 (1): 59–71.

Cooke, G. (2009) 'The cosmeceutical face: time-fighting technologies and the archive', *Transformations*, 17. Online: http://www.transformationsjournal. org/journal/issue_17/article_03.shtml (accessed 18 August 2010).

Coombes, Annie (2003) *History After Apartheid: Visual Culture and Public Memory in a Democratic South Africa*. Durham, NC: Duke University Press.

Cottle, Simon (2009) 'New Wars and the Global War on Terror: On Vicarious, Visceral Violence', in *Global Crisis Reporting: Journalism in a Global Age*. Maidenhead: Open University Press, pp. 109–26.

Crisell, Andrew ([1986] 1994) *Understanding Radio*, 2nd edn. London: Routledge.

Crownshaw, Richard (2000) 'Performing Memory in Holocaust Museums', *Performance Research*, 5 (3):18–27.

Crownshaw, Richard, Rowland, Anthony and Kilby, Jane (eds) (2010) *The Future of Memory*. Oxford: Berghahn Books.

Custen, George F. (2001) 'Making History', in Marcia Landy (ed.), *The Historical Film: History and Memory in Media*. Piscataway, NJ: Rutgers University Press, pp. 67–97.

Dayan, Daniel and Katz, Elihu (1992) *Media Events: The Live Broadcasting of History*. Cambridge, MA: Harvard University Press.

De Groot, Jerome (2006) 'Empathy and Enfranchisement: Popular Histories', *Rethinking History*, 10 (3): 291–413.

De Groot, Jerome (2009) *Consuming History: Historians and Heritage in Contemporary Popular Culture*. London: Routledge.

Derrida, Jacques (1994) *Spectres of Marx: The State of the Debt, the Work of Mourning and the New International*, trans. Peggy Kamuf. London: Routledge.

Derrida, Jacques (1996) *Archive Fever: A Freudian Impression*, trans. E. Prenowitz. Chicago: University of Chicago Press.

Dienst, Richard (1994) *Still Life in Real Time: Theory After Television*. Durham, NC: Duke University Press.

Doonan, Simon (2008) 'Forces of Nature: Simon Doonan Sits Down with

Madonna to Talk Style and Substance', *Elle*, 31 March. Online: http://www. elle.com/Pop-Culture/Cover-Shoots/Force-Of-Nature (accessed 20 July 2010).

Draaisma, Douwe (2000) *Metaphors of Memory: A History of Ideas about the Mind*. Cambridge: Cambridge University Press.

Dyer, Richard (1992) *Only Entertainment*. London: Routledge.

Eley, Geoff (1995) '*Distant Voices, Still Lives*, The Family is a Dangerous Place: Memory, Gender, and the Image of the Working Class', in Robert A. Rosenstone (ed.), *Revisioning History: Film and the Construction of a New Past*. Princeton: Princeton University Press, pp. 17–43.

Elsaesser, Thomas (2003) 'Where Were You When . . .? Or, "I Phone, Therefore I Am"', *PMLA*, 118 (1): 120–2.

Engel, Susan (2000) *Context is Everything: The Nature of Memory*. New York: W. H. Freeman.

Erll, Astrid (2008) 'Literature, Film, and the Mediality of Cultural Memory', in Astrid Erll and Ansgar Nünning (eds), *Cultural Memory Studies: An International and Interdisciplinary Handbook*. Berlin: Walter de Gruyter, pp. 389–98.

Erll, Astrid (2010) *Travelling Memory: Remediation Across Time, Space and Cultures*. Keynote Speech, Transcultural Memory Conference, Institute of Germanic and Romance Studies, University of London, 4–6 February. Online: http://www.igrs.sas.ac.uk/research/transculturalmemory.htm (accessed 5 May 2010).

Erll, Astrid and Nünning, Ansgar (eds) (2008) *Cultural Memory Studies: An International and Interdisciplinary Handbook*. Berlin: Walter de Gruyter.

Facebook Press Room (2009) 'Statistics'. Online: http://www.facebook.com/press/info.php?statistics (accessed 11 November 2009).

Faith, Karlene and Wasserlein, Frances (1997) *Madonna: Bawdy and Soul*. Toronto: University of Toronto Press.

Fentress, James and Wickham, C. J. (1992) *Social Memory: New Perspectives on the Past*. Oxford: Wiley-Blackwell.

Finkelstein, Norman G. (2000) *The Holocaust Industry: Reflections on the Exploitation of Jewish Suffering*. London: Verso.

Fisk, Robert (2005) *The Great War for Civilisation: The Conquest of the Middle East*. New York: Knopf.

Fiske, John (1987) *Television Culture*. London: Methuen.

Fiske, John (1989a) *Understanding Popular Culture*. London: Routledge.

Fiske, John (1989b) *Reading the Popular*. London: Unwin Hyman.

Foot, John (2009) *Italy's Divided Memory*. Basingstoke: Palgrave Macmillan.

Foster, Hal (1996) 'The Archive without Museums', *October*, 77: 97–119.

Foucault, Michel (1977) 'Film and Popular Memory', *Edinburgh Magazine*, 2: 22.

Foucault, Michel (1978) *The History of Sexuality, Volume 1: An Introduction*, trans. Robert Hurley. New York: Pantheon.

Fouz-Hernandez, Santiago and Jarman-Ivens, Freya (eds) (2004) *Madonna's*

Drowned Worlds: New Approaches to Her Cultural Transformations 1983–2003. Aldershot: Ashgate.

Frosh, Paul and Pinchevski, Amit (2009) *Media Witnessing: Testimony in the Age of Mass Communication*. Basingstoke: Palgrave Macmillan.

Fukuyama, Francis ([1989] 1992) *The End of History and the Last Man*. New York: Avon Books/Free Press.

Garde-Hansen, Joanne (2007) 'It's not About the Technology: Shifting Perceptions of History and Technology in the BBC's Digital Storytelling Project', *International Digital Media and Arts Journal*, 4 (1): 41–5.

Garde-Hansen, Joanne (2009) 'MyMemories? Personal Digital Archive Fever and Facebook', in Joanne Garde-Hansen, Andrew Hoskins and Anna Reading (eds), *Save As . . . Digital Memories*. Basingstoke: Palgrave Macmillan, pp. 135–50.

Garde-Hansen, Joanne (2010) 'Measuring Mourning with Online Media: Michael Jackson and Real-Time Memories', *Celebrity Studies*, 1 (2): 233–5.

Garde-Hansen, Joanne, Hoskins, Andrew and Reading, Anna (2009) *Save As . . . Digital Memories*. Basingstoke: Palgrave Macmillan.

Gauntlett, David (2002) *Media, Gender and Identity: An Introduction*. London: Routledge.

Gauntlett, David (2005) *Moving Experiences: Media Effects and Beyond*, 2nd edn. London: John Libbey.

Gehl, Robert (2009) 'YouTube as Archive: Who Will Curate This Digital Wunderkammer?', *International Journal of Cultural Studies*, 12 (1): 43–60.

Geraghty, L. (2007) *Living with Star Trek: American Culture and the Star Trek Universe*. London: I. B. Tauris.

Gibson, William (1993) *Virtual Light*. London: Penguin.

Graham, Mark (2009) 'Mapping the Geographies of Wikipedia Content'. Blog posting, 12 November 2009. Online: http://zerogeography.blogspot.com/2009/11/mapping-geographies-of-wikipedia.html (accessed 13 August 2010).

Grainge, Paul (2002) *Monochrome Memories: Nostalgia and Style in Retro America*. Westport, CT: Praeger.

Grainge, Paul (2003) *Memory and Popular Film*. Manchester: Manchester University Press.

Grusin, Richard (2010) *Premediation: Affect and Mediality After 9/11*. Basingstoke: Palgrave Macmillan.

Guerra, Joey (2009) 'Madonna's Celebration is Impressive', *Houston Chronicle* (Hearst Corporation), 28 September. Online: http://www.chron.com/disp/story.mpl/ent/music/cdreviews/6641754.html (accessed 29 October 2009).

Hacking, Ian (1995) *Rewriting the Soul: Multiple Personality and the Science of Memory*. Princeton: Princeton University Press.

Halbwachs, Maurice (1980) *The Collective Memory*, trans. Francis J. Ditter Jr and Vida Yazdi. New York: Harper Colophon.

Halbwachs, Maurice ([1952] 1992) *On Collective Memory*, trans. Lewis A. Coser. Chicago: University of Chicago Press.

Hall, Stuart (1997) *Representation: Cultural Representations and Signifying Practices*. Maidenhead: Open University Press.

Hansen, Mark B. (2004) *New Philosophy for New Media*. Cambridge, MA: MIT Press.

Hansen, Miriam Bratu (1996) '*Schindler's List* is not *Shoah*: The Second Commandment, Popular Modernism and Public Memory', *Critical Inquiry*, 22 (2): 292–312.

Hartley, John and McWilliam, Kelly (eds) (2009) *Story Circle: Digital Storytelling Around the World*. Oxford: Blackwell.

Haug, Frigga et al. (eds) (1987) *Female Sexualization: A Collective Work of Memory*. London: Verso.

Hebdige, Dick (1979) *Subculture: The Meaning of Style*. London: Methuen.

Hepp, Andreas, Krotz, Friedrich, Moores, Shaun and Winter, Carsten (eds) (2008) *Connectivity, Networks and Flows: Conceptualizing Contemporary Communications*. New York: Hampton Press.

Hewison, Robert (1987) *The Heritage Industry: Britain in a Climate of Decline*. London: Methuen.

Higson, Andrew (2003) *English Heritage, English Cinema*. Oxford: Oxford University Press.

Hills, Matt (2002) *Fan Cultures*. London: Routledge.

Hilmes, Michele and Loviglio, Jason (eds) (2002) *Radio Reader: Essays in the Cultural History of Radio*. London: Routledge.

Hirsch, Marianne (1997) *Family Frames: Photography, Narrative and Postmemory*. Cambridge, MA: Harvard University Press.

Hirsch, Marianne and Smith, Valerie (eds) (2002) 'Gender and Cultural Memory', Special Issue of the journal *Signs*, 28 (1).

Hodgkin, Katharine and Radstone, Susannah (eds) (2005) *The Politics of Memory: Contested Pasts*. Piscataway, NJ: Transaction Publishers; previously published as *Contested Pasts: The Politics of Memory*, Routledge Studies in Memory and Narrative. London: Routledge.

Hodgkin, Katharine and Radstone, Susannah (eds) (2006) *Memory, History, Nation: Contested Pasts*. New Brunswick, NJ: Transaction Publishers.

Hoggart, Richard (1957) *The Uses of Literacy: Changing Patterns in English Mass Culture*. Fair Lawn, NJ: Essential Books.

Hoggart, Richard (2004) *Mass Media and Mass Society: Myths and Realities*. London: Continuum.

Holdsworth, Amy (2010) 'Who Do You Think You Are? Family History and Memory on British Television', in Erin Bell and Ann Gray (eds), *Televising History: Mediating the Past in Postwar Europe*. Basingstoke: Palgrave, pp. 234–47.

Holland, Patricia (1957) *The Uses of Literacy*. London: Penguin.

Holland, Patricia (1991) 'Introduction: History, Memory and the Family Album', in Jo Spence and Patricia Holland (eds), *Family Snaps: The Meanings of Domestic Photography*. London: Virago Press.

Hopper, Paul (2007) *Understanding Cultural Globalisation*. London: Polity.

Hoskins, Andrew (2001) 'New Memory: Mediating History', *Historical Journal of Film, Radio and Television*, 21: 333–46.

Hoskins, Andrew (2003) 'Signs of the Holocaust: Exhibiting Memory in a Mediated Age', *Media, Culture and Society*, 25 (1): 7–22.

Hoskins, Andrew (2004a) *Televising War: From Vietnam to Iraq*. London: Continuum.

Hoskins, Andrew (2004b) 'Television and the Collapse of Memory', *Time and Society*, 13 (1): 109–27.

Hoskins, Andrew (2005) 'Constructing History in TV News from Clinton to 9/11: Flashframes of History – American Visual Memories', in D. Holloway and J. Beck (eds), *American Visual Cultures*. London: Continuum, pp. 299–307.

Hoskins, Andrew (2010) 'The Diffusion of Media/Memory: The New Complexity', in *Warwick Books*. Online: http://www2.warwick.ac.uk/news-andevents/warwickbooks/complexity/andrew_hoskins/ (accessed 31 March 2010).

Huyssen, Andreas (1995) *Twilight Memories: Marking Time in a Culture of Amnesia*. London: Routledge.

Huyssen, Andreas (2003a) *Present Pasts: Urban Palimpsests and the Politics of Memory*. Palo Alto, CA: Stanford University Press.

Huyssen, Andreas (2003b) 'Trauma and Memory: A New Imaginary of Temporality', in Jill Bennett and Rosanne Kennedy (eds), *World Memory: Personal Trajectories in Global Time*. Basingstoke: Palgrave Macmillan, pp. 16–29.

Ingram, Matthew (2008) 'Twitter: The First Draft of History?' Blog post, 12 May 2008. Online: http://www.mathewingram.com/work/2008/05/12/twitter-the-first-draft-of-history/ (accessed 29 July 2009).

Irwin-Zarecka, Iwona (1994) *Frames of Remembrance: The Dynamics of Collective Memory*. New Brunswick, NJ: Transaction Books.

Ishizuka, Karen L. and Zimmermann, Patricia R. (eds) (2007) *Mining the Home Movie: Excavations in Histories and Memories*. Berkeley: University of California Press.

Jenkins, Henry (1992) *Textual Poachers: Television Fans and Participatory Culture*. New York: Routledge.

Jenkins, Henry (2001) 'Interview with Henry Jenkins and Matt Hills at the Console-ing Passions Conference, University of Bristol, July 7th', *Intensities*, 2. Online: http://intensities.org.

Jenkins, Henry (2006a) *Fans, Bloggers and Gamers: Exploring Participatory Culture*. New York: New York University Press.

Jenkins, Henry (2006b) *Convergence Culture: Where Old and New Media Collide*. New York: New York University Press.

Jenkins, Henry (2010) 'John Fiske: Now and the Future', *Confessions of an ACA-Fan: The Official Weblog of Henry Jenkins*. Blog posting, 16 June. Online: http://henryjenkins.org/2010/06/john_fiske_now_and_the_future.html (accessed 12 August 2010).

Jenkins, Keith, Morgan, Sue and Munslow, Alun (eds) (2007) *Manifestos for History*. Oxford: Routledge.

Johnson, Richard, McLennan, Gregor, Schwarz, Bill and Sutton, David (eds) (1982) *Making Histories*. London: Anchor.

Kaloski Naylor, Anna (2010) 'Michael Jackson's Post-Self', *Celebrity Studies*, 1 (2): 251–3.

Kansteiner, Wulf (2002) 'Finding Meaning in Memory: A Methodological Critique of Collective Memory Studies', *History and Theory*, 41: 179–97.

Kansteiner, Wulf (2007) 'Alternate Worlds and Invented Communities: History and Historical Consciousness in the Age of Interactive Media', in Keith Jenkins, Sue Morgan, Alun Munslow (eds), *Manifestos for History*. Oxford: Routledge, pp. 131–48.

Katz, James E. and Aakhus, Mark (2002) *Perpetual Contact: Mobile Communication, Private Talk, Public Communication*. Cambridge: Cambridge University Press.

Katz, James E. and Sugiyama, Satomi (2006) 'Mobile Phones as Fashion Statements: Evidence from Student Surveys in the US and Japan', *New Media Society*, 8 (2): 321–37.

Kear, Adrian and Steinberg, Deborah Lynn (1999) *Mourning Diana: Nation, Culture and the Performance of Grief*. London: Routledge.

Kellner, Douglas (1995) *Media Culture: Cultural Studies, Identity, and Politics Between the Modern and the Postmodern*. London: Routledge.

Kelly, Kevin (2010) 'The Shirky Principle', *The Technium*. Online: http://www.kk.org/thetechnium/archives/2010/04/the_shirky_prin.php (accessed 3 June 2010).

Keneally, Thomas (1982) *Schindler's Ark*. London: Hodder & Stoughton.

Kidd, Jenny (2009) 'Digital Storytelling and the Performance of Memory', in Joanne Garde-Hansen, Andrew Hoskins and Anna Reading (eds), *Save As ... Digital Memories*. Basingstoke: Palgrave Macmillan, pp. 167–83.

Kitch, Carolyn (2003) 'Mourning in America: Ritual, Redemption, and Recovery in News Narrative After September 11', *Journalism Studies*, 4 (2): 213–24.

Kitch, Carolyn (2005) *Pages from the Past: History and Memory in American Magazines*. Chapel Hill, NC: University of North Carolina Press.

Kitch, Carolyn (2008) 'Placing Journalism Inside Memory – and Memory Studies', *Memory Studies*, 1 (3): 311–20.

Kitch, Carolyn and Hume, Janice (2008) *Journalism in a Culture of Grief*. London: Routledge.

Klaebe, Helen G. and Foth, Marcus (2006) *Capturing Community Memory with Oral History and New Media: The Sharing Stories Project*. In 3rd International Conference of the Community Informatics Research Network (CIRN), Prato, Italy, 9–11 October.

Klein, Kerwin Lee (2000) 'On the Emergence of Memory in Historical Discourse', *Representations*, 69: 127–50.

Kuhn, Annette (1995) *Family Secrets: Acts of Memory and Imagination*. London: Verso.

Kuhn, Annette (2000) 'A Journey Through Memory', in Susannah Radstone (ed.), *Memory and Methodology*. Oxford: Berg, pp. 179–96.

Kuhn, Annette (2002) *An Everyday Magic: Cinema and Cultural Memory*. London: I. B. Tauris.

Kuhn, Annette and McAllister, Kirsten Emiko (eds) (2006) *Locating Memory: Photographic Acts*. Oxford: Berghahn Books.

Lambert, Joe ([1997] 2009) 'Where It All Started: The Center for Digital Storytelling in California', in John Hartley and Kelly McWilliam (eds), *Story Circle: Digital Storytelling Around the World*. Oxford: Blackwell, pp. 79–90.

Landsberg, Alison (2004) *Prosthetic Memory: The Transformation of American Remembrance in the Age of Mass Culture*. New York: Columbia University Press.

Landy, Marcia (ed.) (2001) *The Historical Film: History and Memory in Media*. Piscataway, NJ: Rutgers University Press.

Le Goff, Jacques (1992) *History and Memory*, trans. Steven Rendall and Elizabeth Claman. New York: Columbia University Press.

Leadbeater, Charles (2008) *We-think: Mass Innovation, Not Mass Production: The Power of Mass Creativity*. London: Profile Books.

Lemon, Alaina (2000) *Between Two Fires: Gypsy Performance and Romani Memory from Pushkin to Postcolonialism*. Durham, NC: Duke University Press.

Lessig, Lawrence (2007) 'Larry Lessig on Laws that Choke Creativity', *TED Talks*. Online: http://www.ted.com/talks/larry_lessig_says_the_law_is_strangling_creativity.html (accessed 7 June 2010).

Levy, Daniel and Sznaider, Natan (2005) *The Holocaust and Memory in the Global Age*. Philadelphia: Temple University Press.

Lipsitz, George (1990) *Time Passages: Collective Memory and American Popular Culture*. Minneapolis: University of Minnesota Press.

Livingstone, Sonia (2008) *On the Mediation of Everything*. Presidential Address to the International Communication Association. Online: http://www.icahdq.org/conferences/presaddress.asp#_ftnref2 (accessed 8 July 2009).

Livingstone, Steven (1997) *Clarifying the CNN Effect: An Examination of Media Effects According to Type of Military Intervention*, Research Paper R-17, Joan Shorenstein Center on the Press, Politics and Public Policy, Harvard University. Online: http://www.hks.harvard.edu/presspol/publications/papers/research_papers/r18_livingston.pdf (accessed 7 July 2009).

Loshitzky, Yosefa (ed.) (1997) *Spielberg's Holocaust: Critical Perspectives on Schindler's List*. Bloomington: Indiana University Press.

Lowenthal, David (1985) *The Past Is a Foreign Country*. Cambridge: Cambridge University Press.

Lowenthal, David (1996) *Possessed by the Past: The Heritage Crusade and the Spoils of History*. New York: Free Press.

Lumb, Rebecca (2010) 'Reunited with the Vietnamese "girl in the picture"',

BBC News, 17 May. Online: http://news.bbc.co.uk/1/hi/world/asia-pacific/ 8678478.stm (accessed 20 August 2010).

Lundby, Knut (ed.) (2008) *Digital Storytelling, Mediatized Stories: Self-representations in New Media*. New York: Peter Lang.

Lundby, Knut (ed.) (2009) *Mediatization: Concept, Changes, Consequences*. Oxford: Peter Lang.

Lyons, James and Plunkett, John (eds) (2007) *Multimedia Histories: From the Magic Lantern to the Internet*. Exeter: University of Exeter Press.

Lyotard, Jean-François ([1979] 2001) *The Postmodern Condition: A Report on Knowledge*, trans. Geoff Bennington and Brian Massumi. Manchester: Manchester University Press.

McArthur, Colin (1978) *Television and History*, BFI Television Monograph. London: BFI Educational Advisory Service.

McChesney, Robert and Nichols, John (2002) *Our Media, Not Theirs: The Democratic Struggle Against Corporate Media*. New York: Seven Stories Press.

Macdonald, Myra (2006) 'Performing Memory on Television: Documentary and the 1960s', *Screen*, 47 (3): 327–45.

McLean, Iain and Johnes, Martin (1999) *The Aberfan Distaster* (website 1997–2001). Online: http://www.nuffield.ox.ac.uk/politics/aberfan/home.htm.

McLuhan, Marshall ([1964] 1994) *Understanding Media: The Extensions of Man*. Cambridge, MA: MIT Press.

McLuhan, Marshall (1967) *The Medium is the Massage: An Inventory of Effects*, with Quentin Fiore. London: Penguin.

Maj, Anna and Riha, Daniel (2009) *Digital Memories: Exploring Critical Issues* (e-book). Online at Inter-Disciplinary.net: http://www.inter-disciplinary. net/wp-content/uploads/2009/12/DigMem-1.3d.pdf (accessed 28 June 2010).

Maltby, Sarah and Keeble, Richard (eds) (2007) *Communicating War: Memory, Media and Military*. Bury St Edmonds: Arima Publishing.

Manovich, Lev (2002) *The Language of New Media*. Cambridge, MA: MIT Press.

Margalit, Avashi (2002) *The Ethics of Memory*. Cambridge, MA: Harvard University Press.

Mayer-Schönberger, Viktor (2009) *Delete: The Virtue of Forgetting in the Digital Age*. Princeton: Princeton University Press.

Meadows, Daniel and Kidd, Jenny (2009) '"Capture Wales": The BBC Digital Storytelling Project', in John Hartley and Kelly McWilliam (eds), *Story Circle: Digital Storytelling Around the World*. Oxford: Blackwell, pp. 91–117.

Merrin, William (2008) *Media Studies 2.0*. Online: http://mediastudies2point0. blogspot.com/ date (accessed 5 May 2010).

Miller, Alisa (2008) 'Alisa Miller shares the news about the news'. Online: http://www.ted.com/index.php/talks/alisa_miller_shares_the_news_about_ the_news.html (accessed 20 November 2010).

Miller, Toby (2002) *Television Studies*. London: British Film Institute.

Miller, Toby (2007) *Cultural Citizenship: Cosmopolitanism, Consumerism and Television in a Neoliberal Age*. Philadelphia: Temple University Press.

Misztal, Barbara (2003) *Theories of Social Remembering*. Maidenhead: Open University Press.

Moir, Jan (2008) 'Madonna Sups Deep at the Fountain of Youth', 26 March. Online: http://www.telegraph.co.uk/comment/columnists/janmoir/3556572/Madonna-sups-deep-at-the-fountain-of-youth.html.

Mooney, Michael M. (1972) *Who Destroyed the Hindenberg*. New York: Dodd, Media & Co.

Morris-Suzuki, Tessa (2005) *The Past Within Us: Media, Memory, History*. London: Verso.

Negroponte, Nicholas (1995) *Being Digital*. London: Vintage.

Nguyen, Nathalie Huynh Chau (2009) *Memory Is Another Country: Women of the Vietnamese Diaspora*. New York: Praeger.

Nora, Pierre (1996–8) *Realms of Memory: Rethinking the French Past*, ed. Lawrence D. Kritzman, trans. Arthur Goldhammer, 3 vols. New York: Columbia University Press.

Nora, Pierre (2002) 'Reasons for the Current Upsurge in Memory', *Eurozine*, 9 April 2002; first published in German in *Transit*, 22 (2002). Online: http://www.eurozine.com/journals/transit/issue/2002-06-01.html (accessed 8 October 2009).

Novick, Peter (1999) *The Holocaust in American Life*. Boston: Houghton Mifflin.

Nussbaum, Martha C. (2001) *Upheavals of Thought: The Intelligence of Emotions*. Cambridge: Cambridge University Press.

Olick, Jeffrey K. (1984) *Les Lieux de Mémoire* (*Realms of Memory*). Paris: Gallimard.

Olick, Jeffrey K. (1999) 'Collective Memory: The Two Cultures', *Sociological Theory*, 17 (3): 333–48.

Olick, Jeffrey (2008) 'From Collective Memory to the Sociology of Mnemonic Practices and Products', in Astrid Erll and Ansgar Nünning (eds), *Cultural Memory Studies: An International and Interdisciplinary Handbook*. Berlin: Walter de Gruyter, pp. 151–62.

Olick, Jeffrey K. and Coughlin, Brenda (2003) 'The Politics of Regret: Analytical Frames', in John Torpey (ed.), *The Politics of the Past: On Repairing Historical Injustices*. Lanham, MD: Rowman & Littlefield, pp. 37–62.

Olick, Jeffrey K. and Levy, Daniel (1997) 'Collective Memory and Cultural Constraint: Holocaust Myth and Rationality in German Politics', *American Sociological Review*, 62 (2): 921–36.

Olick, Jeffrey K., VinitskySeroussi, Vered and Levy, Daniel (2010) *The Collective Memory Reader*. Oxford: Oxford University Press.

Olick, Jeffrey K., VinitskySeroussi, Vered and Levy, Daniel (2011) *The Collective Memory Reader*. Oxford: Oxford University Press.

Packard, Noel (ed.) (2009) *Sociology of Memory: Papers from the Spectrum*. Newcastle: Cambridge Scholars Publishing.

Papoulias, Constantina (2005) 'From the Agora to the Junkyard: Social Memory and Psychic Materialities', in Susannah Radstone and Katharine Hodgkin (eds), *Memory Cultures: Memory, Subjectivity and Recognition*. Piscataway, NJ: Transaction Books, pp. 114–30.

Parry, Ross (2006) *Recoding the Museum: Digital Heritage and the Technologies of Change*. London: Routledge.

Pease, Edward C. and Dennis, Everette E. (eds) (1995) *Radio: The Forgotten Medium*. Piscataway, NJ: Transaction Publishers.

Pentzold, Christian (2009) 'Fixing the Floating Gap: The Online Encyclopaedia Wikipedia as a Global Memory Place', *Memory Studies*, 2 (2): 255–72.

Peters, Isabella (2009) *Folksonomies: Indexing and Retrieval in Web 2.0*. Berlin: Walter de Gruyter.

Pickering, Michael and Keightley, Emily (2006) 'The Modalities of Nostalgia', *Current Sociology*, 54 (6): 919–41.

Pilkington, Doris (1996) *Follow the Rabbit-Proof Fence*. Brisbane: University of Queensland Press.

Popular Memory Group (1982) 'Popular Memory: Theory, Politics, Method', in Richard Johnson et al. (eds), *Making Histories*. London: Hutchinson, pp. 205–52.

Postman, Neil (1986) *Amusing Ourselves to Death: Public Discourse in the Age of Show Business*. London: Penguin.

Postman, Neil (1992) *Technopoly: The Surrender of Culture to Technology*. New York: Vintage.

Prelinger, Rick (2009) 'The Appearance of Archives', in Pelle Snickers and Patrick Vondrau (eds), *The YouTube Reader*. London: Wallflower Press, pp. 268–74.

Puttnam, David (2004) 'Has Hollywood Stolen Our History?', in David Cannadine (ed.), *History and the Media*. Basingstoke: Palgrave Macmillan, pp. 160–6.

Radstone, Susannah (2007) *The Sexual Politics of Time: Confession, Nostalgia, Memory*. London: Routledge.

Radstone, Susannah and Katharine Hodgkin (eds) (2005) *Memory Cultures: Memory, Subjectivity and Recognition*, Piscataway, NJ: Transaction Books; previously published in 2003 as *Regimes of Memory*, Routledge Studies in Memory and Narrative. London: Routledge.

Raphael, Frederic (1980) 'The Language of Television', in Leonard Michaels and Christopher B. Ricks (eds), *The State of the Language*. Berkeley: University of California Press, pp. 304–12.

Reading, Anna (2002) *The Social Inheritance of the Holocaust: Gender, Culture and Memory*. Basingstoke: Palgrave Macmillan.

Reading, Anna (2003) 'Digital Interactivity in Public Memory Institutions: The Uses of New Technologies in Holocaust Museums', *Media, Culture and Society*, 25 (1): 67–86.

Reading, Anna (2008) 'The Mobile Family Gallery? Gender, Memory and

the Cameraphone', *Trames: Journal of the Humanities and Social Sciences*, 12 (62/57) (3): 355–65.

Reading, Anna (2009) *Towards a Philosophy of the Globital Memory Field*. LANDMARKS 2 Conference: Communication and Memory, Institute of Germanic and Romance Studies, SAS, University of London, 9–11 December.

Reading, Anna (2010) *Mobile and Static Memories in Gypsy, Roma and Traveller Communities*. Media, Memory and Gypsy, Roma and Traveller (GRT) Communities Symposium, Research Centre for Media, Memory and Community, University of Gloucestershire, 22 June. Online: http://www. glos.ac.uk/research/mac/mmc/Pages/default.aspx.

Reynolds, Gillian (2008) 'The Week in Radio', *The Telegraph*, 2 December.

Richardson, Ingrid (2005) 'Mobile Technosoma: Some Phenomenological Reflections on Itinerant Media Devices', *Fibreculture: Internet Theory, Criticism and Research*, 6. Online: http://journal.fibreculture.org/issue6/ issue6_richardson.html (accessed 9 November 2009)

Richardson, Kathleen and Hessey, Sue (2009) 'Archiving the Self? Facebook as Biography of Social and Relational Memory', *Journal of Information, Communication and Ethics in Society*, 7 (1): 25–38.

Richardson, Ingrid, Third, Amanda and MacColl, Ian (2007) 'Moblogging and Belonging: New Mobile Phone Practices and Young People's Sense of Social Inclusion', *ACM International Conference Proceedings*, 274: 73–8.

Ricœur, Paul (1984) *Time and Narrative*, Vol. 1. Chicago: University of Chicago Press.

Ricœur, Paul (2004) *Memory, History and Forgetting*, trans.Kathleen Blamey and David Pellauer. Chicago: University of Chicago Press.

Roediger, H. L., Dudai, Y. and Fitzpatrick, S. M. (eds) (2007) *Science of Memory: Concepts*. Oxford: Oxford University Press.

Rosenfeld, Gavriel D. (2009) 'A Looming Crash or a Soft Landing? Forecasting the Future of the Memory "Industry"', *Journal of Modern History*, 81:122–58.

Rosenstone, Robert A. (2001) 'The Historical Film: Looking at the Past in a Postliterate Age', in Marcia Landy (ed.), *The Historical Film: History and Memory in Media*. Piscataway, NJ: Rutgers University Press, pp. 50–66.

Rosenzweig, Roy and Thelen, David (1998) *The Presence of the Past: Popular Uses of History in American Life*. New York: Columbia University Press.

Rossington, Michael and Whitehead, Anne (eds) (2007) *Theories of Memory: A Reader*. Edinburgh: Edinburgh University Press.

Roth, Michael S. (1995) '*Hiroshima Mon Amour*: You Must Remember This', in Robert A. Rosenstone (ed.), *Revisioning History: Film and the Construction of a New Past*. Princeton: Princeton University Press, pp. 91–101.

Rothberg, Michael (2009) *Multidirectional Memory: Remembering the Holocaust in the Age of Decolonization*. Palo Alto, CA: Stanford University Press.

Rubinstein, Daniel and Sluis, Katrina (2008) 'A Life More Photographic: Mapping the Networked Image', *Photographies*, 1 (1): 9–28.

Ruddock, Andy (2001) *Understanding Audiences: Theory and Method*. London: Sage.

Samuel, Raphael (1996) *Theatres of Memory: Past and Present in Contemporary Culture*, Vol. 1. London: Verso.

Schama, Simon (2004) 'Television and the Trouble with History', in David Cannadine (ed.), *History and the Media*. Basingstoke: Palgrave Macmillan, pp. 20–33.

Schröter, Jens (2009) 'On the Logic of the Digital Archive', in Pelle Snickars and Patrick Vonderau (eds), *The YouTube Reader*. London: Wallflower Press, pp. 330–46.

Schwarz, Barry (1982) 'The Social Context of Commemoration: A Study in Collective Memory', *Social Forces*, 61 (2): 367–77.

Schwichtenberg, Cathy (1993) *The Madonna Connection: Representational Politics, Subcultural Identities and Cultural Theory*. Boulder, CO: Westview Press.

Shandler, Jeffrey (1999) *While America Watches: Televising the Holocaust*. Oxford: Oxford University Press.

Shingler, Martin and Wieringa, Cindy (1998) *On Air: Methods and Meanings of Radio*. London: Arnold.

Shirky, Clay (2008) *Here Comes Everybody: The Power of Organizing Without Organizations*. London: Penguin.

Shirky, Clay (2009) 'Clay Shirky: How Social Media Make History', *TED Talks*, June. Online: http://www.ted.com/talks/lang/eng/clay_shirky_how_cellphones_twitter_facebook_can_make_history.html (accessed 30 June 2010).

Shirky, Clay (2010a) *Cognitive Surplus: Creativity and Generosity in a Connected Age*. London: Allen Lane.

Shirky, Clay (2010b) 'The Collapse of Complex Business Models', *Clay Shirky Weblog*. Online: http://www.shirky.com/weblog/2010/04/the-collapse-of-complex-business-models/ (accessed 3 June 2010).

Smither, Roger (2004) 'Why Is So Much Television History About War?', in David Cannadine (ed.), *History and the Media*. Basingstoke: Palgrave, pp. 51–66.

Snickars, Pelle (2009) 'The Archival Cloud', in Pelle Snickars and Patrick Vonderau (eds), *The YouTube Reader*. London: Wallflower Press, pp. 292–313.

Snickars, Pelle and Vonderau, Patrick (eds) (2009) *The YouTube Reader*. London: Wallflower Press.

Snyder, Bob (2000) *Music and Memory: An Introduction*. Cambridge, MA: MIT Press.

Sontag, Susan (2002) 'Looking at War: Photography's View of Devastation and Death', *The New Yorker*, 9 December. Online: http://www.newyorker.com/archive/2002/12/09/021209crat_atlarge?currentPage=all#ixzz0yJ0aII9I.

Sontag, Susan (2003) *Regarding the Pain of Others*. New York: Farrar, Strauss & Giroux

Spigel, Lynn (1995) 'From the Dark Ages to the Golden Age: Women's Memories and Television Reruns', *Screen*, 36 (1): 16–33.

Spigel, Lynn (2005) 'Our TV Heritage: Television, the Archive and the Reasons for Preservation', in Janet Wasko (ed.), *A Companion to Television*. Oxford: Blackwell, pp. 67–100.

Srivastava, L. (2005) 'Mobile Phones and the Evolution of Social Behaviour', *Behaviour and Information Technology*, 2 (2): 111–29.

Starkey, Guy (2004) *Radio in Context*. Basingstoke: Palgrave Macmillan.

Stiegler, Bernard (2003) 'Our Ailing Educational Institutions', *Culture Machine*, 5. Online: http://www.culturemachine.net/index.php/cm/issue/view/13.

Sturken, Marita (1997) *Tangled Memories: The Vietnam War, the AIDS Epidemic, and the Politics of Remembering*. Berkeley: University of California Press.

Sturken, Marita (2002) 'Television Vectors and the Making of a Media Event: The Helicopter, the Freeway Chase and National Memory', in James Friedman (ed.), *Reality Squared: Televisual Discourses on the Real*. New Brunswick, NJ: Rutgers University Press, pp. 185–202

Sturken, Marita (2007) *Tourists of History: Memory, Kitsch, and Consumerism from Oklahoma City to Ground Zero*. Durham, NC: Duke University Press.

Sturken, Marita (2008) 'Memory, Consumerism and Media: Reflections on the Emergence of the Field', *Memory Studies*, 1 (1): 73–8.

Sussex Technology Group (2001) 'In the Company of Strangers: Mobile Phones and the Conception of Space', in Sally Munt (ed.), *Technospaces: Inside the New Media*. London: Continuum, pp. 205–23.

Sutton, John (2007) *Philosophy and Memory Traces: Descartes to Connectionism*. Cambridge: Cambridge University Press.

Taylor, Diana (2003) *The Archive and the Repertoire: Performing Cultural Memory in the Americas*. Durham, NC: Duke University Press.

Theiss, Evelyn (2009) 'My Lai Photographer Ron Haeberle Exposed a Vietnam Massacre 40 Years Ago Today in *The Plain Dealer*', 20 November. Online: http://www.cleveland.com/living/index.ssf/2009/11/plain_dealer_published_first_i.html (accessed 1 September 2010).

Thelen, David (ed.) (1990) *Memory and American History*. Bloomington: Indiana University Press.

Thelwall, Mike and Vaughan, Liwen (2004) 'A Fair History of the Web? Examining Country Balance in the Internet Archive', *Library and Information Science Research*, 26 (2): 162–76.

Tulving, E. (2007) 'Are There 256 Different Kinds of Memory?', in J. S. Nairne (ed.), *The Foundations of Remembering: Essays in Honor of Henry L. Roedinger, III*. New York: Psychology Press, pp. 39–52.

Turner, Graeme and Tay, Jinna (eds) (2009) *Television Studies After TV: Understanding Television in the Post-Broadcast Era*. London: Routledge.

Uricchio, William (2009) 'The Future of a Medium Once Known as Television', in Pelle Snickars and Patrick Vonderau (eds), *The YouTube Reader*. London: Wallflower Press, pp. 24–39.

van Dijck, José (2007) *Mediated Memories in the Digital Age*. Palo Alto, CA: Stanford University Press.

van Dyke, Ruth M. and Alcock, Susan E. (eds) (2003) *Archaeologies of Memory*. Oxford: Blackwell.

van House, Nancy and Churchill, Elizabeth F. (2008) 'Technologies of Memory: Key Issues and Critical Perspectives', *Memory Studies*, 1 (3): 295–310.

Vigilant, Lee Garth and Williamson, John B. (2003) 'Symbolic Immortality and Social Theory: The Relevance of an Underutilized Concept', in Clifton D. Bryant (ed.), *Handbook of Death and Dying Volume 1*. London: Sage, pp. 173–82.

Vincendeau, Ginette (2001) *Film/Literature/Heritage*. London: BFI.

Volkmer, Ingrid (ed.) (2006) *News in Public Memory: An International Study of Media Memories across Generations*. New York: Peter Lang.

Waldman, Diane and Walker, Janet (1999) *Feminism and Documentary*, Minneapolis: University of Minnesota Press.

Walker, Janet (2005) *Trauma Cinema: Documenting Incest and the Holocaust*. Berkeley: University of California Press.

Walter, Tony (1999) *The Mourning for Diana*. Oxford: Berg.

Weiss, Allen S. (ed.) (2001) *Experimental Sound and Radio*, A TDR Book. Cambridge, MA: MIT Press.

Wertsch, James (2002) *Voices of Collective Remembering*. Cambridge: Cambridge University Press.

Wesch, Mike (2008) *An Anthropological Introduction to YouTube*. Presentation to the Library of Congress. Online: http://www.youtube.com/watch?v=TPAOlZ4_hU&feature=player_embedded#! (accessed 12 August 2010).

Williams, Helen, Conway, Martin and Cohen, Gillian (2008) 'Autobiographical Memory', in Gillian Cohen and Martin A. Conway (eds), *Memory in the Real World*, 3rd edn. Hove: Psychology Press/Taylor & Francis, pp. 21–90.

Williams, Raymond (1975) *Television: Technology and Cultural Form*. Berlin: Schocken Books.

Wilson, Shaun (2009) 'Remixing Memory in Digital Media', in Joanne Garde-Hansen, Andrew Hoskins and Anna Reading (eds), *Save As . . . Digital Memories*. Basingstoke: Palgrave Macmillan, pp. 184–97.

Winter, Jay and Sivan, Emmanuel (eds) (2000) *War and Remembrance in the Twentieth Century*. Cambridge: Cambridge University Press.

Wright, Patrick (2009) *Living in an Old Country: The National Past in Contemporary Britain*. Oxford: Oxford University Press.

Young, Greg (2004) 'From Broadcasting to Narrowcasting to "Mycasting": a Newfound Celebrity in Queer Internet Communities', *Continuum: Journal of Media and Cultural Studies*, 18 (1): 43–62.

Young, James E. (1993) *The Texture of Memory: Holocaust Memorials and Meaning*. London: Yale University Press.

Zelizer, Barbie (1992) *Covering the Body: The Kennedy Assassination, the Media, and the Shaping of Collective Memory.* Chicago: University of Chicago Press.

Zelizer, Barbie (1995) 'Reading the Past Against the Grain: The Shape of Memory Studies', *Critical Studies in Mass Communication*, 12 (2): 215–39.

Zelizer, Barbie (1997) 'Every Once in a While: *Schindler's List* and the Shaping of History', in Yosefa Loshitzky (ed.), *Spielberg's Holocaust: Critical Perspectives on Schindler's List.* Bloomington: Indiana University Press, pp. 18–40.

Zelizer, Barbie (1998) *Remembering to Forget: Holocaust Memory Through the Camera's Eye.* Chicago: University of Chicago Press.

Zelizer, Barbie (2002) 'Photography, Journalism, and Trauma', in *Journalism after September 11.* New York: Routledge, pp. 48–68.

Zelizer, Barbie (2010) *About to Die: How News Images Move the Public.* Chicago: University of Chicago Press.

Zelizer, Barbie and Stuart Allan (eds) (2002) *Journalism after September 11.* New York: Routledge.

Zerubavel, Yael (1997) *Recovered Roots: Collective Memory and the Making of Israeli National Tradition.* Chicago: University of Chicago Press.

Žižek, Slavoj (1996) 'I Hear You with My Eyes', in Renata Salaci and Slavoj Žižek (eds), *Gaze and Voice as Love Objects.* Durham, NC: Duke University Press.

Zuckerman, Ethan (2010) 'Listening to Global Voices', *TED Talks.* TEDGlobal Conference, Oxford. Online: http://www.ted.com/talks/ethan_zuckerman.html.

Audio/Visual References

Hiroshima Mon Amour (1959, dir. Alan Resnais)

The Hindenberg (1975 dir. Robert Wise)

Star Wars Episode IV: A New Hope (1977, dir. George Lucas)

The Deer Hunter (1978, dir. Michael Cimino)

Coming Home (1978, dir. Hal Ashby)

Shoah (1985, dir. Claude Lanzmann)

Desperately Seeking Susan (1985, dir. Susan Seidelman)

Platoon (1986, dir. Oliver Stone)

First Person Plural (1988, dir. Lynn Hershmann Leeson)

Seeing is Believing (1991, dir. Lynn Hershmann Leeson)

Cold Lazarus (1993, Dennis Potter)

Schindler's List (1993, dir. Steven Spielberg)

Blue (1993, dir. Derek Jarman)

Strange Days (1995, dir. Kathryn Bigelow)

Star Trek: First Contact (1996, dir. Jonathan Frakes)

The Matrix (1999, dir. Wachowski Brothers)

High Fidelity (2000, dir. Stephen Frears)

90 Miles (2001, dir. Juan Carlos Zaldivar)

Rabbit Proof Fence (2002, dir. Philip Noyce)

9/11 (2002, dir. Naudet Brothers)

My Big Fat Greek Wedding (2002, dir. Joel Zwick)

Country of My Skull (2004, dir. John Boorman)

Downfall (2004, dir. Oliver Hirschbiegel)

The Final Cut (2004, dir. Omar Naim)

World Trade Center (2006, dir. Oliver Stone)

The Boy in the Striped Pyjamas (2008, dir. Mark Herman)

Enemies of the People (2009, dir. Rob Lemkin and Thet Sambath)

The Interview Project (2009–10, dir. David Lynch)

Who Do You Think You Are? (BBC, 2010)

My Big Fat Gypsy Wedding (Channel 4, 2010)

JFK – A Presidency Revealed (History Channel, 2003)

Top of the Pops (BBC, 1964–2006)

Grand Theft Auto (Rockstar Games, 1997–2009)

Twin Towers: A Memorial in Sound (BBC Radio 4, 2002)

Index

169